T0397213

The Architecture of Exhibitions

The Architecture of Exhibitions embarks on a comprehensive exploration of creativity and design innovation within exhibition spaces. It describes the fundamental principles of exhibition design, tracing the origins of creativity and considering its evolutionary significance.

The book challenges conventional boundaries imposed by rigid classifications, drawing on heuristic studies in biology and the transformative concept of exaptation. It questions the traditional separations between art, science and technology, which often hinder innovation. By advocating for an interdisciplinary approach, it reimagines creativity that transcends conventional limits. Through practice-based research, multidisciplinary case studies and technological innovations, with a focus on generative AI, the book illustrates how modern exhibition spaces actively engage with their audiences, highlighting their profound impact beyond academic discourse.

This book is designed for curators, designers and scholars who are passionate about the future of exhibition spaces. It offers a comprehensive understanding through its four-part structure, making it an essential read for anyone interested in the dynamic interplay between art, technology and society. The book is also designed as an instrument for the education of architecture, design and art students.

Alessandro Melis is a distinguished architect and art curator who currently holds the prestigious position of the first Endowed Chair Professor at the New York Institute of Technology. He was appointed by the Italian Minister of Culture as the curator of the Italian Pavilion at La Biennale di Venezia in 2021 and was honored as an ambassador of Italian Design in 2020–2024 (Italian Ministry of Foreign Affairs).

Rozina Vavetsi is Associate Professor at New York Tech, an award-winning visual designer and a Fulbright U.S. Scholar. With over two decades of experience in higher education, she combines forward-thinking pedagogy with invaluable industry expertise, demonstrating a strong commitment to bridging the gap between academia and the professional design world. Professor Vavetsi inspires her students to push disciplinary boundaries, emphasizing research, the exploration of emerging technologies, and creative problem-solving. She teaches a diverse array of design courses at both the graduate and undergraduate levels, maintains an active freelance career, and frequently participates in international conferences to stay abreast of idea exchanges and developments in the design landscape. Her design work has been featured in prestigious publications and exhibited in various venues around the world. Professor Vavetsi's research

interests include typography, information design, environmental graphic design, design thinking, human-centered design, and participatory design.

Fabio Finotti, an Emeritus Professor at the University of Pennsylvania, held the prestigious Mariano DiVito Chair of Italian Literature. Additionally, Finotti's leadership extends to his role as the President of the Interuniversity Master's Degree in Italian Studies, a collaborative program between the University of Trieste and the University of Udine. Appointed by the Italian Government, Finotti has been the Director of the Italian Institute of Culture in New York since 2020.

Routledge Research in Architecture

The *Routledge Research in Architecture* series provides the reader with the latest scholarship in the field of architecture. The series publishes research from across the globe and covers areas as diverse as architectural history and theory, technology, digital architecture, structures, materials, details, design, monographs of architects, interior design and much more. By making these studies available to the worldwide academic community, the series aims to promote quality architectural research.

Eating, Building, Dwelling
About Food, Architecture and Cities
Edited by David Arredondo Garrido, Juan Calatrava and Marta Sequeira

Photography, Architecture, and the Modern Italian Landscape
Primitivism and Progress
Lindsay Harris

Street by Street Retrofit
A Future for Architecture
Mike McEvoy

Philosophical Hermeneutics and the Architecture of Álvaro Siza
Meaning, Action and Place
Sally J. Faulder

Valences of Historiography
Essays on Architectural History
Edited by Gevork Hartoonian

The Architecture of Exhibitions
Experiential Design
Alessandro Melis, Rozina Vavetsi and Fabio Finotti

For more information about this series, please visit: www.routledge.com/Routledge-Research-in-Architecture/book-series/RRARCH

The Architecture of Exhibitions

Experiential Design

**Alessandro Melis, Rozina Vavetsi
and Fabio Finotti**

Routledge
Taylor & Francis Group

LONDON AND NEW YORK

Designed cover image: Padiglione Italia (Curator: Alessandro Melis). 17. Mostra Internazionale di Architettura della Biennale di Venezia 2021 (photo credit: Andrea Avezzù/ La Biennale Venezia).

First published 2025
by Routledge
4 Park Square, Milton Park, Abingdon, Oxon OX14 4RN

and by Routledge
605 Third Avenue, New York, NY 10158

Routledge is an imprint of the Taylor & Francis Group, an informa business

British Library Cataloguing-in-Publication Data
A catalogue record for this book is available from the British Library

ISBN: 978-1-032-73629-7 (hbk)
ISBN: 978-1-032-73632-7 (pbk)
ISBN: 978-1-003-46518-8 (ebk)

DOI: 10.4324/9781003465188

Typeset in Times New Roman
by Apex CoVantage, LLC

Contents

Figures

Preface

The Architecture of Exhibitions sets out on a comprehensive exploration of creativity and innovation within the realm of exhibition spaces. The work aims to provide a broad overview, investigating the fundamental principles of exhibition spaces, tracing the origins of creativity and considering their evolutionary significance.

The book challenges the conventional boundaries imposed by rigid classifications and categories, drawing on heuristic studies in biology and the transformative concept of exaptation. This critique questions the traditional separations between art, science and technology as well as the distinctions among various art forms. Often, these distinctions act as barriers to innovation and adaptation, particularly in the context of global crises. By advocating for an interdisciplinary approach, the book promotes a reimagined understanding of creativity that transcends conventional limits.

Emphasizing practice-based research, the book presents an array of multidisciplinary case studies and technological innovations. These examples highlight how modern exhibition spaces are not merely passive venues but active participants in the conversation between art and its audience. Through their significance, methodological rigor, and originality, these cases illustrate the profound impact that innovative exhibition design can have beyond academic discourse.

The book is structured into four distinct parts, each contributing to a comprehensive understanding of exhibitions within alternative and extended frameworks. The structure takes readers on a journey from foundational concepts about the necessity and origins of art exhibitions to cutting-edge practices and interdisciplinary perspectives.

The first part explores the evolutionary origins of exhibition spaces, offering a radical rethinking of the historical and theoretical foundations of art exhibitions. By providing a contextual framework, it lays the groundwork for understanding how early human creativity evolved and the pivotal role that exhibition spaces have played in this process.

The second part shifts focus to environmental graphic design and technological advancements. This section highlights the transformative power of emerging technologies, such as generative AI and machine learning, in reshaping contemporary exhibition spaces. These technological innovations bridge the gap between theory

and practice, showcasing how they are revolutionizing the way art is experienced and understood.

The third part presents a collection of practice-based research and international case studies, offering a wealth of insights from experts across various fields. This section underscores the diverse and interdisciplinary nature of contemporary art exhibitions, illustrating the transformative potential of exhibitions that transcend traditional boundaries through guest contributions and real-world applications.

In the final part, the book synthesizes the interdisciplinary perspectives and real-world applications discussed in the previous sections. This concluding section reflects on the future of exhibition spaces, emphasizing the need for adaptive and innovative approaches in an ever-changing global landscape. By exploring the dynamic interplay between art, technology and society, the book encourages readers to envision new possibilities for the future of creativity and exhibition design.

It also includes a handbook for design, offering practical guidelines and innovative strategies for creating engaging and impactful exhibition spaces that resonate with contemporary audiences and future generations.

Acknowledgements

The authors extend their deepest gratitude to the IDC Foundation for its unwavering support. The practice-based research projects presented in this book were made possible largely due to its continuous backing. Special thanks are owed to Raymond Savino and Henry Miller for their exceptional contributions.

We are also profoundly grateful to Mariangela Zappia, Ambassador of Italy to the United States, for fostering collaborative opportunities during the celebrations of Italian Republic Day on June 2, 2022. Our heartfelt thanks go to Renzo Macelloni, Mayor of Peccioli; Arianna Merlini, President of Belvedere SpA; Maria Porro, President of the Salone del Mobile Milano; Marva Griffin, the visionary creator and curator of the Salone Satellite; and Patrizia Catalano and Maurizio Barberis of Hoperaperta for their invaluable collaboration on the exhibitions showcasing practice-based research at the School of Architecture and Design at the New York Institute of Technology.

We would also like to express our sincere appreciation to the following individuals whose insights, collaboration and support have been indispensable to our work: Roberto Frangione, Eva Sohlman, Neal MacFarquhar, Nancy Pena, Telmo Pievani, Heather Pringle, Ian Tattersall, Niles Eldredge, Elisabeth Vrba, Richard Sennett, David Turnbull, Consuelo Nava, Mose' Ricci, Paolo Belardi, Monica Battistoni, Domenico Lucanto, Christian Pongratz, Pamela Cole, Giovanni Pellerito, Elisabeth Aitken Rose, Julia Gatley, Chris Chang, Trevor Keeble, Tarek Teba, Amy Bravo, Liam Stumbles, Jumhur Gokchepenar, Emanuele Lisci, Gian Luigi Melis, Nico Panizzi, Ilaria Fruzzetti, Filippo Mariani, Donatella Ulzega, Gian Benedetto Melis, Luca Gregorio, Francesco Secchiaroli, Eric Goldemberg, Daniela Perrotti, Paola Boarin, Malina, Mannarino, and William Carpenter.

A special note of thanks to Natalia Giovannetti for her collaboration in the editorial organization of this book.

Their contributions, whether through inspiration, knowledge, collaboration, guidance or support, have been instrumental in the success of this work. We are truly grateful for their involvement and dedication.

A New Perspective on the Origin of Art Exhibition

1 The Origin of the Design of Exhibition Space

From Cave Art to Göbekli Tepe

Alessandro Melis, Rozina Vavetsi and Fabio Finotti

Before the Birth of the Architecture Typologies

Imagine an alternative world in which art and science are nuanced manifestations of the same human creativity. You observe a painting in a museum, but in reality, you are witnessing an expression of associative thinking and an effort to propel serendipity in a research lab. Stemming from this and several related consequential differences, even the organization of daily life, building typologies and the entire city would transform. This is just a possibly marginal and limited understanding of the potential consequences in a human society from this very simple, though counterintuitive, modification of our idea of categories. However, it becomes very clear from the first expressions of symbolic representations in caves, spanning thousands of years – even before Homo sapiens and in other human societies like the Neanderthals – that art and science are even more than two manifestations of the same thing; they are, in fact, the same thing. More than to understand a potential reality, the categorization that occurs post hoc are instrumental to describe human agency as a purpose-driven process or as a way to interpret the complexity of reality beyond mere sensory experience.

The history of humanity, in fact, unfolds as a tale of perpetual conflict between the potentially impossible notion that an objective reality exists and the inherent impossibility of grasping it through our subjective instruments, constrained by the limits of our senses.

From the allegory of the cave to cinematic simulacra such as *The Matrix*, one element transcends the unease of the timeless struggle between subject and object: the fear that another entity might manipulate our subjectivity or dominate reality.

The unsettling nature of the uncanny triggers all phobias in humanity that believes it controls its own mind, only to find itself at the mercy of the unconscious.

Observing the associative operations of creativity, as opposed to rational thought, we realize our difficulty in discerning categories and functions in art stems from the fact that art exists at the boundary between the need for order and what appears as uncontrollable chaos. Thus, art allows us to confront that abyss and cross the line beyond which it is clear we know nothing and control nothing – or, even more nihilistically, that there is nothing to control. The first lie of subjectivity is precisely the notion of order and harmony in nature and in reality.

DOI: 10.4324/9781003465188-2

The exploration of exhibition space design as an architectural typology embarks on a journey that spans several centuries, reflecting the evolution of our societal, cultural and technological environments, as well as the categories that might help or impede us in accessing a higher level of awareness of the complexity of unreachable reality. This historical trajectory not only highlights the physical and conceptual developments in spaces dedicated to the display of art, artifacts, and information but also mirrors broader shifts in human civilization. However, to fully understand the essence and origins of the human inclination to exhibit artifacts, it is imperative to investigate a broader and more profound manifestation of human needs that extends thousands of years into our past. This inquiry implies an understanding of the genesis of creativity itself, a phenomenon likely related to a pivotal evolutionary transformation in the Homo sapiens brain occurring between 200,000 and 150,000 years ago (Melis et al., 2024).

This book represents a first attempt to provide a comprehensive understanding of how exhibition spaces have metamorphosed over time or functionally adapted from existing shelters, tracing their lineage from rudimentary practices of display preceding ancient civilizations to the sophisticated and immersive digital experiences that characterize the modern era. The narrative weaves together historical milestones, cultural shifts, and technological innovations that have collectively influenced the evolution of these spaces.

Beyond architectural and historical perspectives, this investigation also probes into the deeper essence of art exhibition as a phenomenon rooted in an evolutionary context, involving genetics and paleo-anthropology. It seeks to uncover the deep connections between the exhibition of creative products and the evolutionary pathways of human beings, suggesting that the need to create and display artifacts is more than a cultural construct; it is an intrinsic part of our genetic makeup that has evolved over millennia. Through this lens, the book aims to analyze the complex relationship between art, science, and human evolution, offering insights into the fundamental reasons behind our enduring compulsion to exhibit and observe.

Exhibition Spaces Beyond Ideological Constructs

Exhibition spaces, in their typological sense, cover a diverse range of environments crafted for the public exhibition of objects, artworks, and information. This notion typically intersects with architectural genres including, but not limited to, museums, galleries, trade fairs, and digital platforms. The evolution of these spaces plays a pivotal role in mediating the relationship between the audience and the exhibited items, thereby significantly impacting the viewer's perception, engagement, and comprehension.

As we embark on tracing the lineage and transformation of exhibition space design, it becomes evident that the influences steering these developments are multidisciplinary, as these spaces have evolved beyond mere venues for displaying artifacts or art; they encapsulate experiences that pervade human existence, transcending a narrowly defined typology. This evolution suggests that the current state of exhibition design might not merely be a result of a deliberate, deterministic

architectural stance but rather an outcome of a broader, more nuanced human creative impulse.

This extended perspective underscores that the concept of exhibition spaces as specialized entities is a relatively recent development. Often, it might appear as if these spaces are shaped more by an imposed design ideology than by a natural progression from the earliest expressions of creativity. Through this examination, we aim to highlight how exhibition spaces have historically reflected environmental behavior before societal values influencing cultural tastes, intellectual currents, and technological capabilities. By understanding this evolution, we can appreciate the depth and breadth of factors that contribute to the design of contemporary exhibition spaces, offering insights into how these environments continue to shape and be shaped by human experience.

From a paleo-anthropological perspective, it is plausible to consider the need to exhibit the products of human creativity as linked to the emergence of creativity itself, occurring between 200,000 and 90,000 years ago, when associative thinking began to flourish, marking a departure from the linear thinking as standard modality of survival. Associative thinking, as Pringle (2013) describes, hinges on the complex increase in interconnections and functional adaptations within the brain's architecture rather than a mere increase in brain size.

These early human activities and creations, devoid of practical purpose, were driven by the manipulation of materials, which included, but were not limited to, mimicking existing forms and colors to represent reality symbolically.

Initially, exhibition impulses were directed toward simple displays, such as the human body, a distinctive rock, or handcrafted or repurposed objects.

This need did not emerge solely from a desire to represent tangible reality, such as hunting scenes, or to create practical objects; from the outset, creativity encompassed abstract and symbolic expressions, ranging from hand stencils and ornaments to the ritual burial of the dead. This highlights a complexity that transcends mere mimicry and tinkering, viewing them not as opposing needs but rather as parts of the same spectrum (Melis et al., 2024).

Our tendency to overestimate conscious awareness often leads us to interpret rational behavior as evidence of the superiority of human intelligence. However, the brain's haphazard evolutionary development, independent of its size, reveals a wellspring of creative potential through a substantial increase in neural connections that do not manifest as intentional purpose. This growth is mainly associated with serendipitous trends in evolution, in line with the theory of exaptation (Gould & Vrba, 1982), which suggests that nature economically repurposes existing structures. The results, in the case of human agency, have been "unexpectedly" – in the sense of distance from original purpose – successful for our evolution. Contemporary neuroscience supports the notion that not all brain areas today fulfill their original evolutionary purpose (Melis & Pievani, 2022; Melis et al., 2022). The brain's capacity for plasticity, both in development and evolution, is a result of such repurposing. For instance, our ability to read and write, functions not directly selected for in our evolutionary history, arises from the adaptive use of brain regions initially dedicated to other tasks. Similarly, our capacity for aesthetic appreciation, possibly

originating from the pleasure associated with vital survival activities, has evolved to include enjoyment without any direct functional advantage. And this is where functionality takes on a more polymorphic meaning, diverging from linearity.

Revisiting the theme of art exhibition, it is plausible that the brain's mechanisms for aesthetic judgment initially evolved to evaluate essential items, such as nutrition, and were later adapted for art appreciation. Our brain's responses to music and food show surprising similarities, challenging the idea of a specialized system for art appreciation. By integrating concepts such as creativity – characterized by diversity, variability, and redundancy – into evolutionary biology, we can better understand the combination of adaptive and exaptive mechanisms that encourage functional innovation. If creative capacities are scalable, demonstrated by the correlation between the genome and brain structure and between the brain and creative expression, then both architectural design and other forms of associative thinking could encourage a beneficial disorder, facilitating serendipitous discoveries and adaptive transformations (Pievani, 2024). Consequently, technology, science, and art can be seen as interconnected expressions of the same fundamental creative drive (Melis, 2020; Nava & Melis, 2021).

In translating the discourse to the context of this book, we can identify a correlation between the act of aimlessly manipulating matter to create objects, artifacts, products, and artwork (these distinctions likely being relatively recent categorizations of an ancient, inherent, and holistic creative transformation of human agency) and the desire to showcase and make this activity known, not only to the creator but, more significantly, to a broader community. This action becomes a manifestation of both individual and collective artistic expression. The evolutionary success of this dynamic is underscored by a feedback mechanism driven by pleasure, which is present even before these objects assume a functional role. This anticipation is what we recognize as the appreciation of art and aesthetics (Melis et al., 2024).

Following Pringle's argument (2013), the enduring link between creation, exhibition, and pleasure is not entirely divorced from the technological context that lends these endeavors value. In essence, it's as though our brains unconsciously evaluate that aesthetic values associated with redundancy, variability, and diversity of forms may serve as a future reservoir of opportunity. Thus, the appreciation of beauty motivates us to produce items without immediate utility, facilitating the creation of things that may prove unexpectedly useful in scenarios where adaptive solutions, emerging from linear thinking, falter due to emergent challenges or unforeseen constraints.

The Dawn of Exhibited Artistry

The shifts in the human brain around 200,000 to 150,000 years ago laid the groundwork for the emergence of creativity, suggesting that the drive to display art is an innate aspect of creativity's inception. Advancements in cognitive functions, such as imagination and symbolic thought, played a crucial role in fostering creativity. Specifically, the spread of cave art around 40,000 years ago highlights the connection between brain evolution and the exhibition of art.

The evolutionary success of these creativity expressions is demonstrated by the significant amount of time early humans devoted to art, even during periods when survival activities would presumably be prioritized. The effectiveness of these creative strategies is further evidenced by their enduring nature and the sensory and emotional enjoyment derived from aesthetic experiences, which serve as feedback mechanisms (Melis, 2023). From this source of tinkering and creativity, functional utility may arise in response to pressing constraints and evolving circumstances.

Prominent cave art sites in Europe, such as France's Chauvet-Pont-d'Arc Cave, renowned for its 36,000-year-old paintings, the Lascaux Caves with their striking 17,000-year-old visuals, and Spain's famed Altamira Cave, exemplify early artists' adeptness and their dynamic interaction with the cave walls, which served as both canvas and exhibition space. This interaction aimed to amplify the three-dimensional effect of their artwork. The array of animal and human figures, alongside symbolic motifs and engravings found within these caves, underscores our ancestors' burgeoning artistic talent. This surge in creativity, spurred by the advent of associative modes, previously described, underscored their "non-intentional scope" to transform these cave environments into spaces for artistic expression, allowing them to share the artistic process and the encompassing visual and sensory experiences with others.

However, it's crucial to acknowledge early in this book and, particularly, in this context that these transformations are rooted in inherent human needs, divergent from the contemporary practice of deliberately and precisely assigning a space for a specific function. This consideration emphasizes that traditional classifications of artistic expressions – and likely other forms of expression – are relatively recent constructs, mostly occurring within the last two centuries.

They aim to define practices with origins extending back hundreds of thousands of years. Terms like *painting*, which we now understand as a form of artistic expression distinct from its technological or evolutionary significance, and *exhibition space*, historically may have been more closely integrated with environmental interactions. From our modern perspective, these terms are often confined to the concepts of content and container, making their original meanings largely indecipherable.

Functions and Gender Dynamics of Prehistoric Artistic Exhibition

The origin of art, understood as a case of exaptation – where regions of the brain, originally developed for other functions, found new purpose in fostering artistic creativity – gave rise to an innovative type of environmental functional co-optation among early humans: the use of surfaces like cave walls or other natural materials as a medium for display. This likely served to enable shared experiences, what we now recognize as rituals, defined in this case as the result of cognitive and neural advancements in Homo sapiens facilitating complex mental tasks. This led to diverse forms of interaction with their environment, which we refer to as artistic expression, characterized by the engagement of multiple senses, including visual and tactile, and possibly involving other experiential aspects not yet detected with our current rational understanding of categories.

The wealth of artistic expression found in early human shelters, which includes the functional co-optation of stones to display three-dimensional artifacts, blurs the distinctions between fine arts – such as paintings and sculptures – and performance and performing arts, as well as between technology and tinkering. Cave sites worldwide feature, for instance, hand stencils and handprints alongside animal depictions, adding complexity to our understanding of early artistic endeavors in relation to current categorizations about the differences between fine and performative arts. Although these classifications are useful for understanding in both contemporary and ancient societies, they might not accurately depict the nature of early human creativity or fully capture our ancestors' experiences, suggesting that both deliberate and accidental artistic acts, as well as distinctions among art forms, are relatively recent constructs. A negotiable point of contact between our modern categories and the more radical, holistic perspective offered by paleo-anthropology is the recognition that these simple primal human gestures may be the ancestors of all current industries – "industry" intended here according to its broad Latin etymology. However, interpreting evolution in this way still leans toward a reassuring, orthodox view of progressive development rather than fully embracing the complexities and nuances of early human creativity and its evolutionary significance.

Techniques of hand stenciling and hand printing, seen in sites like the El Castillo cave in Spain and the Pech Merle cave in France, reflect diverse artistic methods and potential functionalities – more than mere purposes. Despite various attempts and hypotheses, researchers have not yet been able to distinguish intentional uses from either conscious or unconscious functional co-optations. These may include symbolic and ritualistic significance, personal or communal identity markers, education, or leisure, which do not seem too distant from the still existing forms of temporary appropriation of public space in historic city centers like Mexico City (Melis et al., 2020), from street art in South Bronx, or in informal art all over the world (Di Raimo et al., 2020).

Particularly, hand stencils and handprints reflect the artistic inclinations of early humans, serving as symbolic signs of self-expression that cannot be reduced to mere descriptions of life experiences or the natural environment, confirming that searching for a single specific purpose or function in these primitive artistic manifestations may be misguided.

Forms of creativity, including purposeless behaviors, embody the essence of creativity as a manifestation of associative thinking. This mode of thinking, according to Pringle (2013), adopted as an alternative during crises, contrasts with conventional deterministic thinking.

Artistic expression offers a means for exploration, experimentation, and creative problem-solving through non-linear and intuitive methods, yielding unexpected insights and perspectives. The art, involving physical contact, allows humans to transfer a significant amount of coded data (associative thinking) onto a "hard drive" (such as a cave wall, serving as exhibition space) through the soft medium (act of drawing).

Tinkering, which involves the manipulation of materials and forms, facilitates the processing of a greater volume of data generated by associative thinking, surpassing the data generated through linear approaches.

The symbolism in certain artistic expressions is akin to encrypted data that requires a "qualitative" decoding system, such as post-rationalization. We can extend this idea further by considering that even psychoanalysis can serve as a decoding system.

Looking back in time, not only do the boundaries between intentionality and functionality blur but distinctions between gender roles also diverge from our current categorizations. This reinforces the idea that the categories we commonly accept don't necessarily reflect reality but instead represent a taxonomical view significantly shaped by societal norms. Initially, cave art was hypothesized to be primarily a male endeavor, associated with hunting rituals and self-affirmation.

Recent studies challenge this traditional view, recognizing that attributing these drawings to a specific gender is a complex and debated issue. Ethnographic studies also indicate that artistic practices were not necessarily gender-exclusive, suggesting a shared artistic endeavor in prehistoric societies influenced by social roles and cultural norms.

Adopting an exaptation perspective, which emphasizes the variability and redundancy of cognitive structures, suggests that artistic gender diversity may have contributed to the success of art sharing and exhibition over thousands of years. In contrast, the period where male-dominated art was prevalent covers a very limited span of our evolution (Melis & Melis, 2021). This position highlights art's role in navigating crises by providing a platform to maximize diversity.

However, all these perspectives remain hypothetical, as identifying the genders of ancient artists is challenging due to limited evidence and the difficulty of making attributions based solely on the art. Efforts to discern the artists' gender include analyzing hand stencils and prints in cave art for physical characteristics, such as size and finger proportions (Soffer, Adovasio, and Hyland, 2000), although these methods are speculative.

Advancements in archaeological techniques, such as the study of ancient DNA or stable isotope analysis, may offer insights into the gender dynamics of prehistoric populations (Vanhaeren et al., 2006). While current research does not allow for definitive conclusions (Lewis-Williams, 2002; White, 2012), it prompts a reevaluation of our understanding of the origins of exhibition spaces and the diverse individuals behind cave art.

Echoes of Eternity: The Dinaledi Chamber and the Genesis of Performative Arts in Prehistoric Architecture

A performative space represents a philosophically intriguing form of art exhibition, as it notably challenges Aristotelian classical categories of reality and resonates with preclassical views that suggest the difficulty of distinguishing life from its representation without an organized taxonomy. Such a space extends beyond its

physical confines to embody a dynamic exhibition of art, where actions, rather than objects, serve as the primary medium of expression.

For instance, if we consider human burial practices, which date back to at least 100,000 years ago, with the earliest definitive evidence found at Qafzeh Cave in Israel, we might conclude that these early burials, characterized by simple pits and the occasional inclusion of grave goods, signify a cognitive leap toward symbolism and the afterlife. The distinction between burial as an act performed for artistic purposes or to fulfill cultural, spiritual, and societal needs might be an artificial construct, relying only on the intentionality behind the categorization that separates and distinguishes these needs. This draws our attention toward binary taxonomies rather than spectrums. However, from an evolutionary standpoint, particularly when considering the emergence of creativity and the mechanism of exaptation, such distinctions become irrelevant: we create the categories and then apply the rules, overlooking the complexity of nuances, overlaps, and multiplicities in favor of a singular narrative.

Over millennia, burial practices have evolved to include more complex rituals, the construction of tombs and cairns, and the use of burial mounds. The diversity in burial traditions reflects the complexity of human societies and their beliefs, spanning across cultures and epochs. From the Neanderthals' flower-laden graves to the elaborate tombs of the Egyptian pharaohs, the evolution of burial practices mirrors the advancement of human civilizations and their shifting perspectives on death, art, and the cosmos, along with the need to share and exhibit these perspectives. In evolutionary terms, these practices might be both a reflection of life and a form of art performance.

The discovery of Homo naledi, a species that bridges the gap between primitive roots and modern complexities, within the so-called Dinaledi Chamber, has ignited debates on the origins of ritualistic behavior and artistic expression. If Lee Berger's hypothesis is accurate, the burial practices found there imply that performative practices originated before Homo sapiens (Berger et al., 2015).

This alleged intentional creation and designation of space for rituals can signify the emergence of architectural spaces not merely as shelters but as stages for human expression and communal identity. The Dinaledi Chamber emerges as a primal stage where the earliest acts of architectural ingenuity and performative art unfolded, suggesting the radical hypothesis that the initial exhibition spaces may have been conceived by hominins other than Homo sapiens. This challenges the notion of Homo sapiens' central position in evolution and underscores the evolutionary importance of diversity.

Göbekli Tepe: Exhibition Spaces Beyond Cave and Burial Art

Spanning thousands of years, from cave art to the Göbekli Tepe carvings – possibly among the oldest known examples of art exhibited in designed spaces – this confirms that the drive to create, to express, and to connect through art exhibition is as ancient as humanity itself.

The discovery of Göbekli Tepe, dating back to approximately 100,000 BCE, represents a challenge to the traditional narrative of human history, particularly in the

context of architecture and art. Positioned at the precipice of human civilization, Göbekli Tepe is not merely an archaeological enigma; it invites us to reconsider the genesis, artistic expression and its exhibition in communal spaces, and the very essence of human creativity and spirituality. Aristotle's view of humans as inherently artistic beings, as outlined in his *Poetics*, alongside the spiritual dimensions often attributed to our ancestors, finds a compelling intersection at Göbekli Tepe. This site, often described as potentially the world's first temple, might also be envisioned as humanity's earliest known art exhibition space, challenging the modern architecture dichotomy between the sacred and the aesthetic.

Archaeological interpretations hint that the stone pillars' configurations and their elaborate carvings likely bore ritual or ceremonial significance (Schmidt, 2010). Yet, fully deciphering their purpose and meaning presents formidable obstacles, challenging the notion that every construction is likely linked to a ritual condition at a certain stage of its evolution as well as various other contextual and subsequent uses.

Göbekli Tepe disrupts the linear progression from hunter-gatherer societies to agricultural settlements, traditionally considered the genesis of architecture (and cities) and, by extension, complex societal structures. The site's elaborate stone pillars, richly adorned with carvings of animals and abstract symbols, are silent evidence of an era where the spiritual and the artistic were likely inseparably linked and connected in many inexplicable ways to other functions that we might today describe as more pragmatic or rational.

Continuing the discussion on the construction workflow of Göbekli Tepe, details regarding the techniques and tools employed remain largely elusive, concealing deeper insights into the artistic skills and methodologies utilized. This obscurity extends to the identities of its creators, whether they were builders, a community of artists, or both, reflecting previous considerations about the site's significance in terms of use. The scale of labor and time investment required for its construction, estimated to involve thousands of people, is left to speculation, informed only by our current understandings and assumptions. It is conceivable that a sophisticated variety of work strategies evolved over the centuries, involving stone-crafting tools and, perhaps, the presence of other construction and artistic components in organic materials now lost to time, obscuring our full grasp of the site's essence. (Clare, 2020; Curry, 2008; Dietrich et al., 2012).

Göbekli Tepe challenges not only the traditional idea of progress in history but also the contemporary notion of its architecture's primary function being associated with spirituality, as evidenced by frequent references to Göbekli Tepe as a temple despite the lack of specific evidence. This taxonomical approach overlooks the intriguing possibility that Göbekli Tepe might have served as an early art exhibition space. Although the concepts of "art" and "exhibition" might have differed significantly from modern interpretations, our understanding of early humans – who possessed cognitive capacities similar to ours – indicates that their desires to display and share craftsmanship, engage in proto-educational activities, or demonstrate showmanship could have been just as vital as ritual practices. This perspective suggests that the dichotomy between ritual and artistic expression in early human societies might not be as clear-cut as traditionally assumed.

This perspective would confirm that for the majority of our evolution, we embraced a more holistic and polymorphic understanding of architecture and space.

Moreover, the current shift toward integrating functions, as opposed to segregating them, in response to ecological considerations, might underscore the obsolescence of a purely typological view.

In this case, as well, the concept of exaptation aids in envisioning Göbekli Tepe as a spandrel (Gould & Lewontin, 1979), in the sense of a venue for multiple, potentially overlapping uses, shaped by collective human effort across generations. This approach moves beyond the assumption that constructions serve singular, narrowly defined purposes. Instead, it suggests that sites like Göbekli Tepe are the result of a dynamic blend of intentions, functions, and meanings, woven together by the diverse efforts of their creators (Melis et al., 2024)

Thus, the reluctance to integrate Göbekli Tepe into broader architectural and artistic discussions may stem from discomfort with its implications. It suggests that our ancestors were capable of conceptualizing and executing monumental projects with profound spiritual, aesthetic, and rational dimensions long before the advent of settled agricultural societies. This realization forces a reevaluation of the origins of art and architecture, suggesting that the impetus to create and to gather around shared art exhibition spaces predates settled life. Göbekli Tepe, therefore, embodies the convergence of the spiritual, the artistic, and the rational, without suggesting a linear progression from one to the other. It implies that our ancestors were not just builders of structures for shelter or ritual but also creators of symbolic spaces that served as canvases for the expression of their innermost thoughts and beliefs.

References

Berger, L. R., Hawks, J., de Ruiter, D. J., Churchill, S. E., Schmid, P., Delezene, L. K., . . . & Zipfel, B. (2015). Homo naledi, a new species of the genus Homo from the Dinaledi Chamber, South Africa. *elife*, *4*, e09560.

Clare, L. (2020). Göbekli Tepe, Turkey. A brief summary of research at a new World Heritage Site (2015–2019). *e-Forschungsberichte des DAI*, *2*, 1–13 (§). http://doi.org/10.34780/efb.v0i2.1012.

Curry, A. (2008, November). Göbekli Tepe: The world's first temple? *The Smithsonian*, 1–10.

Di Raimo, A., Lehmann, S., & Melis, A. (Eds.). (2020). *Informality through sustainability: Urban informality now*. Routledge.

Dietrich, O., Köksal-Schmidt, Ç., Notroff, J., Schmidt, K., & Kürkçüoglu, C. (2012, May). Göbekli Tepe: A stone age sanctuary in South-Eastern Anatolia. *Actual Archaeology*.

Gould, S. J., & Lewontin, R. C. (1979). The spandrels of San Marco and the Panglossian paradigm: A critique of the adaptationist programme. *Proceedings of the Royal Society of London. Series B, Biological Sciences*, *205*(1161), 581–598.

Gould, S. J., & Vrba, E. S. (1982). Exaptation – A missing term in the science of form. *Paleobiology*, *8*(1), 4–15.

Lewis-Williams, D. (2002). *The mind in the cave: Consciousness and the origins of art*. Thames & Hudson.

Melis, A. (2020). Urban exaptation: Verso una nuova tassonomia della citta'ecologica. In *Innovazione armonica*. Rubbettino Editore.

Melis, A. (2023). Architecture through drawing. *diségno*, *11*(13), 33–42.

Melis, A., Lara-Hernandez, J. A., & Melis, B. (2022). Learning from the biology of evolution: Exaptation as a design strategy for future cities. *Smart and Sustainable Built Environment*, *11*(2), 205–216.

Melis, A., Lara-Hernandez, J. A., & Thompson, J. (2020). *Temporary appropriation in cities*. Springer.

Melis, A., & Pievani, T. (2022). Exaptation as a design strategy for resilient communities. In *Transdisciplinarity* (pp. 307–327). Springer International Publishing.

Melis, A., Pievani, T., & Lara-Hernandez, J. A. (2024). *Architectural exaptation. When function follows form*. Routledge.

Melis, B. (2021). Community resilience through exaptation: Notes for a transposition of the notions of exaptation into a design practice to promote diversity and resilience as an alternative to planning determinism during crisis. *Interdisciplinary Journal of Architecture and Built Environment, 106*(23), 32–36.

Nava, C., & Melis, A. (2021). A radical bioecological paradigm for design technologies with a transdisciplinary approach. *TECHNE-Journal of Technology for Architecture and Environment,* 103–111.

Pievani, T. (2024). *Serendipity: The unexpected in Science*. MIT Press.

Pringle, H. (2013). The origins of creativity. *Scientific American, 308*(3), 36–43.

Schmidt, K. (2010). Göbekli Tepe: The stone age sanctuaries. New results of ongoing excavations with a special focus on sculptures and high reliefs. *Documenta Praehistorica, 37*(1), 239–256.

Vanhaeren, M., d'Errico, F., Stringer, C., James, S. L., Todd, J. A., & Mienis, H. K. (2006). Middle paleolithic shell beads in Israel and Algeria. *Science, 312*(5781), 1785–1788.

White, R. (2012). *Prehistoric art: The symbolic journey of humankind*. Harry N. Abrams.

2 Art Exhibition From the Classic Perspective

Alessandro Melis, Rozina Vavetsi and Fabio Finotti

Nature and Mimesis in Art Exhibition

Today, we often discuss art from avant-garde movements to abstraction as introducing, in Hegel's words, elements of complexity that make it less immediate and distant from the classical idea of beauty and imitation of nature. However, through the lens of exaptation, one might argue that both forms of creativity have always coexisted, perhaps not even in a binary form but more in a combinatory manner. It is, instead, the way we categorize human actions, including the pursuit of art exhibition, that has changed.

Even though the thesis of this book is that art originates as something more complex than mere deterministic imitation of nature, cave art demonstrates that the imitation of nature is one of the drivers of creativity, contributing to its combinatorial mechanism. Furthermore, the evolution of mimetic theory throughout history reflects the critical relationship, through our perceptions, between art and its representations of reality. Our taxonomical understanding of the latter can be entrusted to artistic expressions and abstractions that evolve over time and, according to Michel Foucault, have meaning only when they are useful (Melis, 2021). But today, in times where the meaning of functionality has shifted from the reductionism of evolutionary orthodoxy toward inscrutable forms of adaptation (and exaptation) to the environment around us, one must ask: useful for what?

The idea of the exhibition space opens up to unexpected discoveries, making the concept of imitation of nature elusive as realities multiply and ripple under the redundant effect of evolutionary waves. In simpler terms, since the real is a variable concept, mimesis, too, becomes a transformative notion.

Consequently, mimetic theory has multiplied, during history, its trajectories and permeated different fields of study, from literature and the arts to psychology explaining its crucial role in the cognitive and social development of the individual, from biomimicry to the imitation of culture in anthropology.

In the comparison between Plato's vision and Aristotle's *Poetics*, the enduring debate in Western culture over the value of art as imitation of nature unfolds as a binary concept. Plato views art as a departure from rationality, an "imitation of imitation" fraught with anguish. In contrast, Aristotle sees art as the essence of humanity; we are inherently artistic beings. Art embodies freedom and pleasure,

DOI: 10.4324/9781003465188-3

enhancing our lives and making us better. From an evolutionary perspective, Aristotle's vision aligns more coherently with the origins of creativity. Art serves as a tool for re-elaboration and imitation, offering functional and potentially cathartic benefits. This perspective explains why primitive humans devoted so much time to an activity that, from a rationalist viewpoint akin to Plato's, might seem non-essential.

Taking a step back to its historical genealogy, mimesis as an art exhibition practice can be traced back to Plato's skepticism, expressed in his *The Republic* (circa 380 BCE), toward the possibility of representing the real world in art. This skepticism is due to his conviction that the physical world is already an imitation of the Forms (or Ideas), which are the ultimate and immutable realities upon which everything that exists is based. The Forms represent truth and perfection, while the sensible world in which we live is only their imperfect copy.

Consequently, art, by imitating the physical world, finds itself to be a second-order imitation, a copy of a copy, and thus even further removed from the truth and the ultimate reality of the Forms. For Plato, therefore, artistic mimesis not only fails to accurately represent reality but can also be harmful to the soul, as it distracts individuals from aspiring to the knowledge of the Forms, which is the path toward wisdom and virtue. His ideal vision of society, as described in *The Republic*, envisions a limited role for artists, who should be subject to censorship and guided to produce works that promote moral values and truth rather than sensory deceptions or ephemeral emotions.

Plato and the Exhibition of the Cave Art as a Philosophical Allegory

Plato's discourse on mimesis is epitomized by the iconic allegory of the cave in Book VII of *The Republic*, which depicts prisoners who have been chained inside a cave all their lives, facing a blank wall. They watch shadows projected on the wall from objects passing in front of a fire behind them and construct beliefs about the world based on these shadows. This exhibition, well-known as an allegory for the human condition, illustrates Plato's view that the material world we perceive through our senses is merely a shadow or reflection of the true reality, the world of Forms. In this context, artistic creation, which imitates the material world, is doubly removed from truth and reality. The allegory serves as a caution against becoming too engrossed in the sensory and illusory aspects of art and life, highlighting the importance of seeking higher knowledge and understanding. It underscores the potential of art to mislead and emphasizes the essential pursuit of philosophical inquiry and intellectual growth to move beyond the shadows and closer to the truth (Fine, 2003).

Among the many interpretations of Plato's "Allegory of the Cave," one particularly evocative idea is that life resembles a theatrical performance, where individuals are compelled to watch as spectators. This perspective also brings to mind the cave art of our ancestors, where early humans used the walls of their shelters as canvases to express their experiences. Though Plato was not aware of these primitive artistic endeavors, the allegory's suggestion becomes even more fascinating. It

illustrates that by manipulating materials and exploring creative avenues, one can maximize serendipitous associations and uncover new opportunities. This notion not only enriches our understanding of the allegory but also underscores the timeless human impulse to create and find meaning in the world around us.

Connections between Plato's "Allegory of the Cave" and prehistoric cave art can include both semiotic and interpretive significance, particularly in terms of the themes of shadow and light, the portrayal of reality, and the journey toward enlightenment or discovery. These interpretations enhance our appreciation of both Plato's philosophical insights and the importance of prehistoric art, though they should not be construed as evidence of a direct historical or factual connection between the two.

Thus, the cave represents, for Plato, the sensory world of appearances, while the shadows symbolize the imperfect and illusory copies of the true Forms. The journey out of the cave and into the sunlight, painful and disorienting at first, symbolizes the ascent of the soul toward the light of knowledge and the understanding of the Forms, representing reality in its highest and purest form.

This journey has been subjected to various interpretations across different philosophical domains. Within the context of exhibition spaces, these interpretations can similarly be linked to collective expressions fueled by human creativity.

The epistemological interpretation focuses on Plato's theory of knowledge and understanding (Audi, 2010). The allegory illustrates the process of enlightenment and the transition from ignorance to knowledge. The cave symbolizes the realm of ignorance, where prisoners, representing ordinary people, are deceived by appearances. The transition from the darkness of the cave to the brightness of the sunlight symbolizes the philosophical pursuit of authentic knowledge, grasping the concept of Forms that denote the highest form of reality beyond what our senses can perceive. Similarly, this journey parallels the possible experiences encountered through art.

The metaphysical reading of the allegory highlights the distinction between the sensory world (the world of appearances) and the intelligible world (the world of Forms). The shadows on the cave wall symbolize physical objects in the world, mere reflections of the Forms. The sun outside the cave represents the Form of the Good, the highest level of reality and the source of all truth and knowledge (Loux & Crisp, 2017). This interpretation explores the essence of reality and the presence of an immutable, higher truth, which can be also reflected in the metaphysical aspects of artistic expression.

From a psychological perspective, the allegory, transferable to the arts, depicts the human condition and the struggle between ignorance and enlightenment. The prisoners' resistance to enlightenment, even when one of them has seen the light, illustrates the human tendency to cling to familiar beliefs and resist new truths. This interpretation explores the psychological barriers to knowledge and the transformative power of education (Freud, 1917). In his seminal work *Introductory Lectures on Psychoanalysis*, Freud (1917) can offer, for instance, a psychological perspective on the allegory, particularly when considering the cave as a symbol of the unconscious mind. Similarly, Carl Jung's investigation into symbols and

the collective unconscious offers a compelling framework for understanding the allegory, particularly in relation to personal and collective enlightenment (2012). This perspective supports the idea that the origins of art could be hypothesized as a collective act of creativity, highlighting the allegory's relevance to discussions of both psychology and art.

Plato also integrates a political dimension into the allegory, reflecting his views on governance and society, as well as echoing the implication of every human expression. The enlightened individual who returns to the cave represents the philosopher-king, a ruler who, having seen the truth, has a responsibility to lead and educate those still in ignorance. This interpretation highlights the philosopher's role in society and the importance of wise and informed leadership for the welfare of the state.

The ethical reading of the allegory addresses the moral implications of enlightenment and ignorance. It suggests that understanding the truth imposes a duty to act according to higher principles and assist others in achieving enlightenment. The challenges of returning to the cave and the hostility faced by the enlightened individual underscore the ethical dilemmas in striving for goodness in a resistant world, which can be confronted with the experiences of artists swinging between subtle forms of power and freedom of expression.

Even when considering their implications and values within the arts, these interpretations demonstrate how humans often differentiate and decouple inherent needs.

Although these distinct categories aid in a logical comprehension of concepts, they fall short in supporting associative and creative interpretations that are part of a continuous spectrum of perceptions, anchored in the human brain's development. This paradox – having evolved a multidimensional ability to understand our surroundings yet insisting on compartmentalizing this understanding – disrupts the natural flow of associative thought, steering it toward more linear ways of thinking. A similar phenomenon can be observed in the contemporary practice of art curation, where the directive approach occasionally becomes authoritative and patronizing. This happens when curators enforce a specific linear interpretation through chronological, geographical, or other perspectives, mistakenly perceiving this method as a necessary form of categorization and a sign of professional expertise. Instead, it should be recognized as merely one among several tools aimed at fulfilling our desire for order while being mindful of its limitations in fostering associative thinking and creativity (Melis et al., 2024).

This is why, in the context of this book, the creative interpretation of the allegory, based on the relevance of associative thinking, argues that all interpretations given can stem contextually or be seen as an adaptive functional co-optation of thoughts, not all emerging intentionally but rather springing in a less linear way, offering both its author and future readers several interpretations.

The reflection of shapes as works of art, related to the imitation of nature and reality, ultimately depends on our individual perception, making us prisoners of our artistic interpretation, not the reality of nature itself. Furthermore, this consideration builds on Plato's ancestral vision of nature as reality, a concept that has become

decoupled from the convergence between reality and nature to today's understanding that reality also includes artificial and other dimensions beyond nature. Again, the need for classification does not necessarily represent the best option for humanity, as the distinction between natural and human-made appears to be at the origin of several global crises, once more highlighting the counter productiveness of a taxonomy when it becomes obsolete or confused with reality.

However, in this context and beyond its several levels of interpretation, the allegory of the cave also corroborates the idea that the exhibition needs of art largely predate our conception of the exhibition space as a sort of freestanding and specialized use, which describes exhibition space as an expression of modern history.

Even this text, like any attempt to speak or describe mimesis as an imitation of reality, is, therefore, an attempt to imitate the imitation of reality.

Thus, the art exhibition, even on this theme, could proceed through an infinite number of layers, each imitating a different layer of the imitation of reality, much like in many cinematographic translations of dreams, such as Christopher Nolan's *Inception*, with the only possible grip on materiality. But even in that case, the illusion of the immanence of matter, dear to proponents of phenomenology in architecture, shatters against psychoanalytic barriers. These barriers had already revealed that our brain is not exclusively rational and suggested that our perception of the world is significantly shaped by our unconscious. Therefore, it is also valid that matter in art may represent a real given or be the echo of a phantom limb pathology.

Aristotle and Art Exhibition as a Pedagogic Instrument

The role of art exhibitions in classical culture as an educational tool is intricately linked to the philosophical foundations of art itself, particularly through the examination of the contrasting viewpoints of Plato and Aristotle on the imitation of reality. Unlike Plato, who regarded mimesis with skepticism, Aristotle offered a more favorable perspective in his *Poetics*. Laying the groundwork for literary theory and aesthetics, Aristotle described mimesis as the essence of art and a fundamental aspect of human nature. He suggested that humans are inherently predisposed to learning through imitation from a young age. He argued that art, as an imitation of life and a representation of reality, facilitates the exploration of truth, beauty, and ethical values. He proposed that whether through painting, sculpture, or performance, art aims to encapsulate and reflect the human condition, providing a lasting framework for understanding it across various mediums.

Aristotle's perspective on mimesis particularly underscores the educational potential of art, asserting that through engagement with art, individuals can gain insights into the human condition. This perspective frames the birth of art exhibition not just as a cultural or aesthetic activity but as one aimed at cultivating understanding and empathy. Catharsis, perhaps one of Aristotle's most impactful contributions, highlights the transformative power of art. The emotional release experienced by the audience, induced by their engagement with the artwork, underscores the therapeutic and enlightening potential of artistic encounters. This concept has anticipated the interpretation of art as a means of personal and collective

introspection, a space for confronting and resolving inner conflicts. The cathartic effects of drama, in fact, exemplify how art can elicit emotional and psychological responses that lead to a deeper comprehension of ourselves and others (Aristotle, 1995).

The concept of creativity as an educational platform supports the hypothesis that art exhibitions, from their earliest forms like cave paintings, were not created in isolation. Instead, they were intended, or more likely co-opted, to be viewed by others at specific moments, soliciting catharsis within the community.

Aristotle's *Poetics* has also exerted a lasting influence on the understanding and development of art, extending beyond mere mimesis and further articulating its meaning. The transferability of his concepts from tragedy and epic poetry to the broader realm of the arts showcases a paradigmatic perspective on the classical understanding of art and the dynamic relationship between the artist and the audience.

These concepts have, in fact, significantly shaped the classical understanding of art through absolutist categories that the Western world has considered permanent and primary over centuries.

The permanence of art exhibitions highlights their enduring pedagogic relevance, crossing temporal and cultural boundaries. By presenting works from various eras and societies, exhibitions offer viewers a portal into different worlds, enabling them to engage with diverse perspectives and experiences. This exposure is invaluable for developing critical thinking and a nuanced understanding of humanity's complex nature.

Throughout history, art exhibitions have adapted to reflect changing societal values, technological advancements, and teaching and learning theories. Yet, their core function – as mediums for learning, storytelling, and emotional engagement – remains constant. This continuity attests to the foundational role of art in education and underscores the importance of maintaining and innovating exhibition practices to meet the evolving needs of learners.

This lineage has undoubtedly bequeathed humanity with an unparalleled artistic heritage. Yet, it has also constrained our capacity to embrace non-deterministic and non-human-centric interpretations of art – interpretations that have endured for millennia and offer a glimpse into how humans might have conceived art in a world unbound by the order we now attribute to the dawn of civilization.

Aristotle's principles of tragedy – unity of plot, character development, and catharsis – have transcended their original context to permeate a diverse array of artistic expressions, including art exhibition curation. The insistence on a coherent and logical sequence of events has become a cornerstone in narrative arts, emphasizing the significance of structured storytelling to captivate audiences. Likewise, Aristotle's focus on ethos and dianoia in character development underscores the importance of personas in conveying universal themes and emotional truths through art.

However, Aristotle's framework also introduces certain constraints, particularly in its human-centric and intentional approach to interpreting reality and art. The emphasis on logical structuring and mimetic representation may obscure the

appreciation of more abstract, non-deterministic forms of art that thrive on ambiguity, disorder, and spontaneity.

The initial understanding of the world through categories extends beyond *Poetics*, impacting how art is perceived as a category among others. In his book *Metaphysics*, a collection of treatises that explore concepts such as substance, essence, form, matter, and the distinction between potentiality and actuality, Aristotle sought to comprehend the fundamental nature of reality, including the existence of beings and their properties, causes, and principles. Aristotle argued that substances are the primary forms of being, and each substance has an essence (or what it means to be that particular thing) that defines its identity. He introduced the concepts of form (the defining characteristics or essence of a substance) and matter (the material from which it is made). According to Aristotle, everything in the physical world is a combination of form and matter. The distinction between potentiality and actuality is crucial in Aristotle's explanation of change and movement. Potentiality refers to the capacity to change, while actuality is the realization of that capacity. For instance, a seed has the potential to become a tree, which becomes actual when it grows into one.

As the father of rational thinking and the developer of the first formal system of logic in the *Organon*, Aristotle has significantly shaped the human-centric perspective of intentionality and determinism.

Aristotle's categories classify the various types of things that exist and the ways they can be predicated or said of a subject, including substance, quantity, quality, relation, place, time, position, state, action, and affection. Aristotle's logic was foundational for the development of later logical systems and remained the dominant system of logic until the 19th century. His work laid the groundwork for much of Western philosophy, science, and logic, and his ideas continue to be studied and debated today. However, the emergence of different modes of thinking, such as associative thinking and the discoveries regarding the unconscious, have challenged and expanded upon Aristotle's rational approach (Aristotle, 1995). His influence is exemplified by his concept of the syllogism, where a conclusion is inferred from two given or assumed premises. Similarly, other rational systems, like the idea of reverse engineering, have created a certain resistance toward evolutionary ideas emerging from exaptation, which challenges the purely adaptive (deterministic) perspective of evolution.

Artworks that challenge classical taxonomies and invite viewers to engage with art on a more instinctual and experiential level might be consistent with the exaptive birth of creativity, linked to ways of thinking without a predefined narrative or message. Classical categories might still be valuable as long as they are useful in overcoming certain forms of evolutionary pressure, but they cannot be the only ones, nor can they be considered immanent.

Art, in this context, is a multidimensional concept that allows for various forms of functional co-optation, sequentially and contextually, serving not only as entertainment but also as a means for understanding and conveying universal truths about human experiences and realities. Our enjoyment of art emerges as a byproduct of evolutionary processes that can acquire functions over time. For instance,

this might occur through the co-optation of brain regions originally dedicated to food taste.

While some aspects of art may not have been original, they have, nonetheless, been co-opted or repurposed for these functions over time.

By viewing art exhibitions as a spandrel (Gould & Lewontin, 1979), we recognize their inherent ability to evolve and acquire new meanings and functions. These include educational purposes and catharsis as well as cultural and aesthetic endeavors that encourage empathy and promote shared experiences of art. While some functions have disappeared over time, others will emerge in the future.

References

Aristotle. (1995). *Poetics* (S. Halliwell, Trans.). Harvard University Press. (Original work published c. 335 BCE)

Audi, R. (2010). *Epistemology: A contemporary introduction to the theory of knowledge.* Routledge.

Fine, G. (2003). *Plato on knowledge and forms: Selected essays.* Oxford University Press.

Freud, S. (1917). *Introductory lectures on psychoanalysis* (Vol. 16, Standard ed.). PEP (Psychoanalytic Electronic Publishing).

Gould, S. J., & Lewontin, R. C. (1979). The spandrels of San Marco and the Panglossian paradigm: A critique of the adaptationist programme. *Proceedings of the Royal Society of London. Series B, Biological Sciences, 205*(1161), 581–598.

Jung, C. G. (2012). *Man and his symbols.* Bantam.

Loux, M. J., & Crisp, T. M. (2017). *Metaphysics: A contemporary introduction.* Routledge.

Melis, A. (2021). *Innovazione armonica.* Rubbettino Editore.

Melis, A., Pievani, T., & Lara-Hernandez (2024). *Architectural exaptation. When function follows form.* Routledge.

3 An Historical Perspective of Architecture for Art Exhibition

Alessandro Melis, Rozina Vavetsi and Fabio Finotti

From Mycenaean Art to Classical Expression

According to MacGregor (2010), the tradition of collecting and displaying objects dates back to ancient civilizations. From the foundation of the earliest cities, and particularly in Ancient Egypt, temples served as repositories for religious artifacts and offerings to the gods, often showcased for public veneration. The walls of the tombs, such as those of Ramses IV and VI, still convey a holistic perspective of art exhibition as an integral part of an intimate space. Similarly, the Greeks and Romans commemorated victories and celebrated cultural achievements by exhibiting statues and spoils of war in public areas such as the Agora and the Forum (Fejfer, 2008).

As noted in previous chapters, the need for exhibiting and sharing creative endeavors predates civilization. Paradoxically, the drive for categorization, which tends to isolate items into distinct silos, is a more conspicuous product of civilization than art exhibition. This inclination has shaped our perception of art exhibition as an isolated necessity.

This particular chapter may be the only one in the book that still uses art history categories. Firstly, its scope is not to build an alternative history but to extend existing taxonomies, demonstrating that even traditional narratives of art transcend single functional categories. Additionally, by exploring traditional classifications, we can observe phenomena that deviate from conventional interpretations, showcasing broader perspectives that render the categories themselves paradoxical. For instance, the evolutionary similarities between churches and mosques illustrate this point. This chapter deliberately avoids exploring the birth of exhibition space as an architectural typology from the Renaissance to modern times, as this coincides with the emergence of the reductionist categories the book intends to challenge.

Returning to the classical world, the role of art and its exhibition, spanning from ancient Greece through Rome, provides profound insights into the cultural and societal values of these civilizations. The manner in which art was displayed, the spaces dedicated to its exhibition, and the societal functions these spaces served reveal much about their aesthetic, religious, and political priorities.

The evolution of art exhibition in ancient Greece is intrinsically linked to the philosophical and governance shifts that occurred, notably with the introduction of democracy.

DOI: 10.4324/9781003465188-4

Initially, in the Mycenaean period (circa 1600 – 1100 BCE), art was predominantly centered around palatial complexes and tombs, serving a chiefly aristocratic and funerary purpose. This art was largely ceremonial, intended to glorify the elite and their divine ancestry (Hemingway & Hemingway, 2000). With the collapse of the Mycenaean civilization and the subsequent emergence of the polis, art began to assume a more public and communal role. The construction of temples and sanctuaries, such as those at Delphi and Olympia, marked a shift toward a collective religious and civic identity, reflecting the community's shared values and beliefs (Pedley, 2015).

The classical period (5th and 4th centuries BCE) witnessed the zenith of this transformation, where art became a medium for expressing the ideals of democracy and civic pride. The construction of the Parthenon (447 – 432 BCE), under the democratic leadership of Pericles, is an example of this shift. Its sculptures and friezes not only honored Athena but also celebrated the collective achievements of the Athenian people (Neils, 2005).

The introduction of democracy by Cleisthenes in 508 / 507 BCE radically altered the governance of Athens, decentralizing power and granting greater participation to its citizens. This democratic ethos permeated the art world, leading to an increase in public spaces for art exhibition and a focus on themes that resonated with the broader populace, such as the heroics of ordinary citizens and the virtues of civic life (Ober, 1989).

The Agora, the hub of political and commercial activity, became a canvas for showcasing this democratic spirit. Statues and monuments commemorating individuals for their service to the city, rather than for their noble lineage, became commonplace, signifying the shift toward a more inclusive and participatory civic culture (Camp, 2003).

The Romans, in their appropriation and adaptation of Greek cultural practices, also inherited the concept of public art exhibition, transforming and expanding it in ways that reflected their own imperial ambitions and societal structures. This Roman approach to art's public role can be observed most vividly in the development and use of the Forum, among other public spaces, which paralleled the Greek Agora but was imbued with distinctly Roman values and purposes.

The Display of Art in the Roman City

The Forum in ancient Rome, analogous to the Greek agora, as the nucleus of Roman political, religious, commercial, and social life, evolved into the ideal venue for the display of art reflective of the power and values of the Roman state. Unlike the Greek agoras, which were centers for civic discourse and democracy, the Roman forums were monumental spaces that underscored the might of Rome and its leaders. This theme extended throughout the entire Roman city, with the exhibition of statues of emperors and generals, triumphal arches, and commemorative monuments that not only glorified Rome's achievements but also propagated the ruling class's image.

The Romans' design of public baths and amphitheaters incorporated artistic detail that transcended mere use of the space, making art an everyday experience for the people. Triumphal arches and other commemorative monuments flourished in Rome as public records of the empire's military victories and collective achievements.

These structures, embellished with storytelling reliefs and inscriptions, were strategically positioned in busy public areas to enhance their visibility and impact. Through art, the Romans communicated with the public, fostering a sense of cultural belonging.

Romans integrated art into virtually every aspect of their public infrastructure. This broad integration suggests that the concept of an exhibition space as a standalone typology is historically limited, confirming the polyfunctional role of art within the built environment.

Although having a Sanskrit root, the Romans were the first to use the word "art" ("ars") to refer primarily to any activity aimed at designing or constructing something in a suitable and harmonious manner. Thus, the exhibition of art in Roman society extended to encompass any form of public work.

Aqueducts, bridges, marketplaces, and baths were all forms of art exhibited to highlight the empire's engineering prowess and aesthetic sensibility, beautifying these spaces while reinforcing the omnipresence of Roman authority and the collective identity of its citizens.

The use of art as a medium of mass communication made classical art one of the most powerful encoded symbols of a broader idea of society and civilization, becoming a topos of urban design and providing a model for contemporary landmark ideas. This approach encouraged diverse interpretations and appropriations, resulting in even opposing cultural narratives, thus confirming McLuhan's powerful motto, "The medium is the message" (McLuhan & Fiore, 1967).

Thus, different iterations of classicism have become representative images of divergent political governance, reflecting the goals of the French bourgeoisie, the independence aspirations of American patriots, and the imperial ambitions of European dictatorships leading up to the Second World War.

The expansive scale of art exhibition in Rome also mirrored the central role of imperial patronage. Emperors and affluent citizens commissioned public artworks as a form of self-promotion and as contributions to the civic and cultural enrichment of the city. This patronage system ensured that art remained an integral part of public life, accessible to all societal levels.

Significantly, patrons like Maecenas, who advised Augustus and supported poets such as Virgil and Horace, extended this tradition of patronage to the literary arts, indicating the broad scope of cultural investment in Rome. The dedication of Vitruvius's *De Architectura* to Emperor Augustus underscores the importance of imperial endorsement in the dissemination of art and architectural principles as well as the risk of art becoming a potential instrument of propaganda.

The Roman tradition of incorporating art into the daily lives of its citizens, exemplified by the embellishment of villas like Pliny's and the expressive frescoes of Pompeii, illustrates the cultural value placed on aesthetic experience, anticipating a trend of modern societies by integrating art from the public realm into private spaces.

From Ruins to Art Exhibition Spandrels

With the fall of the Roman Empire and the emergence of decentralized communities, new city models and ways to exhibit art arose, moving away from the organized territorial infrastructure characteristic of Roman centuriation. These models often repurposed the remnants of previous structures, allowing for a less rigidly regulated incorporation of classical elements and creating spaces where the distinction between structure and decoration became less evident. Architectural forms initially developed as Christian versions of the basilica later flourished into the great Gothic cathedrals. These cathedrals represented a form of art exhibition that was global in scope, where engineering knowledge, the skill of stone carvers, and symbolic meanings were inseparable, all contributing to *Gesamtkunstwerk* – a concept underlying, in this case, the creation of a comprehensive art exhibition where content and container blended into an indistinguishable whole.

This holistic manifestation of art exhibition embodies art and creativity as a collective effort of entire communities, supported by small groups of itinerant builder-artist-stone carvers traversing Europe under the aegis of Christianity. This approach fostered the idea of a shared cultural and artistic heritage with informal traits and forms of functional co-optation, which also contributed to the conceptual upcycling of the medieval city, making it a model for compact, mixed-use sustainable cities.

As described in the previous chapter, the interaction between intentionality and determinism in the exhibition of Gothic art has attracted the interest of Stephen Jay Gould and Richard Lewontin (1979) in explaining the complexity of biological evolutionary mechanisms through the notion of the spandrel. This concept describes a structural element of San Marco's Cathedral in Venice, used as an art exhibition device:

> The great central dome of St. Mark's Cathedral in Venice presents in its mosaic design a detailed iconography expressing the mainstays of Christian faith. Three circles of 2 figures radiate out from a central image of Christ: angels, disciples, and virtues. *Each circle is divided into quadrants, even though the dome itself is radially symmetrical in structure. Each quadrant meets one of the four spandrels in the arches below the dome. Spandrels – the tapering triangular spaces formed by the intersection of two rounded arches at right angles are necessary architectural byproducts of mounting a dome on rounded arches. Each spandrel contains a design admirably fitted into its tapering space. An evangelist sits in the upper part flanked by the heavenly cities. Below, a man representing one of the four biblical rivers (Tigris, Euphrates, Indus, and Nile) pours water from a pitcher in the narrowing space below his feet.*
>
> *The design is so elaborate, harmonious, and purposeful that we are tempted to view it as the starting point of any analysis, as the cause in some sense of the surrounding architecture. But this would invert the proper path of analysis. The system begins with an architectural constraint: the necessary four spandrels and their tapering triangular form. They provide a space*

in which the mosaicists worked; they set the quadripartite symmetry of the dome above Such architectural constraints abound, and we find them easy to understand because we do not impose our biological biases upon them. Every fan-vaulted ceiling must have a series of open spaces along the midline of the vault, where the sides of the fans intersect between the pillars. Since the spaces must exist, they are often used for ingenious ornamental effect.

The same paradigmatic unity, in Gothic art, between exhibition and structure also emerges from the following example of King's College Chapel in Cambridge (Gould & Lewontin, 1979):

The spaces contain bosses alternately embellished with the Tudor rose and portcullis. In a sense, this design represents an "adaptation," but the architectural constraint is clearly primary. The spaces arise as a necessary by-product of fan vaulting; their appropriate use is a secondary effect. Anyone who tried to argue that the structure exists because the alternation of rose and portcullis makes so much sense. in a Tudor chapel would be inviting the same ridicule that Voltaire heaped on Dr. Pangloss: "Things cannot be other than they are . . . Everything is made for the best purpose. Our noses were made to carry spectacles, so we have spectacles. Legs were clearly intended for breeches, and we wear them." Yet evolutionary biologists, in their tendency to focus exclusively on immediate adaptation to local conditions, do tend to ignore architectural constraints and perform just such an inversion of explanation.

Their use of architectural metaphors to explain evolutionary biology underscores the interdisciplinary resonance of art, where elements initially conceived as structural necessities or limitations are repurposed or imbued with artistic and symbolic significance. In particular, the medieval cathedral, far from being a mere place of worship, emerges as a manifestation of communal identity and artistic expression. It encapsulates the collective efforts and aspirations of the communities that built them, marking a departure from the more formalized expressions of Roman architecture.

Early Islamic Architecture and Byzantine Influences

If we embrace this holistic, evolutionary view of the Middle Age cathedrals – beyond the declared intention of religious representation – and of the medieval European city as more than just a bastion of Christianity, we can observe common traits in the Mediterranean area that emerged after the fall of the Roman system, which was based on architectural orders and rigid planning schemes (Khemri et al., 2020).

The development of the mosque typology is also accompanied by a rich array of artistic expressions integrated into the architectural structure. Similarly, North African cities, characterized by Ottoman heritage such as medinas, are recognizable for their urban morphologies that, like European compact cities, depart from the modern trends of reductionist and mechanistic use of spaces. This concept is

even described by an Algerian term, *El Houma*, which describes the convergence between community resilience and the physical feature of the urban space including its performing and visual art opportunities (Khemri et al., 2020).

Islamic culture shares a similar evolutionary foundation with other traditions, without strictly interpreting this in a historical sense. The mosque, as a distinct architectural and cultural form, plays a pivotal role in the history of Islamic art and architecture. Complementary to the church's reuse and reinterpretation of Roman ruins, mosques have also been influenced by pre-existing Byzantine constructions. A shared genotype of Islamic art emerged in the 7th century as Islam spread across the Arabian Peninsula and beyond, making mosques not just places for communal worship but also expressions of Islamic aesthetics and values.

This development occurred within a context of significant interaction between the emerging Islamic culture and the Byzantine Empire, leading to a fascinating cross-pollination of artistic and architectural ideas. The first mosques were simple structures, often converted from existing buildings in the territories that came under Muslim control.

They were pragmatic and focused on functionality, accommodating the growing Muslim community's need for a space to perform their prayers.

A significant example is the Prophet's Mosque in Medina, which was expanded and developed from the house of the Prophet Muhammad after his migration (Hijra) to the city in 622.

As Islam expanded into Byzantine territories from the 7th century onwards, Islamic architecture began to absorb and reinterpret elements of Byzantine art, coinciding with a growing manifestation for exhibited art. The Umayyad Caliphate (661–750) played a crucial role in this cultural synthesis. The Great Mosque of Damascus, built by the Umayyad Caliph Al-Walid I between 706 and 715, exemplifies the integration of Byzantine elements into Islamic architecture. The mosque's layout, mosaics, and use of domes reflect a Byzantine influence, adapted to Islamic religious and cultural contexts. This synthesis of architectural elements could be seen as an evolutionary metaphor, similar to San Mark's spandrel.

The Dome of the Rock in Jerusalem, completed in 691 under the patronage of Umayyad Caliph Abd al-Malik, is another prime example of Islamic architecture, rich with potential spandrels. The grand dome, emerging from an octagonal structure adorned with extensive Byzantine-influenced mosaics, demonstrates this structural-decorative synthesis. Islamic artists adapted these mosaics to reflect Islamic theological themes, eschewing figurative representations in favor of geometric patterns, calligraphy, and vegetal motifs.

This period saw the emergence of a distinct Islamic aesthetic that, while drawing on Byzantine and other precedents, achieved symbols of the omnipresence of God through repetitive geometric patterns and the artful use of Arabic calligraphy. These elements exhibit an ambition for functional unity, which in this sense can be considered a feature that corroborates the hypothesis of art as an encoded product of creativity. This synthesis associates social, cultural, and ritual needs with aesthetic and symbolic values, becoming central to the Islamic artistic vocabulary and defining the visual identity of Islamic sacred spaces.

Islamic architecture, with its emphasis on interior spaces designed to inspire contemplation and community and its integration of art, architecture, and written language, offers a compelling example of a holistic perspective on art exhibition. This approach challenges the limited perspective that seeks to distinguish between the architectural envelope and its decorative elements. The enduring legacy of this synthesis is visible in the mosques and religious buildings that continue to be central to Islamic worship and community life across the world.

The early development of Islamic architecture, with its intricate relationship with Byzantine traditions, underscores the complex interplay of cultural, religious, and political factors in the formation of Islamic art. This phase of multifunctional and encoded information transmission within architectural spaces finds its conclusion with the advent of modernity.

References

Camp, J. M. (2003). *The Athenian Agora: A short guide to the excavations*. American School of Classical Studies at Athens.

Fejfer, J. (2008). *Roman portraits in context*. De Gruyter.

Gould, S. J., & Lewontin, R. C. (1979). The spandrels of San Marco and the Panglossian paradigm: A critique of the adaptationist programme. *Proceedings of the Royal Society of London. Series B, Biological Sciences, 205*(1161), 581–598.

Hemingway, C., & Hemingway, S. (2000). Art of the Mycenaean age. In *Heilbrunn timeline of art history*. The Metropolitan Museum of Art.

Khemri, M. Y., Melis, A., & Caputo, S. (2020). Sustaining the liveliness of public spaces in El Houma through placemaking: The case of Algiers. *The Journal of Public Space, 5*(1), 129–152.

MacGregor, N. (2010). *A history of the world in 100 objects*. Penguin Books.

McLuhan, M., & Fiore, Q. (1967). *The medium is the massage*. Random House.

Neils, J. (2005). *The Parthenon: From antiquity to the present*. Cambridge University Press.

Ober, J. (1989). *Mass and elite in democratic Athens: Rhetoric, ideology, and the power of the people*. Princeton University Press.

Pedley, J. G. (2015). Greek art and architecture. In C. Marconi (Ed.), *The Oxford handbook of Greek and Roman art and architecture*. Oxford University Publisher.

Present and Future Scenarios for Art Exhibition

4 Graphic Narratives for Social Transformation

Weaving Stories Into the Built Environment

Alessandro Melis, Rozina Vavetsi and Fabio Finotti

Definition and Scope of Environmental Graphic Design (EGD)

Environmental graphic design (EGD) utilizes the built environment as a canvas to transform ordinary physical spaces into vivid narratives, enhancing and complementing the themes and messages of exhibitions. Every design element within the three-dimensional architectural settings influences the overall atmosphere, shaping visitors' perceptions and interactions, and, ultimately, defining the essence of the displayed content.

With origins dating back to prehistoric times, when early humans used cave walls for communication and connection, EGD continues to bridge functionality with aesthetics. In our visually driven world, it stands out as a captivating storyteller, impacting our experiences and perceptions.

Environmental graphic design is the art and science of leveraging visual elements and communication techniques to enhance spatial experiences, establish identity, and create a sense of place in physical environments. It utilizes imagery, signage, typography, color, and multimedia within architectural spaces to facilitate navigation, define identity, promote brand recognition, evoke emotional responses, and influence opinions (Lewis & Vogler, 2009). This multidisciplinary field integrates graphic design, architecture, technology, and behavioral psychology to impart purpose and meaning to interior and exterior areas and goes beyond mere visual appeal; it establishes distinct identity of a place, fosters effective wayfinding, creates legible cities, conveys social messages, and connects people.

EGD's ability to merge the ordinary with the extraordinary and the tangible with the virtual allows it to transcend traditional boundaries, redefining how people interact with their surroundings in innovative ways and transforms spaces into immersive experiences. Whether in educational institutions, retail venues, healthcare settings, corporate offices, museums, or urban landscapes, EGD creates meaningful connections between people and their environments and among each other.

Graphic design and architecture have long coexisted to create a stronger sense of place and narrative within buildings, fostering a deep bond between people and

DOI: 10.4324/9781003465188-6

their surroundings. This relationship, which dates back centuries is evident in hieroglyphics, symbols, inscriptions, façade stenciling, and visual cues, which were used to guide travelers and communicate cultural narratives,

> EGD actively engages people in a complex and multidimensional world, transforming physical environments into educational and entertaining experiences that enhance customer or employee involvement in business domains, broaden audience participation in cultural endeavors, or advocate for socially-conscious design within activist communities.
>
> (Austin, 2020)

Environmental graphic design also taps into psychology, evoking memories and emotions through design elements like typography, color choices, and placemaking integrated with technology. It strives to make spaces integral to a person's identity, demanding a deeper level of sensitivity and understanding, engaging every aspect of the human experience – body, mind, heart, and spirit. EGD essentially becomes a spatial storyteller.

Due to its significant physical presence in places of collective experiences, EGD goes beyond merely aesthetic and functional purposes to become a compelling force in addressing societal disparities. It repurposes shared spaces such as libraries, parks, and public squares into venues that empower individuals and groups, fostering actions that contribute to a fair and united society (Austin, 2020).

Key Components of EGD

Examining diverse case studies and covering a spectrum of scales and themes, this chapter focuses on EGD's significant impact on highlighting social issues and fostering social transformation.

EGD encompasses several essential elements that collectively enhance its ability to convey information, guide people, and enrich the overall human experience within constructed environments.

The following sections of this chapter will investigate the evolution, content, and case studies related to environmental graphic design (EGD). The chapter will also include specific terminology to differentiate EGD from other design disciplines such as architecture and industrial design, which share historical and developmental patterns with EGD. Important terminology of the key components of EGD follow:

Signage serves as a crucial component of environmental graphic design (EGD), communicating information, defining the atmosphere, and establishing a sense of place within architectural environments. It involves careful attention to typography, color palettes, materials, and strategic positioning to ensure clarity, legibility, and an enhanced user experience.

Wayfinding, the process of guiding people through complex environments, is another significant aspect of EGD (Lynch, 1960). Integrated systems, including signage, maps, landmarks, and digital interfaces, facilitate navigation, reduce uncertainty, and enhance spatial orientation for users within built and urban environments.

Branding is essential in EGD, as it goes beyond just serving a purpose; it helps create and strengthen brand identities in physical spaces. It involves creating a unique identity for a product, service, or company to ensure easy recognition and foster strong connections with customers. Corporate offices, retail environments, and cultural institutions utilize graphic elements, logos, color schemes, and consistent visual messaging to effectively communicate their brand's value and engage their target audience.

Placemaking is a collaborative and creative process that creates engaging, vibrant, and welcoming environments that hold meaning. It significantly relies on EGD to enhance common spaces and help shape the overall user experience. Graphics, murals, sculptures, and interactive installations are employed to convey and maximize the cultural, historical, and social aspects of a location, fostering a sense of community, identity, and connection among visitors.

Technology is embraced as an essential component of EGD, integrating interactive displays, dynamic signage, augmented reality (AR), and mobile applications into overall design solutions (Müller, 2019). Digital elements not only provide real-time information but also enable rapid and adaptive changes based on time, location, environmental conditions, social dynamics, business needs, and demographic considerations.

Sustainability has increasingly become a focal point in EGD practice (Bai, 2015). Designers now prioritize the use of eco-friendly materials and energy-efficient lighting in their projects, aiming to minimize environmental impact and align with broader societal goals of responsible design.

Central to EGD is the principle of *user-centered design*, which involves conducting extensive user research to understand the needs, behaviors, and preferences of the target audience (Brault, 2019). This approach ensures that EGD solutions are tailored to enhance user experience, effectively meet accessibility requirements, and promote user satisfaction and engagement within the built environment.

The Evolution of Environmental Graphic Design

Throughout history, there have been pivotal milestones and moments in the development of EGD as a design discipline, tracing its development from early signs and symbols through integration with Modernist architecture, and its contemporary emphasis on sustainability, inclusivity, and technology-driven solutions.

The incorporation of graphic design into the built environment dates back to early expressions of collective stories through cave paintings and inscriptions on buildings (Cramsie, 2010). Graphic elements have coexisted with architectural features, shaping the overall experience of public spaces and buildings.

Early Manifestations of Environmental Graphic Design

While Rome is often regarded as the birthplace of Western typography, imagery, symbols, and visual storytelling in architectural settings, the unique interplay between design elements and the built environment traces its beginnings to much earlier periods in human history.

The origins of environmental graphic design date back to the prehistoric era (30,000 BCE–5000 BCE), when symbols, inscriptions, pictographs, and other visual markers were created in caves and on rocks. These early forms of visual communication served to guide travelers, mark territory and ownership, and convey cultural narratives. Over time, these primitive drawings evolved into various systems of graphic communication, incorporating visual symbols to represent written and spoken language.

The creation of cuneiform by the Sumerians (3100 BCE) marked a major advancement in human communication. This early writing system, based on wedge-shaped symbols inscribed on clay tablets, enabled long-distance communication and the preservation of information across time and space.

In Western Europe, monuments and other structures evolved into vessels for storytelling and ritual symbolism, with stone-built burial chambers featuring large stones engraved with decorative patterns. During the Roman Empire, from the first century BCE through the second century CE, capital square letters became the dominant letterforms, renowned for their geometric precision and architectural integrity in monumental inscriptions. Stone inscriptions, mosaics, and column dedications served as early examples of environmental graphic design, providing information while conveying cultural and historical narratives within architectural contexts.

In the Middle Ages (500–1300) there was an emergence of town seals, monograms, emblems, and coats of arms as markers of identification and symbols of status. Craftsmen and merchants who regulated economic, political, and military affairs used distinctive banners and flags to represent their trades and industries.

During the Renaissance period (1300–1600) in Western Europe, the cultural revival was characterized by a renewed appreciation for classical literature, art, and architecture. Monarchs, churches, and other organizations utilized more elaborate banners, flags, and signboards to promote their commercial activities, authority, and missions.

In the 17th and 18th centuries, the printing press became widely used, resulting in an abundance of posters and broadsides used for commercial advertising in urban environments. The Industrial Revolution brought significant changes to the built environment, with advancements in building construction and printing techniques leaving enduring impacts on environmental graphic design.

Environmental Graphic Design in the Modern Era

Environmental graphic design (EGD) draws inspiration from various art and architectural movements and design pioneers of the modern era, embodying the interplay between aesthetics, spatial design, and communication within the built environment.

In the late 19th and early 20th centuries, the Art Nouveau movement celebrated organic forms and intricate ornamentation. EGD adopted this approach by incorporating curvilinear shapes, decorative motifs, and flowing typography into signage and graphics on the built environment (Goubert, 2019). Art Nouveau's emphasis on harmonious design principles further influenced how information was presented within architectural spaces.

The Modernist movement of the early to mid-20th century championed simplicity, functionality, and minimalism in design. Pioneers like Walter Gropius and Ludwig Mies van der Rohe promoted the idea that "less is more." EGD subsequently embraced clean lines, sans-serif typography, and a focus on legibility and functionality in signage and wayfinding systems (Tondreau, 2003). This approach aimed to reduce visual clutter and enhance user experience.

The Bauhaus in the early 20th century played a pivotal role in revolutionizing design by blending art, craft, architecture, and technology. The movement aimed to create functional, aesthetically pleasing designs accessible to all people, regardless of social class, shaping the built environment and democratizing access to design.

A few decades later, Postmodernism challenged the rigidity of Modernism by encouraging the use of historical references, diverse and eclectic styles, and playful combinations of elements. Designers embraced this artistic freedom by exploring various typographic styles, colors, and visual languages in signage and branding (Mitchell & Webb, 2009) while also incorporating a sense of irony, humor, and cultural critique within the built environment.

Twentieth-century architecture and design innovators such as Frank Lloyd Wright, Walter Gropius, Le Corbusier, and Charles Eames championed the seamless integration of graphics, signage, and typography within architectural spaces (Nesbitt, 2016). They played a crucial role in transforming built environments with groundbreaking graphic design solutions, cementing EGD's role in enhancing spatial experiences and addressing cultural, social, and economic factors, reflecting societal changes and needs (Hollis, 2002). Graphic designers such as Paul Rand and Massimo Vignelli also began incorporating graphic design into architectural contexts.

Deborah Sussman, another pioneer in environmental graphic design, collaborated closely with architects to integrate visual elements into architectural spaces. She infused buildings and their structural elements with signage, typography, and vibrant colors. Sussman coined the terms "graphic architecture" and "supergraphics," arguing that these elements did not need to conform to traditional physical space limitations: "They could have their own life and go beyond the ceiling, be cropped, be as though it had almost flown over the architecture. The idea of supergraphics was not that it was just 'big,'" she added, "but that it was 'bigger' than the architecture."

In recent decades, the principles of environmental graphic design have started to take shape and become more structured.

In the mid-20th century, pioneering design firms such as Chermayeff & Geismar and Vignelli Associates established graphic design principles for wayfinding, signage systems, and identity programs for institutions, airports, and corporate

environments. Kevin Lynch's seminal work, "The Image of the City" (1960), marked a significant milestone by formalizing wayfinding (Lynch, 1960), which later became foundational for environmental graphic design (EGD) professionals. These principles emphasized the importance of legibility, landmarks, and clear paths in urban environments. The establishment of organizations like The Wayfinding Council (TWC) in 2000 advanced the professionalization of EGD by promoting industry standards and best practices for wayfinding and signage. These standards have been crucial in ensuring that EGD solutions are both functional and accessible.

In the late 20th century, the advent of the Information Age and digital technology transformed EGD and allowed it to become more experiential. Interactive screens, dynamic displays, and multimedia installations became integral to the EGD toolkit (Lechner, 2016), allowing for real-time updates, user interactivity, and the integration of environmental graphics into architectural spaces (Müller, 2019). EGD was no longer just static but could shift and adapt more readily for user-centric messaging and experiences.

In the 21st century, EGD has embraced sustainability as a core principle, reflecting the broader shift toward environmentally conscious design disciplines. Environmental responsibility and materials selection are now integral considerations in EGD projects (Bai, 2015).

Contemporary EGD increasingly emphasizes inclusivity and accessibility. Designers are addressing the needs of more diverse audiences (cultural, linguistic, religious, political, socio-economic, gender, etc.) to help ensure that EGD solutions are accessible to all (Brault, 2019). This reflects a commitment to equity and universal design principles.

Significance of EGD in Contemporary Design

Environmental graphic design (EGD) plays a crucial role in society at various levels.

At its most fundamental level, EGD creatively and methodically infuses graphical elements into a place's bricks, glass, steel, and concrete to help define its purpose and establish a visitor's role within it. Design enhances a place's character and charm, inviting exploration, fostering community engagement, and creating lasting memories. Beyond mere aesthetics or decoration, EGD shapes the overall experience and encapsulates a place's essence.

As our physical world becomes more complex and intricate, EGD simplifies navigation, reduces frustration, and instills confidence for a wider range of people through elements like clear signage, intuitive wayfinding systems, and interactive displays (Tondreau, 2003).

Though not always consciously noticed, the work of environmental graphic designers lays the foundation for subconscious connections, using design to create a subliminal, immersive vocabulary that reinforces the architectural context to foster a deep sense of belonging and community.

The subconscious effects of EGD extend to corporate and organizational branding, where graphic design within physical settings enhances brand recognition and conveys brand identity and values.

Designers employ a diverse range of tools, including identity, typography, symbols, materials, colors, signage, wayfinding, and public art, to elevate the built environment and imbue personal significance for each visitor. Small design details, like typefaces or the placement of graphic backgrounds for selfies, can significantly change the atmosphere and encourage interactions, showcasing the transformative potential of EGD.

Today, by embracing digital innovation, EGD incorporates interactive displays, dynamic signage, augmented reality (AR) applications, real-time information, and mobile interfaces to enhance efficacy and effectively engage modern audiences (Müller, 2019). EGD increasingly emphasizes sustainability, embracing eco-conscious practices to minimize ecological footprints that align with broader imperatives of conscientious design (Bai, 2015). Additionally, EGD actively promotes inclusivity and accessibility, carefully addressing diverse user demographics and requirements (Brault, 2019).

Most importantly, EGD plays a pivotal role in communicating essential messages to local and broader communities. Whether enhancing social consciousness and cohesion, driving political action, or emphasizing on health and safety priorities, EGD uniquely reaches large audiences in relevant settings, shaping public opinion, and mobilizing collective action. EGD often leads the way in social transformation.

Crafting Spatial Narratives to Foster Social Transformation

The impact of environmental graphic design goes beyond form and function. At its core, it utilizes a diverse array of sensory stimuli and serves as a storyteller to convey narratives, elevate emotional engagement and collective consciousness, celebrate cultural significance and bring social change.

Connecting people to a place through visual storytelling, cultural context, and heritage fosters a sense of belonging and community; it serves as a universal medium for making strong connections between individuals and the spaces they inhabit, creating bridges that unite people with their environments (Hayden, 1997).

Emotional connections to a place can be cultivated through both grand, impactful visuals or subtle, thoughtful details, encouraging individuals to view a place as an extension of their identity and connect (Jacobs, 1992). Designers enhance these connections by incorporating branding and placemaking elements into their projects, enriching the overall experience and creating environments that resonate emotionally and socially with visitors.

Environmental graphic design holds a significant place in our visual legacy, valued for its practical functionality and aesthetic appeal. Its evolution has been shaped not only by technical advancements but also by its deep-rooted connection to art, architecture, and cultural shifts over time. From urban streetscapes to office

buildings, museums to shopping malls, various spaces have undergone transformation through the application of environmental graphic design.

These interventions have been directly influenced by the prevailing social, political, and economic conditions of their respective eras. Examples include Russian constructivist wall murals lining the streets of Moscow during the Bolshevik Revolution; the Las Vegas Strip; the festive and celebratory graphics of the 1984 Los Angeles Summer Olympics; and. the provocative typographic walls of the Vietnam Veterans Memorial in Washington, D.C.; (RSM Design, 2021)

Kevin T. Leicht defines social change as the substantial transformation of social organization and cultural norms over time. Social organization encompasses enduring networks of interpersonal connections characterized by habitual and recurrent interactions. Meanwhile, cultural norms encompass shared modes of existence and cognition, encompassing symbols and linguistic expressions, collective knowledge, beliefs, and values delineating moral parameters, as well as norms dictating expected behaviors. Additionally, culture incorporates a spectrum of techniques, spanning from commonplace practices like traditional recipes to advanced technologies and material artifacts (Harper & Leicht, 2018).

Social transformation encompasses changes in various aspects of human life, including values, beliefs, institutions, behaviors, and power dynamics. It can occur gradually or rapidly, driven by various factors such as technological advancements, political movements, economic shifts, and cultural evolution.

Social transformation entails restructuring every facet of life: from culture and social relations to politics and the economy, from the way we think to the way we live.

Environmental Graphic Design in Action (Case Studies)

Environmental graphic design (EGD) has the capacity to narrate powerful stories of diverse communities and their cultural significance, serving dual purposes of enhancing aesthetics and fulfilling functional needs and, most importantly, raising awareness, educating the public, and fostering community engagement.

Public art and installations, integrated into interior and exterior environments, create a sense of unity, elevate the visual appeal of the space and serve as focal points of interest, engaging visitors on multiple levels. They enlighten people about the historical significance of a site, provide insights of local culture and heritage, and create a deeper understanding and appreciation of regional customs and traditions. Finally, they instill a richer comprehension and admiration for identity, knowledge, and ambiance, influencing societal transformation.

Influential individuals, groups, organizations, and companies have utilized the built environment to make an impact. Environmental graphic design became an immense power to leverage the physical space, raise awareness about critical issues, and affect people's emotions and advocate for social transformation.

The following examples illustrate how EGD drives positive change and fosters social transformation.

Influential Individuals and Organizations for Social Transformation

Examples of notable individuals and organizations that have harnessed the transformative potential of design follow.

Art and Activism by Keith Haring

Keith Haring, an American artist and social activist who emerged from the New York City graffiti subculture of the 1980s, used vibrant artworks and large-scale murals to address political and societal issues such as AIDS awareness, LGBTQ+ rights, nuclear disarmament, apartheid, and the crack cocaine epidemic.

Haring believed in the power of art to reach and affect people directly, transcending barriers of language and culture. He saw public spaces as platforms for dialogue and engagement, and he used them to communicate his messages to a broad audience.

One of Haring's most famous public art projects was his series of subway drawings in New York City during the 1980s. Using chalk, he created spontaneous pieces of art on unused advertising panels in subway stations. These drawings were temporary, often erased by subway cleaners, but they captured the attention of commuters and passersby, bringing art into the everyday lives of ordinary people.

Haring also painted numerous murals on buildings around the world, including the iconic *Crack Is Wack* mural in Harlem, New York, which addressed the devastating impact of the crack cocaine epidemic on marginalized communities. Through these large-scale public artworks, he aimed to provoke thought and inspire action.

Overall, Keith Haring's public art and activism were inseparable aspects of his creative vision. He believed that art had the power to change the world, and he used his talent and platform to make a positive impact on society.

Social Commentary by Banksy

The 1990s saw the emergence of Banksy, an anonymous street artist, in England. Banksy, whose identity remains subject to speculation, became known for politically charged and often subversive public artworks. Banksy's thought-provoking art tackled issues such as capitalism, war, and government surveillance, challenging societal norms.

Like many street and graffiti artists before him, Banksy's work goes beyond aesthetics; it uses imagery in the public realm to question the status quo to serve as a powerful form of social commentary, often highlighting injustice.

By using public environmental spaces such as buildings, sidewalks and even park benches as his canvas and cleverly integrating with pre-existing elements, Banksy's work grabs attention, challenges viewers to reconsider assumptions and perspectives, and helps spark larger conversations on important social issues that are often overlooked.

And just as design is an iterative and constantly evolving art form, Banksy's work is adapting, evolving to reflect changing societal climate. His art stands as a

powerful example of how creative expression in the public physical environment can foster empathy and community and provoke thought and action. His ability to blend activism with creativity has made him an influential force in contemporary art and social change.

Ethnicities by Eduardo Kobra

Eduardo Kobra, a prominent Brazilian street artist renowned for his vibrant and large-scale murals, has created artworks displayed prominently all over the world. Kobra uses his art to raise awareness about various social issues, including climate change, peace, and cultural diversity. His murals often provoke thought and dialogue among viewers.

Created for the 2016 Rio Olympic Games, his mural *Ethnicities* or *Etnias* depicts five indigenous people from five continents, a concept based on the five Olympic rings. Kobra's bold, geometric mural communicates, as he said: "That we are all one. We're living through a very confusing time with a lot of conflicts; wanted to show that everyone is united; we are all connected."

Kobra's Olympic mural, spanning 190 meters in length and 15 meters in height, currently holds the Guinness World Record for largest mural created by one artist. It took over two months to finish and required over 493 gallons of paint and 3,500 cans of spray paint.

Stop Telling Women to Smile Posters by Tatyana Fazlalizadeh

New York City artist Tatyana Fazlalizadeh wanted to convey a powerful message about a prevalent form of gender inequality experienced by women: street harassment in the form of catcalls. She created three straightforward posters, titled "Stop Telling Women To Smile," referencing the frequent unsolicited and often inappropriate comments, whistles, or shouts directed to women in public places.

The series commenced in the fall of 2012 and Fazlalizadeh positioned her posters in public street locations where catcall harassment commonly occurs. Posters feature portraits of women alongside captions such as "Not Here to Be Pretty for You," and "My Worth Extends Beyond My Body."

Student Assassinations Memorial in Mexico by Francisco Toledo

On September 26, 2014, over 100 students from a rural teachers' college in Ayotzinapa, Mexico, traveled to Iguala to commemorate the Mexico City student massacre of 1968. Tragically, that night, 43 of these students disappeared after local police and drug gangs were involved in their murder and disposal of their bodies.

The horrible crime deeply shocked Mexico. In March 2015, profound sadness and anger were expressed through a poignant memorial sponsored by the Raúl Isidro Burgos Teachers' College. The memorial featured empty school chairs adorned with kites bearing the faces of the missing students. Designed by Oaxaca painter Francisco Toledo, these kites were intended for passersby to fly. Toledo

collaborated with artisans from the "Art and Paper" workshop in San Agustín Etla to collectively create these kites.

Orlando Towers in Soweto, SA and the End of Apartheid

The brutal killing of numerous protesting black school children in the South African black township of Soweto on June 16, 1976, sparked global outrage and marked a pivotal moment in South African history.

The uprising against apartheid that began in Soweto spread countrywide and profoundly changed the socio-political landscape in South Africa. Ultimately, this movement led to the dismantling of apartheid and the establishment of universal suffrage in 1994.

The Orlando Towers are decommissioned water-cooling towers rising above Soweto and have been repurposed in recent years to display large murals and advertisements. The dramatic and colorful imagery towering above the otherwise flat Soweto landscape has served as a visual landmark fostering connectivity in a region historically divided, and inspiring hope for a better future. The towers stand as a symbolic and enduring reminder of how perseverance and determination can transform neglected spaces into masterpieces, embodying South Africa's cultural and historical heritage.

AIDS Memorial Quilt

Conceived in 1985 at the peak of the AIDS health crisis in the United States, the AIDS Memorial Quilt is a traveling public art initiative featuring quilted panels adorned with names and symbolic imagery, serving as a memorial to those who died in the AIDS epidemic. First publicly displayed in 1987, the initiative aimed to raise awareness of the disease and its devastating effects, and advocate for more medical research toward finding a cure.

As of 2020, the AIDS Memorial Quilt comprises over 48,000 panels, weighing over 54 tons, and stands as the largest example of community folk art in the world. The quilt continues to grow annually through submissions to The NAMES Project Foundation, which oversees the project. Due to its immense size, the complete quilt is rarely displayed in one location, as it has become too vast for most public spaces.

"Art on the Steps" at the New York Public Library by Andy Golub and Substantia Jones

The human body can serve as a powerful and effective medium for public art, conveying crucial messages, fostering awareness, and inspiring social change.

In June 2015, artist Andy Golub and photographer Substantia Jones teamed up to spark conversations among passersby, tourists, and locals with a powerful message promoting body positivity – right on the front steps of the New York Public Library. Golub applied green body paint and striking black strokes on large-size

models, turning them into living canvases that boldly challenged societal views on nudity while celebrating the diversity of human bodies.

Their collaboration advocated for body positivity, asserting that every individual deserves recognition, celebration, and acceptance. By confronting stereotypes and promoting self-acceptance across diverse body shapes, sizes, and backgrounds, they left a profound impact on all who witnessed this powerful blend of art and advocacy.

Despite facing obstacles – such as police questioning the project's legality and some individuals sexualizing the participants – Jones asserted that their impact was undeniable: "We made some people think."

"It's Not Happening Here But It's Happening Now" by Amnesty International

Amnesty International, an international non-governmental organization, has conducted powerful human rights advocacy campaigns globally for decades. Through emotionally charged and often shocking imagery and messaging, their publicly displayed posters, banners, and billboards have captured people's attention to human rights abuses, promoted justice, and urged action on behalf of prisoners of conscience and marginalized communities worldwide.

In 2006, the advertising agency Walker in Switzerland designed 200 posters depicting real scenes of human rights abuses from around the world. Each poster juxtaposes a photo of a human rights abuse with a second photo of the immediate physical surroundings – streets, buildings, and greenery. Placed on billboards, these visuals create the illusion that viewers and victims are in the same location, aiming to evoke a sense of proximity and empathy toward those who are suffering.

Greenpeace and Amazon Deforestation

Greenpeace is an international organization known for its direct action campaigns and grassroots activism in support of the environment. Utilizing public art graphics such as murals, banners, and projections, Greenpeace aims to raise awareness about urgent environmental issues like deforestation, ocean pollution, and climate change. Their public displays are designed to be dramatic and attention-grabbing.

In 2020, Greenpeace illegally displayed a massive banner on the main European Commission (EC) headquarters building in Brussels. The banner condemned the deforestation of the Amazon and criticized the pending trade deal between the European Union (EU) and the South American Mercosur trading bloc. Against the backdrop of a burning rainforest, the banner displayed messages such as "Amazon fires" and "Europe, guilty," accompanied by actual smoke flares to underscore the severity of the Amazon fires. The campaign highlighted the EU's significant role in global deforestation and advocated for legislation to prevent products associated with deforestation from entering the European market.

These individuals and organizations harness the power of environmental graphic design to engage communities, stimulate dialogue, and inspire action on critical social and environmental issues. They exemplify the profound impact that visual communication can have in driving social transformation.

Building Narrative Environments Through Technology

Environmental graphic design today has moved beyond traditional painting and print production to integrate cutting-edge technologies into physical spaces, offering adaptability, real-time information, interactivity and immersive environments to enhance user experiences, deliver information more effectively, and connect people in stronger and healthier communities.

Digital technologies in EGD are no longer fancy frills but have become essential components of physical environments. Digital signage enables real-time updates and dynamic messaging, adjusting content based on time, events, or user interactions. Adaptive lighting and projection mapping technologies create visually stunning and dynamic environments, projecting images or information onto a wide variety of building surfaces.

Touchscreens and kiosks facilitate interactive navigation within and about spaces. Multimedia presentations in exhibits enhance storytelling by combining audio, video, and interactive elements, fostering collaboration and engagement, and are particularly effective in museums, galleries, and visitor centers. Companion mobile apps complement EGD by offering personalized information, navigation assistance, and additional content related to the environment but in a more personal and customized context. QR codes and NFC technology enable users to access contextual information by scanning codes with their smartphones.

Augmented reality (AR) and virtual reality (VR) technologies provide immersive experiences by layering dynamic digital information over physical spaces for tours and interactive exhibits. Interpretive graphics, interactive displays, and multimedia installations enrich the visitor experience by conveying information and actively engaging audiences, transforming what would otherwise be static displays.

Digital technologies in EGD also offer other benefits. Adaptable digital graphics convey messages adaptively, while remote management enables efficient maintenance and rapid content updates for digital displays. Accessibility features ensure inclusivity and an accessible experience for all users, reflecting a shift toward more interactive, personalized, and seamlessly integrated experiences.

Designers and companies are embracing these technologies to create dynamic, immersive and engaging messaging platforms that cater to the ever-evolving needs and expectations of users in increasingly complex physical environments, blurring the lines between physical space and digital realms.

Prestigious firms, like Pentagram, C&G Partners, Populous, Altitude Design, Nelson Worldwide and others, develop effective environmental graphic design to educate, humanize, and simplify the complexities of the built environment; create

legible cities; and transform spaces into immersive experiences with higher purpose and meaning.

Public installations, community-based and civic narratives, murals, and innovative displays not only enhance the aesthetics and functionality of a place, but they also serve as catalysts for interaction and dialogue, reflecting the values of the culture and history of places and transforming them into wholesome and immersive experiences.

Digital Anti-Smoking Campaign for Apoteket Hjärtat Pharmacy by Åkestam Holst, Sweden

The Swedish pharmacy chain Hjärtat aimed to deliver a powerful anti-smoking message by partnering with the Clear Channel and Åkestam Holst advertising agencies to set up an interactive display in a bustling Stockholm plaza. Whenever a pedestrian would light up a cigarette near the display, built-in smoke detectors would trigger a video of a man coughing on the screen.

This dynamic and responsive environmental display grabbed attention and sent a powerful message that was fully contextual. As people started watching, subsequent videos would educate on the dangers of smoking and secondhand smoke. The Hjärtat billboard attracted significant attention, with videos of it in operation going viral globally, once of which had 600,000 views on the pharmacy's Facebook and YouTube channels.

"Look at Me" Domestic Awareness Digital Billboard by Women's Aid by WCRS, UK

In a groundbreaking initiative, Women's Aid launched an interactive ad demonstrating how collective action can combat domestic violence. Their "Look at Me" campaign uses facial recognition technology to detect when individuals focus on an image of a bruised woman.

When passersby look at the screen, a live video feed at the bottom of the ad tracks and displays the growing number of viewers. As more people pay attention, the woman's bruises gradually heal, symbolizing how awareness and acknowledgement can contribute to addressing domestic violence. The innovative use of technology in a public space made a powerful point about how battered women needed to be brought out of the shadows of shame and fear and how shining light on the issue could help them heal.

The Quake Museum, Spain

The Quake Museum offers visitors a fascinating immersive experience reliving Lisbon's most transformative and devastating event, the Lisbon earthquake and the subsequent tsunami of 1755. Using cutting-edge earthquake simulators and providing a 4D experience, viewers are able to stroll virtually through the streets of the lost city, revisit the wonders and horrors of the time, and witness the unfolding drama. Quake Museum offers the ultimate experiential journey as it allows the

visitors to truly immerse in a different time and place and absorb the broader political, scientific, and historical contexts.

Against the Odds Exhibition at the Museum of Jewish Heritage by C&G Partners, USA

The *Against the Odds* exhibit is a collaboration between the Museum of Jewish Heritage and the C&G Partners design firm. It is a multisensory, highly interactive design experience that invites visitors to explore the journey of Jewish refugees and their hardships in immigrating to the United States. Through a variety of media, including authentic documents, firsthand testimonies, and immersive design elements, the exhibit showcases the endless challenges of this journey.

At the heart of the display are the towering "paper walls," serving as symbols of the bureaucratic obstacles and extensive paperwork that hindered Jews in this extraordinary endeavor. Intriguing artifacts and the interplay between physical and digital spaces are utilized to convey information and create a powerful narrative.

Native New York Experience at the National Museum of American Indians by C&G Partners, USA

C&G Partners collaborated with the Smithsonian National Museum of the American Indian on exhibition, graphic, and media design for a unique permanent experience. This project follows a literal path spanning hundreds of miles through New York State and New York City. The experience features 12 stops that debunk common myths using Native objects and interactive media within theatrical design settings.

Custom illustrations by Native graphic novel creators are integrated throughout, enhancing interpretive panels and exhibit stations. Maps are used extensively to guide visitors along the trail and tell historical narratives of Native people. Innovative media techniques and digital experiences activated by gestures create an experiential environment that goes beyond traditional screens.

The exhibition showcases the rich cultural heritage and contributions of Native people across centuries, emphasizing educational engagement and immersive storytelling.

Revealed: The Hunt for Bin Laden for National September 11 Memorial & Museum by C&G Partners, USA

The *Revealed: The Hunt for Bin Laden* exhibition at the National September 11 Memorial and Museum in New York City employs "phygital" (physical-digital) experiences to use physical space as a narrative tool. C&G Partners designed the graphics and displays to establish an immersive atmosphere conveying location, time, and narrative.

Featuring compelling media and evidence such as artifacts, diagrams, models, maps, interviews, and videos strategically arranged, the exhibition unfolds like

a crime story, incorporating unprecedented FBI and CIA documentation on the decade-long pursuit of bin Laden. This exhibition serves as both an educational tool and a memorial, offering insights into modern counterterrorism efforts and reflecting on the impact of bin Laden's actions on global history.

"#WeThe15" by Adam&EveDDB and Pentagram Design, USA

#WeThe15 is a global inclusivity movement for people with disabilities, striving to be the largest human rights initiative in history. Supported by organizations such the United Nations and UNESCO, it addresses the marginalized status of the 15% of the world's population (1.2 billion people) with disabilities. The movement aims to draw attention to the issues and rights of these people worldwide.

Launched at the 2020 Summer Paralympics in Tokyo in 2021, the "#WeThe15" campaign gained global visibility during the opening ceremonies. Athletes wore temporary tattoos while landmarks and large screens worldwide illuminated in a distinctive purple color.

The campaign illustrated the effective use of unique branding and landmark illumination to amplify communication during major international events, spreading the movement's message globally.

Machine Art at MORI Art Museum, Japan

Machine Art is an exhibit that opened in 2024 at the Mori Art Museum in Tokyo. It showcases contemporary artworks that blend human artistry and technology. It is housed in a physical space where reality and virtual worlds converge in an uncertain future. Harnessing game engines, VR, AR, interactive networks, and generative AI, the works explore new aesthetics and digital image-making through diverse datasets. Some works investigate the way online avatars and characters can foster new gender and racial identities that transcend social norms and restrictions.

Featuring artworks co-created by "machines" and artists and offering immersive experiences through large-scale installations, the exhibition invites visitors to reflect on the relationship between humans and technology and consider important contemporary issues such as the environment, historical interpretation, humanity, ethics, and diversity. Emotions evoked by the works range from love, elation, and empathy to fear and anxiety.

Conclusion

Environmental graphic design possesses a remarkable power to transcend societal, and it serves as a catalyst for positive change, sparking movements that inspire meaningful action.

By shaping perceptions and influencing behaviors, it has the potential to turn dreams for a better world into tangible realities. Environmental graphic design not only beautifies spaces but also amplifies voices, championing causes that drive social transformation and foster a global community.

References

Austin, T. (2020). *Narrative environments and experience design space as a medium of communication*. Routledge.

www.adsoftheworld.com. Look at me. www.adsoftheworld.com/campaigns/look-at-me

www.artshelp.com. World Record Breaking Muralist Eduardo Kobra Paints Sustainable Stories of Unity, Justice, and Climate Action Across Continents. www.artshelp.com/eduardo-kobra-brazilian-muralist-sustainable-art-un-goals

Bai, Y. (2015). Sustainable environmental graphic design: Integrating graphic communication within the built environment. *Design Principles & Practices: An International Journal, 9*(1), 53–67.

www.bestofinnovation.com. (2018, January 29). In Review: *Swedish Billboard that Coughs at Smokers!* https://bestofinnovation.com/2018/01/29/in-review-swedish-billboard-that-coughs-at-smokers/#:~:text=As%20described%20in%20TheFix%3A%20The,of%20smoking%20and%20secondhand%20smoke

Brault, M. (2019). Designing inclusive environments: Bringing environmental graphic design into the age of accessibility. In *Proceedings of the Human Factors and Ergonomics Society annual meeting* (Vol. 63, No. 1, pp. 226–230). Sage.

www.cgpartnersllc.com. Against the Odds. www.cgpartnersllc.com/projects/museum-of-jewish-heritage-against-the-odds/

www.cgpartnersllc.com. Native New York. www.cgpartnersllc.com/projects/native-new-york/?set=new-featured

www.cgpartnersllc.com. *Revealed: The hunt for Bin Laden*. www.cgpartnersllc.com/projects/revealed-hunt-bin-laden/?set=new-featured

Cramsie, P. (2010). *The story of graphic design: From the invention of writing to the birth of digital design*. British Library.

Goubert, A. (2019). Art Nouveau and the graphic arts. In H. Silverman (Ed.), *A companion to Modernist art* (pp. 267–281). Wiley.

www.e3s-conferences.org. (2023, October, 11). *The importance of environmental graphics in urban spaces*. www.e3s-conferences.org/articles/e3sconf/abs/2023/73/e3sconf_iced2023_12013/e3sconf_iced2023_12013.html

Harper, C. L., & Leicht, K. T. (2018). *Exploring social change: America and the world* (7th ed.). Routledge.

Hayden, D (1997). *The power of place: Urban landscapes as public history*. MIT Press.

Hollis, R. (2002). *Graphic design: A concise history*. Thames & Hudson.

www.itsnicethat.com. (2021, August 19). *#WeThe15 sees Pentagram collaborate on a boldly minimalistic campaign for the world's largest marginalised community*. www.itsnicethat.com/news/pentagram-wethe15-graphic-design-190821

Jacobs, J. (1992). *The death and life of great American cities*. Vintage.

Lechner, G. (2016). Digitalization and environmental graphic design. In L. Simon (Ed.), *Digitalization in open information systems* (pp. 147–162). Springer.

Lewis, K., & Vogler, E. (2009). *Graphic design for architects: A manual for visual communication*. Routledge.

Lynch, K. (1960). *The image of the city*. MIT Press.

Mitchell, W. J., & Webb, T. (2009). *The logic of architecture: Design, computation, and cognition*. MIT Press.

Müller, C. (2019). Environmental graphic design in the age of digital media. In M. Meire & C. Debruyne (Eds.), *Handbook of research on cross-disciplinary perspectives on contemporary perspectives on environment and culture* (pp. 172–196). IGI Global.

Nesbitt, J. (2016). *Theorizing a new agenda for architecture: An anthology of architectural theory 1965–1995*. Princeton Architectural Press.

www.oxfordbibliographies.com. (2013, September 30). *Social Change*. www.oxfordbibliographies.com/display/document/obo-9780199756384/obo-9780199756384-0047.xml

www.smithsonianmag.com. (2013, February). *The story behind Banksy.* www.smithsonian mag.com/arts-culture/the-story-behind-banksy-4310304

RSM Design. (2021). *Graphic connections in architecture: RSM design. Visual profile books*. SAGE Publications.

www.theguardian.com. *More is more: The gaudy genius of the late Deborah Sussman.* www.theguardian.com/artanddesign/architecture-design-blog/2014/aug/27/graphics-genius-deborah-sussman

Tondreau, B. (2003). *Wayfinding and signing guidelines for airport terminals and landside.* Federal Aviation Administration.

www.viriatovb.medium.com. (2019, August 9). "It's Not Happening Here. But It Is Happening Now." *Campaign: A case study for the 're-humanisation' of human rights abuse victims.* https://viriatovb.medium.com/amnesty-internationals-it-s-not-happening-here-5328ae3bb68f

5 Future Developments

Alessandro Melis, Rozina Vavetsi and Fabio Finotti

An Extensive Notion of Mimesis

In the contemporary era, interpretations of mimesis as a creative act have further multiplied. The modern approach to curating art exhibitions, for instance, has embraced the introduction of digital tools and alternative perspectives such as virtual reality. Moreover, technological progress and the metaphysical nature of new materials allow for the creation of works that involve viewers in an immersive exploration of the possible, the plausible, and the impossible. The rise of multiversal platforms has also facilitated forms of collective creativity, dissolved many conventional boundaries of authorship and given way to more inclusive and democratic artistic expressions.

The proliferation of opportunities to imitate numerous layers of reality, thanks to the advent of generative artificial intelligence, transcends the limits of traditional mass production, enabling the creation and exhibition of infinite artworks that are both similar and distinct from all others (Carpo, 2023). The rekindled interest in the concept of style is evident in works that, while sharing the same geometric shapes, diverge in the materials used; or conversely, in works that, despite using the same materials, allow for infinite iterations of form. This polymorphism not only enriches the aesthetic experience but also invites reflection on the nature of art itself, in both pre-humanistic and post-human craftsmanship.

In the field of generative art, mimesis evolves into a complex and ambiguous tool that challenges conventional perceptual boundaries, underscoring that art is essentially an evolutionary act rather than creation *ex nihilo*, rooted in an adaptive process. Today's interpretations of mimesis explore the symbiotic relationship between humanity and the evolutionary dynamics of the environment, with art serving as a navigation tool through which our existence is oriented within an extensive ecological network. It suggests that what we refer to as creativity, seen as an isolated flash of genius, is, in reality, an essential evolutionary and collective effort to decipher our role within nature (rather than create an artificial alternative to it).

This evolving understanding of mimesis and its application across various fields highlights an ongoing dialogue between art and reality, the individual and the collective, the physical and the metaphysical. It reflects a broadened scope of what

DOI: 10.4324/9781003465188-7

art can represent and how it functions as a mirror, a lens, or even a disruptor of our perceptions and interactions with the world around us. As we continue to navigate through technological advancements and ecological challenges, the concept of mimesis, in its myriad forms and interpretations, remains a pivotal framework for exploring the depth of our engagement with reality and our endless quest for understanding and self-expression.

Epistemology as an Attempt to Make Complexity Understandable Without Simplifications

Despite the insistence on this narrative, the main fear regarding AI is not about job loss but the age-old human problem: the fear of losing control and being overwhelmed by forces of chaos. It is about the anxiety of being dethroned from the center of our perceived reality. This is reminiscent of the disquiet brought by the loss of heliocentrism or the shift from creationism, as Gould (1996) pointed out.

We agonize over the notion that, despite its immense power, AI lacks the indefinable quality of creative intelligence or imagination. Yet, we fail to admit that this so-called creative intelligence is essentially associative thinking – nothing more. AI, in fact, mirrors this associative thinking and embodies pure creativity. It is not an isolated artificial entity but a component of a composite reality, linked to humans who design algorithms, initiate datasets, and utilize AI, thereby forming a collective creative agency.

If AI, through machine learning, processes more information and produces more art pieces, potentially making human input unnecessary, we must question what need AI would fulfill. However, why dismiss associative thinking as "just" a simple process? Isn't it, in fact, a marvel to realize that we are part of a collective intelligence rather than solitary rangers in the desert of creativity?

The anthropocentric perspective we apply to creativity is the same attitude that leads us to measure the soul in terms of mere matter. Similarly, when we worry about environmental crises, we speak of saving the world and nature, though nature and the planet do not share our sense of urgency or survival goals – they exist beyond human taxonomies.

The underestimation of the intelligence capacity of generative AI stems from our wish to see artificiality as an alternative to human existence. However, generative AI can also be viewed as a scalable and natural extension of human ingenuity. Thus, when we downplay its critical and intentional intelligence, we are manifesting our fear of competition after having invented the existence of a competitor. This leads us to confuse natural evolutionary processes with purely humanistic goals and purposes.

From Turing to Tomorrow

If art exhibitions are a byproduct of the human need to imitate the multiple layers of reality, the exploration and advancement of AI represent a parallel quest, replicating and extending human cognitive abilities through technology.

The intellectual foundation of AI can be traced back to pioneering thinkers such as Alan Turing, whose work laid the groundwork for the theoretical underpinnings of computing and intelligence evaluation, and John McCarthy, whose vision at the Dartmouth Conference in 1956 introduced the term "artificial intelligence" into the academic vernacular. This period heralded the inception of AI as a formal field of study, characterized by an initial emphasis on creating rule-based systems that mimic human capacities for solving problems and making decisions. Initially, these AI systems were reliant on explicit instructions, which limited their performance in situations that required flexibility or faced unpredictability.

The landscape of AI underwent a significant transformation with the advent of machine learning in the closing decades of the 20th century. This shift from rigid, rule-based architectures to adaptable, learning-based models marked a pivotal change in the approach to artificial intelligence. At its core, machine learning involves crafting algorithms that can learn from and adapt to new data over time, thus allowing systems to process extensive datasets, identify patterns, and autonomously make informed decisions. The process of collecting and preparing data became essential, as the quality and representation of the data directly influenced the effectiveness of machine learning algorithms in their learning processes (Russell & Norvig, 2016).

Once trained, AI models find applications in a myriad of domains – ranging from healthcare diagnostics, financial analytics, and autonomous vehicle navigation, to content creation in the entertainment industry – where they persistently evolve and enhance their functionality by leveraging ongoing feedback. This capacity for continuous improvement highlights AI's potential to drive unprecedented efficiency and innovation across various sectors.

However, the widespread adoption of AI technologies raises pressing ethical dilemmas. Concerns over privacy are paramount, given AI's reliance on personal data to optimize its operations. Moreover, the propensity of AI systems to perpetuate or even exacerbate biases, due to skewed or incomplete datasets, raises alarm over the potential for inequitable or prejudiced decisions. The specter of job automation and the displacement of workers further fuels critical debates on the socio-economic implications of AI's ascendancy. These challenges underscore the imperative for developing and adhering to ethical guidelines in AI research and application, emphasizing the importance of transparency, accountability, and fairness in the implementation of these technologies. A commitment to ethical AI involves rigorous data management practices, strategies to counteract biases, and thoughtful consideration of the broader societal impacts of AI advancements (Bostrom, 2014; Crawford, 2020; Yan & Li, 2020).

In this evolving narrative of AI, the journey from rudimentary rule-based algorithms to sophisticated machine learning models reflects not just technological progress but also a deepening understanding of the complex interplay between artificial intelligence and human society. As AI continues to mature and integrate into various facets of daily life, the dialogue around its ethical, social, and economic implications becomes increasingly vital, guiding the development of technologies that not only innovate but also respect and enhance human values and equity.

As the frontier of artificial intelligence (AI) technologies pushes forward, the dialogue on ethical considerations takes on critical importance. This conversation necessitates a collaborative effort among technology developers, policymakers, and society at large to navigate the moral challenges AI presents, ensuring that its evolution and deployment serve to advance societal progress and enhance human well-being.

The rapid advancement in AI capabilities highlights the notion of artificial general intelligence (AGI), a type of AI designed to comprehend, learn, and apply knowledge in a broad array of activities, akin to the cognitive functions of humans. The quest for AGI opens up extraordinary prospects while posing significant ethical and philosophical questions about the boundaries of machine intelligence and the possibility of AI reaching a state of consciousness or self-awareness.

Moreover, the concept of augmented intelligence, where AI systems enhance rather than substitute human intelligence, marks a pivotal area of investigation. This perspective focuses on the collaborative synergy between human and artificial intelligence, aiming to augment human analytical and creative capabilities. Such an approach envisions a future in which AI acts as a powerful ally, amplifying human potential and enabling achievements beyond our current capabilities.

The international competition for AI supremacy also presents geopolitical implications, as nations strive for leadership in AI innovation. This race accentuates the need for global cooperation and the establishment of regulatory measures to ensure that AI advancements contribute positively to humanity and do not deepen worldwide disparities.

In light of AI's transformative impact, fostering a comprehensive understanding of its effects is essential. Interdisciplinary research spanning technology, ethics, social sciences, and public policy is vital to comprehensively address the intricacies of integrating AI into societal fabrics. Encouraging open, inclusive dialogues and partnerships can enable us to leverage AI's advantages while confronting its challenges, paving the way for a future where technology is in harmony with ethical standards and human values.

AI and the Ethics of Creativity

The rapid evolution of AI necessitates ethical vigilance to maintain our adaptability and avert potential environmental or societal disruptions that AI may inadvertently cause. The ethical concerns surrounding AI often reflect our difficulty in fully comprehending its complex nature and implications, particularly concerning humanity's creative evolution.

Steven Jay Gould, in 1996, pointed out humanity's inherent propensity toward self-destruction, a characteristic connected with our understanding of intelligence. This propensity predates modern technological advancements, suggesting that the primary hazard of AI may not be its potential to supersede us but rather its ability to amplify our existing tendencies and behaviors significantly.

The analogy of Huxley's chessboard, presented in his work "A Liberal Education and Where to Find It" (1868), uses the metaphor of a chessboard governed

by natural laws, with nature – or in contemporary interpretations, AI – serving as an impartial, yet challenging opponent. This allegory, while critiqued by modern evolutionary biologists, encapsulates a view once popular among Darwin's contemporaries, including Huxley himself. It underscores the flawed belief in human supremacy over nature, influencing our urban and technological landscapes and shaping the ethical discourse on AI, especially in matters of creativity and authorship.

Concerns about creativity and authorship in the context of AI stem from apprehensions about losing creative control, anchored in outdated dichotomies rather than an understanding of the creative process. Creativity, an evolutionary trait that has propelled human innovation, is not diminished by AI but rather can be expanded and enhanced. AI's role in the creative process challenges us to rethink notions of authorship and creativity, advocating for a broader, more inclusive view of intelligence and creative expression.

As we explore the ethical dimensions of AI's societal integration, it is paramount to adopt a nuanced perspective on intelligence, creativity, and their interrelation with technology. Recognizing the limitations of existing paradigms and AI's potential as a catalyst for innovation, we must strive for an adaptive, reflective approach to AI ethics. Such an approach encourages us to transcend apprehensions and embrace the expansive possibilities that artificial intelligence offers for growth and creative exploration.

Art Exhibition as a Tangible Abstraction of the Reality

The concept of reification, which involves the abstraction of concepts being treated as if they were tangible, real objects, invites a thorough exploration of critical texts spanning philosophy, sociology, and psychology. This process of abstraction – stemming from the Latin word "res," meaning "thing" – plays a significant role in shaping our understanding of societal structures and how individuals perceive and interact with the world around them.

Art exhibitions exemplify this process by converting abstract artistic concepts into concrete experiences for audiences. These exhibitions stem from the human desire to replicate the various dimensions of reality, thereby making the abstract tangible. Similarly, the exploration and progression of AI mirror this pursuit, as they aim to replicate and enhance human cognitive functions through technology.

Philosophically and within Marxist theory, the discussion of reification finds its roots in Karl Marx's seminal work, *Capital: A Critique of Political Economy* (1867). Marx introduces the idea of commodity fetishism, a specific type of reification prevalent in capitalist societies, where relationships between people take on the form of relationships between commodities. This concept is vital for understanding how the essence of human labor and social interactions becomes masked by the commodification inherent in capitalism, leading to a distorted understanding of social relations (Marx, 1867).

Building on Marx's foundation, Georg Lukács, in *History and Class Consciousness: Studies in Marxist Dialectics* (1971), examines the broader impacts

of reification on consciousness and the organization of society under capitalism. Lukács' investigation into how human relations are objectified and alienated within capitalist structures offers important insights into the systemic dehumanization and mechanization of social interactions (Lukács, 1971).

In the field of sociology, Peter L. Berger and Thomas Luckmann's *The Social Construction of Reality: A Treatise in the Sociology of Knowledge* (1966) explores how societal constructs come to be regarded as real. Although their work does not explicitly focus on reification, it critically examines the processes through which social constructs are universally accepted as tangible, thereby resonating with the essence of reification (Berger & Luckmann, 1966).

Michel Foucault, through his pivotal works *Discipline and Punish: The Birth of the Prison* (1977) and *The History of Sexuality, Volume 1: An Introduction* (1978), provides valuable insights into the reification of power relations and knowledge into concrete societal practices and institutions. Foucault's analysis of how disciplinary mechanisms and discourses solidify power dynamics and norms within society, although not labeled as reification per se, aligns with the critical examination of how abstract concepts are materialized and accepted as unchangeable components of the social order (Foucault, 1977, 1978).

Together, these foundational works illuminate the varied nature of reification, providing a rich framework for understanding its role in capitalist society, the establishment and perpetuation of social norms, the dynamics of power relations, and the intricate relationship between knowledge and the structural realities of society. Through these lenses, reification is revealed not just as a theoretical concept but as a critical tool for analyzing the complexities of how abstract notions are transformed into perceived concrete realities, deeply influencing both societal structures and individual consciousness.

In the realm of art exhibitions, this theoretical framework helps us understand how artworks – originally abstract creations – are reified within gallery spaces, becoming tangible representations of broader social, cultural, and intellectual currents. Similarly, the development of AI can be seen as a form of reification, where abstract cognitive processes are transformed into concrete technological systems. This parallel between art and AI underscores the ongoing human quest to understand and replicate the complex nature of reality.

From Categorization to Taxonomies

The reflection on categorization in the initial chapters introduces subunits, classifications, and taxonomies, with the latter providing a detailed and rigid framework for organizing our ideas about reality. Examining taxonomy through the lens of reification offers valuable insights into how knowledge is organized and understood, particularly when considering Michel Foucault's philosophies. Taxonomy, a system of classification that arranges concepts, objects, or information into categories based on specific criteria, is crucial for making sense of complex structures. This method extends beyond its biological origins of categorizing life forms into hierarchical systems and is essential in various domains for structuring information.

Reification becomes critical in taxonomic discussions as it transforms human-devised classifications and abstractions into perceived natural, fixed divisions in the world. This approach can obscure the subjective and constructed nature of these categories, falsely presenting them as inherent properties of the objects classified rather than as reflections of human judgment and societal conventions.

Michel Foucault, with his thorough investigations into the archaeology of knowledge and his analysis of discourses shaping epistemes – the knowledge frameworks of specific epochs – critically explores the power and implications of taxonomies in human sciences. His seminal work, *The Order of Things* (1966), examines how different historical periods are defined by distinct epistemes that legitimize certain taxonomies and knowledge divisions as valid, thereby shaping our perception of reality.

Foucault challenges the reified nature of taxonomic categories, arguing they are not universal truths but are shaped by specific historical, cultural contexts, and power relations. He posits that taxonomies serve as mechanisms through which knowledge is organized, controlled, and disseminated, cautioning against their seeming neutrality. These classifications play a role in defining norms, dictating what is considered "normal" versus "abnormal," or "licit" versus "illicit," embedding exclusionary practices and power dynamics into the fabric of knowledge and society.

Viewing taxonomy through the lens of reification and Foucault's critical perspective prompts a reconsideration of the origins, functions, and impacts of the classifications that underpin our understanding of the world. It highlights the necessity of acknowledging the constructed nature of these categories and the underlying power structures they perpetuate. This awareness challenges us to critically assess the classifications that define our realities and to remain vigilant about how they may shape, limit, or expand our understanding of the world around us.

Art exhibitions serve as a prime example of this process, transforming abstract artistic ideas into tangible experiences for viewers. These exhibitions stem from the human desire to replicate the various dimensions of reality, thereby making the abstract tangible. In this context, the exploration and advancement of AI mirror this pursuit, as they aim to replicate and enhance human cognitive functions through technology. Just as taxonomies in art exhibitions help categorize and present diverse artistic expressions, AI seeks to organize and process vast amounts of data to extend human cognitive capabilities.

In the broader discourse on artificial intelligence (AI), the critique of binary oppositions and the recognition of our evolutionary limitations highlight the complexities of categorization and the potential pitfalls of applying reified taxonomies uncritically. This perspective challenges the notion of a dichotomy between humanity and an emergent "artificial" intelligence as adversaries, suggesting instead that our technological creations are extensions of our evolutionary journey, reflecting our capabilities and limitations.

The recognition that humans remain the sole surviving species of a once-diverse lineage points to a critical misinterpretation of our place within the natural order, often perpetuated by anthropocentric taxonomies. This view obscures the

interconnectedness that characterizes biological evolution and the impact of human actions on the planet's future and all its inhabitants. Scholars like E. O. Wilson in *Biophilia* (1984) and Yuval Noah Harari in *Sapiens* (2015) underscore the deep connections humans share with the natural world and the significant, often detrimental, impact of human activities on the biosphere.

Addressing the challenges posed by anthropocentric views, especially in the context of AI, requires a fundamental shift in understanding our place within the natural world. Acknowledging the complex relationships that define the web of life and the dependence of human survival on the vitality of the biosphere is essential. By adopting a more holistic and inclusive approach to classification and technology development, we can foster technologies that promote sustainable development, enhance human welfare, and ensure the preservation of the planet for future generations, aligning technological advancement with ethical and ecological considerations.

Thus, the exploration of reification, taxonomy, and their application in art exhibitions and AI reveals the detailed ways in which human understanding and technological progress are deeply connected. By critically examining and challenging the reified structures that shape our perceptions, we can cultivate a more nuanced and responsible approach to knowledge and innovation, one that respects and enhances the diverse and interconnected realities of our world.

An Extended Taxonomy of AI Creativity

The apprehension surrounding artificial intelligence (AI) also transcends the fear of it eluding human oversight to become a renegade force. More critically, the concern is rooted in the potential of AI to serve as an amplification of human imperfections, notably through the imposition of our rigid frameworks upon the fabric of reality. This shift in perspective moves the dialogue away from a scenario where AI gains autonomy and acts against its creators, focusing instead on how AI might magnify the inherent flaws and biases in our perception and interaction with the world around us. Adhering too stringently to the taxonomies we've constructed, without acknowledging the fluid and interconnected essence of the natural world and technological advancements, positions AI to potentially accentuate and expand upon these constraints, fostering developments that might be detrimental to humanity. Consequently, this discussion aims to delineate a concept of creativity facilitated by AI, advocating for a broader taxonomy that surmounts the prevailing binary categorizations. This endeavor draws inspiration, once more, from the evolutionary concept of exaptation, which illustrates how characteristics can evolve to serve purposes distinct from their initial functions.

When the concept of exaptation – delineating the phenomenon whereby traits gain new functions unrelated to their original evolutionary purposes – is applied to the realm of AI, it suggests a paradigm where AI's function transcends the simplistic binary of acting merely as a tool or a threat. Instead, AI emerges as a collaborator in the creative process, endowed with the capacity to contribute to human creativity and innovation in ways that surpass existing categorical limitations. This

evolved taxonomy not only recognizes AI's potential to recontextualize its capabilities in the face of emerging challenges and opportunities but also promotes a refined understanding of AI as both a reflection and an enhancement of human intellect through a cooperative relationship.

Embracing exaptation enables the cultivation of an environment in which AI serves as a catalyst for dismantling the entrenched categorizations that currently limit our cognitive processes. This approach heralds a shift toward a more dynamic and adaptable interaction between humans and technology, spurring the pursuit of novel avenues in creativity and problem-solving. The incorporation of AI into a broader and more adaptable taxonomy stands to augment our capacity for innovation, equipping us to tackle complex issues in more comprehensive and creative ways.

Therefore, recasting the narrative on generative AI from a dichotomy of control and antagonism to one of mutual collaboration and shared evolution paves the way for fully leveraging the capabilities of artificial intelligence. By broadening our taxonomic frameworks to encompass more cohesive and interconnected categories and by gleaning insights from the heuristic value of exaptation, we are better positioned to navigate the multifaceted risks and prospects AI presents. This strategy not only curtails the likelihood of adverse, self-inflicted outcomes but also unlocks new possibilities for creativity and advancement, heralding a future where AI and human ingenuity converge in the pursuit of progress and innovation.

Generative Creativity in the Exhibition of the Arts

Generative AI stands as a catalyst for transformative change in the realms of art and architecture, leveraging cutting-edge technologies like generative adversarial networks (GANs) and variational autoencoders (VAEs). These innovations are reshaping the landscape of creative possibilities, offering novel methodologies for artistic and design endeavors while prompting a critical examination of traditional notions of creativity and ownership. As such, generative AI is not just a tool but a paradigm shift, altering the way creative output is conceptualized and produced (Elgammal et al., 2017; Liapis et al., 2018).

Within architecture and design, the impact of generative AI is profound, employing sophisticated algorithms to envision a vast array of design solutions tailored to meet diverse criteria related to efficiency, structural soundness, and optimal use of space (Akbarzadeh et al., 2018). By simulating intricate environmental interactions like airflow and thermal dynamics, generative AI contributes to the development of buildings that are both more sustainable and effective (Kolarevic, 2019). Moreover, the integration of AI in analyzing data enables the seamless incorporation of user preferences and environmental considerations into the design process, thus enhancing the functionality and pertinence of architectural endeavors (Veloso et al., 2020). This technological progress fosters a collaborative ethos, where machine learning becomes an integral part of the creative process, offering innovative solutions and foresight into potential design challenges, thereby amplifying the collective creative potential of architects and designers (Ciftcioglu et al., 2019).

This technological evolution invites reflection on the essence of creativity and the significance of human contribution in the creation of outstanding visual arts and designs. Generative AI blurs the lines that have traditionally separated the artificial from the natural and human creativity from that of AI, opening new horizons for creative expression. It cultivates an inclusive creative community where developers of algorithms, users, and contributors to data pools all play vital roles in the creative process, thus democratizing and expanding the scope of artistic and architectural output.

Generative AI empowers artists and designers to integrate their work with that of their peers, facilitating the creation of artworks that exceed the cognitive capabilities of the human mind. This approach fosters a collective form of creativity that utilizes shared algorithms and databases, challenging entrenched beliefs about art and ownership. It advocates for a renewed perception of creativity as the result of both intentional and spontaneous collaborative efforts. This perspective underscores the intricate, communal nature of creative work, proposing that our appreciation of art and design should evolve to include the contributions of generative AI as a vital and enriching aspect of the creative world.

Generative AI and Exaptation

The repurposing of traits for functions they were not originally selected for, known as exaptation, is well-illustrated by the example of bird feathers. Initially evolved possibly for thermal regulation, they became instrumental in flight, a classic case of exaptation where the original purpose was overtaken by a new, advantageous function. This concept of utilizing existing structures for novel purposes extends well beyond the biological realm, permeating technology, architecture, and the arts, where existing tools, ideas, and practices find new life and applications unforeseen by their original creators.

In the technological sphere, the internet's evolution is a striking instance of exaptation. Designed initially for specific scientific and military communications, it has morphed into a global platform for myriad activities, including commerce, social interaction, and entertainment, far exceeding its original scope. Similarly, in the creative arts, the practice of repurposing materials or concepts to generate artworks that depart significantly from their origins underscores the inherent creativity in seeing potential beyond intended uses.

Exaptation, therefore, not only highlights the dynamic and innovative nature of evolution and design but also emphasizes the adaptability and potential for existing elements to be reimagined and repurposed. This understanding enriches our perspective on development and innovation, suggesting that progress often leverages what already exists in new and transformative ways.

In the creative and technological domains, generative AI's application of exaptation is particularly compelling. Generative AI involves the innovative use of existing data – be it images, sounds, or text – to produce novel artistic or design outputs. This mirrors the evolutionary process of adapting features for new

functions, showcasing the capacity for what might be deemed obsolete or redundant to become the cornerstone of creative breakthroughs.

Creativity, at its heart, is about combining and reinterpreting existing elements to forge new, valuable creations. This process, intrinsic to both human and AI-driven creativity, depends on merging diverse ideas or concepts to produce original outcomes. The uniqueness of a creative work often lies in how distinct it is from its original influences, achieved through blending and associative thinking. This challenges traditional views on authorship, rooted in the desire for individual recognition, and highlights creativity as a collective endeavor enriched by various contributions.

Generative AI's role in creativity transcends simple mimicry or reproduction. Instead, it embarks on a complex, sometimes autonomous journey of creating new combinations from existing data, akin to the human brain's idea generation through subconscious connections. This unpredictable, emergent quality of creativity allows for the development of truly innovative ideas and artifacts, underscoring generative AI's potential to produce genuinely novel contributions to art, design, and beyond.

The advancements in generative AI invite us to rethink our understanding of creativity, authorship, and the dichotomy between the natural and artificial. By recognizing AI's role in the creative process as an augmentation of human ingenuity rather than a replacement, we open the door to a more comprehensive and inclusive appreciation of creativity. This approach not only expands the realm of what is deemed creative but also fosters a synergistic collaboration between human and machine intelligence. As we delve deeper into the capabilities of generative AI, it becomes evident that the future of creativity hinges on our ability to integrate these technologies in ways that enhance and amplify our natural creative instincts.

The Evolution of Art Exhibition: Practice-Based Research in the Age of AI and Technology

The integration of generative AI into various fields, including digital art, architecture, and design, heralds a transformative era in how we create, share, and exhibit art. This innovative approach not only challenges traditional views on authorship and creativity but also embraces the concept of exaptation – whereby existing structures are repurposed for new functions – as a fundamental principle for groundbreaking innovation.

Consider *Two Acrobats* by Fadhil Fadhil and Monica Battistoni. This installation exemplifies the potential of generative AI to merge physical and digital realms, creating new dimensions in performance art. Displayed at the 2023 FuoriSalone di Milano with IDC Foundation support, the work uses AI to deepen the narrative of acrobatic performance, intertwining themes of resilience and theatrical magic. This project highlights AI's ability to enhance creativity and foster new artistic and cultural expressions.

Similarly, the *Padiglione della Scienza* initiative, a collaboration between Emanuele Lisci and Dustin White, promoted by Roberto Frangione (Italian

Government), showcases AI's transformative role. By integrating AI-generated imagery, this project creates a harmonious blend of organic and engineered elements in architectural design, underscoring Italy's commitment to technological and ecological advancement.

The Italian Institute Culture New York's poetic creativity project, promoted by Fabio Finotti, combines poetry with visual arts through AI-driven image generation and 3D fabrication. This initiative transforms abstract literary themes into tangible art, pushing the boundaries of artistic exploration.

These examples underscore the profound impact of generative AI on reinterpreting creativity and authorship (Alessandro/Reuters 2024). By repurposing existing elements for new applications, AI challenges static art interpretations and invites a reevaluation of traditional artistic methodologies. This integration of AI into creative practices prompts broader consideration of technology's societal role and ethical implications, advocating for a collaborative environment that enhances the relationship between human and artificial creativity.

Heliopolis 21 Architects' practice-based research, for example, explores architectural exaptation, enriching architectural taxonomies with eco-conscious strategies. Projects like *Cyberwall I and II* and *Geocity* exemplify this approach. *Cyberwall I*, showcased at the 2021 Venice Biennale Italian Pavilion, exemplifies sustainable and inclusive design by repurposing Iris Ceramica Group's technology for new graphic compositions on ceramic surfaces. This not only highlights innovative design possibilities but also sparks discussions on the interaction between human-made and natural elements.

The sustainable aspects of these projects are further emphasized by Iris Ceramica Group's Active Surfaces®, eco-active materials that combat pollution and promote health and environmental well-being. The *Cyberwall* projects illustrate sustainability through innovative material use and production methods.

Installations like *Spandrel II* and *Genoma* at the Venice Biennale advocate for ecologically integrated architecture, combining aeroponic cultivation and biodiversity preservation within architectural designs. These projects underscore the importance of interdisciplinary collaboration and experimental approaches in addressing future challenges.

The *Black Box* and *Createch* installations further explore architectural exaptation, investigating sustainable food production and the educational potential of innovative design practices. These case studies illuminate the transformative power of design and the crucial role of sustainability and multidisciplinary collaboration in shaping architecture's future.

Creativity, often perceived as an individual pursuit, is, in reality, a collective process shaped by a network of influences. The dialogue around authorship and AI integration in creative processes requires a reconsideration of creativity as a communal and iterative journey. By recognizing the collaborative essence of creativity and the complementary role of AI, we can embrace a future where creativity thrives through the synergy of human and artificial intelligence, fostering a more inclusive and innovative exploration of our collective creative potential.

References

Akbarzadeh, M., Liu, Y., & Xie, M. (2018). A review of applications of generative design in architecture: Looking back to see the future. *Automation in Construction, 94*, 264–275.

Alessandro/Reuters. (2024). *AI might kill the 'starchitect' – but make real estate more sustainable. Context.* Thomson Reuters Foundation.

Berger, P. L., & Luckmann, T. (1966). *The social construction of reality: A treatise in the sociology of knowledge.* Anchor Books.

Bostrom, N. (2014). *Superintelligence: Paths, dangers, strategies.* Oxford University Press.

Carpo, M. (2023). *Beyond digital.* MIT Press.

Ciftcioglu, Ö., Gül, L. F., & Çagdas, G. (2019). From generative design to generative architecture: A decade of research in computational and parametric design. *Design Studies, 63*, 1–29.

Crawford, K. (2020). The trouble with bias. In *Feminist AI: Vision and practice* (pp. 125–139). Carnegie Mellon University.

Elgammal, A., Liu, B., Elhoseiny, M., & Mazzone, M. (2017). CAN: Creative adversarial networks, generating "art" by learning about styles and deviating from style norms. https://arxiv.org/abs/1706.07068.

Foucault, M. (1966). *The order of things: An archaeology of the human sciences* (Original French ed.). Gallimard, Pantheon Books (English translation).

Foucault, M. (1977). *Discipline and punish: The birth of the prison.* Vintage Books.

Foucault, M. (1978). *The history of sexuality: Vol. 1. An introduction.* Pantheon Books.

Gould, S. J. (1996). *The mismeasure of man.* W. W. Norton and Co.

Harari, Y. N. (2015). *Sapiens: A brief history of humankind.* Harper.

Huxley, T. H. (1868). A liberal education and where to find it: An inaugural address. In *Lay sermons* (pp. 31–59). Cambridge University Press.

Kolarevic, B. (2019). Architecture in the age of artificial intelligence. In C. Alexandru (Ed.), *Architecture in the age of the 4th industrial revolution* (pp. 149–160). Springer.

Liapis, A., Yannakakis, G. N., & Togelius, J. (2018). Computational game creativity. In *Artificial and computational intelligence in games* (pp. 41–63). Springer.

Lukács, G. (1971). *History and class consciousness: Studies in Marxist dialectics.* MIT Press.

Marx, K. (1867). *Capital: A critique of political economy* (Vol. 1). Penguin Classics.

Russell, S., & Norvig, P. (2016). *Artificial intelligence: A modern approach.* Pearson.

Veloso, P., Achten, H., Janssen, P., & Barros, M. (2020). Machine learning and artificial intelligence in architecture: Opportunities and challenges. *Frontiers of Architectural Research, 9*(4), 641–658.

Wilson, E. O. (1984). *Biophilia.* Harvard University Press.

Yan, W., & Li, A. I. (2020). Architectural design in the age of AI. *Nexus Network Journal, 22*(1), 93–113.

6 Community Resilience at the Venice Biennale (2021–2023)

Maria Perbellini, Alessandro Melis, Marcella Del Signore, Gertrudis Brens and Sung Park

The Practice of Exaptive Design Following the Form

This chapter describes the case study of the *Resilient Communities* project for the Italian Pavilion at the Venice Biennale 2021, showcasing the application of principles such as environmental graphic design, the introduction of innovative technologies, and architectural exaptation. As previously discussed, exaptation is a concept from evolutionary biology that suggests biological structures have latent potentials that can be harnessed in new ways beyond their current functions.

The design for the Italian Pavilion began with the consideration that spontaneous novelty often emerges as potential exaptations – existing structures that gain new functions over time. Pievani (2024) illustrates this with the human body, which features numerous exaptations resulting from the shift to bipedalism, such as the trade-offs seen in human childbirth. Human DNA is a redundant network brimming with potential exaptations, including re-functionalized genes.

In architecture, exaptation highlights the difference between functionality and rationality, emphasizing the distinction between intentional functional determinism and non-deterministic, creative design approaches. Exaptive design incorporates elements of diversity, variability, and redundancy, even without a clear final purpose, anticipating future adaptability. Temporary, spontaneous appropriations of public spaces exemplify functional co-optation in architecture, enhancing neighborhood resilience by utilizing areas not initially intended for such uses. This form of exaptation in urban design demonstrates how spaces can be dynamically repurposed, reflecting the principles of evolutionary biology.

Thus, the project titled *Resilient Communities* for the Italian Pavilion at La Biennale Venezia 2021 exemplifies the groundbreaking application of exaptation in architecture. This text builds on the reflections about the Italian Pavilion presented in our previous publication, *Architectural Exaptation*, coauthored with Telmo Pievani and Antonio Lara-Hernandez. The project advocates for transdisciplinary studies that transcend traditional thinking by incorporating concepts from evolutionary biology. It underscores the importance of challenging established norms and orthodoxies in design to better address environmental crises. By embracing complexity, disorder, and darkness, the Pavilion aims to shift perspectives and

DOI: 10.4324/9781003465188-8

embrace uncertainty and change as vital strategies for effectively tackling global challenges.

The project celebrates architectural disorder as a key to creating resilience, akin to the diversity and redundancy found in genomes and the human brain (Melis, 2021d, 2021e). It highlights the benefits of structural plasticity in evolutionary biology, acknowledging that non-adaptive mechanisms, often marginalized, play crucial roles in nature's complexity. The exhibition argues against rigid planning frameworks that fail to adapt to environmental changes and contribute to CO_2 emissions (Melis, 2021f).

Showcasing radical and disruptive technologies, the Italian Pavilion challenges prescriptive design taxonomies, advocating for continually reassessing architectural concepts to meet societal needs. Johannes Kepler's principle of natural efficiency, "Nature uses as little as possible of anything," resonates with the idea that architecture should be economical and functional, inspired by natural selection's co-opting of existing structures for new uses (Melis, 2021b).

The Dark Side of Creativity

The concept of "dark architecture" explores the intentional use of darkness as a design element, fostering creativity and possibilities. Albert Einstein's reflections on darkness as a place of creativity underscore this approach. Just as darkness allows for the potential of light, designing spaces with intentional darkness can enhance creativity, intimacy, privacy, and dramatic effects. This idea challenges conventional perceptions, advocating for architectural designs that embrace obscurity and uncertainty to create adaptable and resilient structures.

The Italian Pavilion explores dark architecture through various projects, emphasizing that the city of the future belongs to a new architectural taxonomy filled with possibilities. By avoiding the "white-box" approach, which limits multifunctional use and free association between exhibits, the pavilion encourages a dynamic and immersive visitor experience. The decorated black walls critique the specialization and singular function of curatorial roles, highlighting the ecological unsustainability of rigid exhibition models (Melis, 2021g).

In times of crises fueled by greenhouse gases, the sky, once a symbol of divine realms, becomes a hazardous force. This paradoxical situation challenges traditional binary logic, demanding a more complex understanding of reality where associative thinking prevails. Art, architecture, technology, and science transcend the boundaries of common sense, offering creative solutions in the face of environmental changes.

The Italian Pavilion project reflects on the potential of disorder in architecture, opposing the dogmatic enforcement of order and hierarchy. By embracing diversity and fluid dynamics, the project advocates for a nuanced and complex reading of reality. The works of architects like Lebbeus Woods, Frederick Kiesler, and others who promote alternative ideas, offer valuable insights into designing resilient communities (Melis, 2022).

Redefining Pedagogies

The *Resilient Communities* project challenges the conventional "white-box" exhibition model, critiquing influential architects who prioritize maintaining established positions over exploring ecologically sustainable forms. Instead, the project harnesses the exaptive potential of inherited structures, creating a dynamic and open experience. This approach aligns with the concept of teaching thresholds, which emphasizes transformative and ontological spaces where knowledge shapes identity (Cousin, 2006).

Resilient Communities envisions an innovative educational model inspired by the workshop of Florentine master Andrea del Verrocchio, emphasizing a teacher-student relationship that fosters creativity and associative thinking. This immersive environment balances knowledge transmission with creative exploration, encouraging unconventional educational experiences.

Challenging intuitive understandings is essential for achieving mastery of threshold concepts, particularly in the face of environmental changes. Thus, the fields of arts and architecture must adopt radical and exploratory teaching approaches that foster creativity and resilience, addressing the needs of future generations effectively.

A Continuing Legacy

The Renaissance marked the birth of the demiurgic idea of the architect and emphasized intentionality in design. This era revitalized mimesis as a fundamental aspect of artistic and literary creation, with a particular focus on the representation of nature and the human form. The humanist ambition to describe the principle of "art imitating life" in absolute terms was central to this period. The Enlightenment further shifted this focus, moving interest in the imitation of reality from artistic representation to scientific research. This shift aimed to transcend the confines of visual perception in favor of understanding the laws of nature.

Modernism, emerging as a revolutionary turning point, saw artists and writers questioning the value and necessity of direct imitation. This period introduced movements that explored subjective, dreamlike, and abstract realities, diverging significantly from traditional positions. The functionalism or rationalism of modern architecture reinforced this trend, emphasizing utility and rational design. The Renaissance also marked a significant shift in the display and organization of objects, epitomized by the emergence of the "cabinet of curiosities" in Europe. These private collections, owned by the wealthy and learned, were eclectic assortments of art, natural history specimens, and archaeological artifacts. They reflected the Renaissance spirit of inquiry and fascination with the natural world and the exotic. The intimate design of these spaces was intended for personal contemplation and scholarly study.

The 19th century democratized access to culture and knowledge through the establishment of public museums. The British Museum, founded in 1753 and

opened to the public in 1759, marked a pivotal moment in the history of exhibition spaces by transitioning from private collections to public institutions. The design of these early public museums was heavily influenced by neoclassical architecture, emphasizing symmetry, order, and grandeur to reflect Enlightenment ideals of reason and progress. The 20th century introduced radical shifts in exhibition space design, influenced by modernist ideas of functionality, simplicity, and the democratization of art and design. The Museum of Modern Art in New York, established in 1929, exemplified this new approach with its flexible gallery spaces, white walls, and emphasis on natural lighting, designed to enhance the viewer's experience of the art on display. The latter half of the century saw further innovations, including interactive exhibits and immersive installations, reflecting a growing understanding of the exhibition space as an active participant in the interpretation of displayed objects.

This evolution from multifunctional, encoded architectural spaces to intentional, rational, and functional design underscores the transformative journey of art and architecture through centuries of cultural and intellectual shifts.

University as a Resilient Community

In 2023, a project for the Venice Biennale focused on the integration of technologies from a pedagogical perspective. The exhibition titled *Students as Researchers: Creative Practice and University Education* was curated by Maria Perbellini, Marcella Del Signore, Athina Papadopoulou, and Sandra Manninger. Set against the backdrop of an era grappling with simultaneous crises affecting various paradigms, this exhibition underscored the urgency for action across social, environmental, political, and economic domains. These interconnected crises highlighted the necessity to expand the scope of architecture toward more responsible practices that foster civic engagement. University education emerges as a fertile ground for cultivating radical visions that challenge the conventions of market-driven societies. The ingenuity and freshness of students can catalyze active and transformative approaches, aiming to revitalize urban environments from mere energy consumers to dynamic power generators, all while ensuring the well-being of our communities.

Orchestrated by the New York Institute of Technology, this exhibition was one of the nine collateral events sanctioned by Lesley Lokko, curator of the 18th International Architecture Exhibition titled *The Laboratory of the Future*, organized by La Fondazione Biennale di Venezia. The exhibition featured contributions from 20 universities, showcasing 23 student projects from around the globe, collectively presented in a physical installation titled *University Dialogs*. This installation embodied the creative practices and processes nurtured by students, guided by esteemed faculty, through diverse investigations.

Students as Researchers also included multimedia exhibitions, workshops, and symposia with associated publications, extending throughout the duration of the 18th International Architecture Exhibition. These platforms offered vibrant and

meaningful interactions through online and in-person work, lectures, roundtable discussions, and workshops, bringing together some of the world's foremost architects, researchers, and educators.

The showcased projects demonstrated how academic institutions are addressing urban challenges and climate issues, emphasizing the importance of civic engagement, community well-being, and safety. These themes are integral to the curricula of the invited universities, fostering dialogues, studies, and initiatives that prioritize the humanity of built environments.

The research projects featured in this exhibition spanned various scales, highlighting emerging themes across different cultures and educational models. At the material scale, projects delved into computational design tools and 3D printing technologies for bioinspired geometries and regenerative biobased materials. These investigations integrated new technologies while reinterpreting indigenous and local crafts and techniques.

At the building scale, projects strategically utilized biobased resources to reduce carbon footprints and energy consumption, addressing accessibility and inclusion by challenging traditional architectural standards. At the urban scale, projects explored resilient community models that respond adaptively to climate change, incorporating circular economy principles and sustainable urban growth strategies. Additionally, by implementing artificial intelligence and machine learning algorithms, students revealed unseen urban elements and questioned existing data structures and design methods.

Teaching can become a research instrument through the exchange of critical ideas with students, facilitated by bidirectional pedagogical models where teachers and learners collaborate. Under the guidance of faculty and practitioners from various design disciplines, students could critically and experimentally interrogate existing modes of production, consumption, building, and living. Thus, *Students as Researchers* brought together research outputs from institutions worldwide, offering fresh perspectives to address urgent social and environmental issues, highlighting the responsibility of future designers.

The exhibition aimed to demonstrate universities' commitment to providing a resonant platform for ongoing and actionable efforts toward envisioning future ways of being in the world. Through proactive, collaborative, and sustainable best practices, designers, educators, and leading administrators can facilitate student research and inquiries for a more balanced, equitable, and just future. Thanks to participating universities from different continents and countries, the exhibition showcased transformative and continuously evolving learning experiences. In contexts that prioritize diversity, equity, and inclusion in all its forms, these experiences prepare students to engage with design practices that encourage action and leadership.

References

Cousin, G. (2006). An introduction to threshold concepts. *Planet*, *17*(1), 4–5.
Melis, A. (2021b). *Periferia e Pregiudizio*. University Press.

Melis, A. (2021e). Decalogue of the contents of the Italian Pavilion. In A. Melis & T. Pievani (Eds.), *Architectural exaptation. Catalogo del Padiglione Italia. La XVII Biennale Venezia* (Vol. 1a). D Editore.

Melis, A. (2021f). Decalogue of the design of the Italian Pavilion. In A. Melis & T. Pievani (Eds.), *Architectural exaptation. Catalogo del Padiglione Italia. La XVII Biennale Venezia* (Vol. 1a). D Editore.

Melis, A. (2021g). Arte e Paesaggio. In *LW circus. Catalogo Sezione Arte e Paesaggio. La Biennale Venezia 2021*. D Editore.

Melis, A. (2022). The demiurgic position of architecture in times of environmental crises. In G. De Finis & C. Pecoraro (Eds.), *Periferi@*. Castelvecchi.

Pievani, T. (2024). *Imperfection*. MIT Press.

Part 3

Practice-Based Research in Contemporary Art Exhibition

7 Art Exhibition

Guest Contributions, Case Studies, Professional and Academic Experiences

Alessandro Melis, Rozina Vavetsi and Fabio Finotti

Part 3 of the book presents a collection of practice-based research enriched by international case studies. These studies explore the possibilities of art exhibition trends described in the second part of the book and address the aims outlined in the first part, fostering a more holistic perspective on art exhibitions. This perspective moves away from viewing art exhibitions as specialized activities confined to conventional "white-box" curatorial paradigms, which require specific professional competencies. Instead, this approach positions them as vessels for cross-disciplinary agencies, promoting an extended taxonomy of creativity where art exhibition and sharing are intrinsic components of a dynamic and evolving practice.

Experts, professionals, independent researchers, and scholars have been invited to share their perspectives, works, and experiences through these studies. This compilation aims to serve as a manual of art exhibition possibilities, overcoming the idea of rigid and ordered categorization.

The guest contributions have been organized into three groups sharing common traits, though their transdisciplinary nature suggests the possibility of alternative groupings. The focus of these groups includes innovations and challenges in traditional art exhibition settings, the introduction of innovative technologies and research practices, and the social and political dimensions of exhibitions, extending into urban and digital environments.

Innovations and Challenges in Traditional Art Exhibition Settings

With their contributions, Anthony Caradonna, Giovanni Santamaria, Andrew Barrie, and Mike Davis share their expertise from both academic and professional viewpoints, presenting diverse examples from the United States and New Zealand.

In "Meta-Exhibition Designs," Anthony Caradonna explores the intersection of artificial intelligence and human consciousness, investigating how creative fields can transcend the traditional logocentric approaches of science. Through a historical and philosophical lens, his text examines various artistic movements and their counter-cultural currents that challenge and expand our cognitive potentials. Caradonna reflects on Donna Haraway's "A Cyborg Manifesto," emphasizing the

DOI: 10.4324/9781003465188-10

fluidity of identity and the rejection of rigid boundaries. This sets the stage for a discussion on how exhibition design can harness AI to enhance human awareness.

The contribution also revisits pivotal moments in art history, such as Marcel Duchamp's 1942 Surrealist exhibition *First Papers of Surrealism*, Ed Ruscha's *Chocolate Room* at the 1970 Venice Biennale, and James Turrell's *Aten Reign* at the Guggenheim in 2013. According to Caradonna, these examples illustrate the transformative power of art and design in questioning perception and experience. He also highlights contemporary installations like Random International's *Rain Room* and Refik Anadol's *Machine Hallucinations*, which utilize technology to create immersive and interactive environments. These works exemplify the integration of machine intelligence with human consciousness, pushing the boundaries of traditional art forms. Ultimately, "Meta-Exhibition Designs" invites readers to contemplate the evolving landscape of exhibition design, where physical and virtual realities converge. Through a synthesis of past and present artistic endeavors, Caradonna envisions a future where holistic and immersive exhibition designs foster heightened awareness and cognitive expansion.

In "The Architecture of Exhibitions and the Exhibition of Architectures," Giovanni Santamaria examines how exhibitions have evolved from mere aesthetic displays to immersive experiences that deeply engage viewers. The 1960s and 1970s saw a shift toward land art, body art, and video art, utilizing ephemeral materials to emphasize the temporality of human experience. This period also marked a crucial transition in architecture, exploring geographical and topographical dimensions, leading to today's landscape-oriented approach.

Santamaria highlights the dissolution of boundaries between art forms, creating synesthetic and participatory experiences through advanced technology. The works of Studio Azzurro and Bill Viola exemplify this shift, transforming art into immersive, multisensory environments. James Turrell's light installations further blur the lines between art and environment, creating perceptual illusions that redefine space. The integration of technology in art and architecture has also led to a seamless blend of organic and machinic elements, as seen in the works of Stelarc and Orlan. This synthesis challenges traditional distinctions between body and machine, further explored in the cinematic worlds of David Cronenberg.

Santamaria also states that, today, art and architecture are called to explore new horizons, combining creative actions with advanced technologies to address environmental and social issues. Projects like the *Tidy Street Project* and *Urban Syncopation* exemplify how art can visualize and engage communities in understanding and addressing critical topics like climate change. These interventions merge aesthetic, technological, and environmental values, creating a shared participatory experience. Looking forward, Santamaria discusses the *Future by Design* exhibition, showcasing innovative design processes promoted at the School of Architecture and Design of the New York Institute of Technology, that integrate creativity, functionality, and sustainability. The collaborative work displayed highlights the importance of experimental methodologies and transdisciplinary collaborations in fostering resilient and sustainable environments.

In "The Tyranny of Distance?," Andrew Barrie and Mike Davis explore the unique challenges and opportunities faced by Aotearoa New Zealand in the realm of architecture, particularly in addressing the climate crisis. They highlight how the physical isolation of New Zealand necessitates a reliance on local materials and innovative, low-tech solutions. The authors begin with the story of their participation in the Venice Biennale in 2021, which started with a shipping container sent from Auckland to Venice. This illustrates the logistical challenges posed by distance, especially considering that Italy is at the antipodes of New Zealand. This container, carrying exhibition materials, arrived in the midst of the COVID-19 pandemic, highlighting the unpredictability and complexity of global logistics.

Barrie and Davis argue for a shift in architectural approach, emphasizing simplicity and local solutions over technological sophistication. They present *Learning From Trees*, their exhibit at the Venice Biennale, which draws on New Zealand's timber-building traditions. This project exemplifies how constraints can drive innovation, resulting in sustainable and locally sourced architectural solutions. The exhibit demonstrates a methodology for creating complex structures from simple, locally available materials. By employing lightweight timber elements and innovative joint systems, the project avoids the pitfalls of expensive and complicated construction methods, instead showcasing the beauty and practicality of timber. The authors conclude with a reflection on New Zealand's architectural history, from the Gothic timber churches of English missionaries to the Modernist timber structures of the post-war period. This lineage of resourcefulness and innovation underlines the potential for low-tech solutions to address contemporary architectural challenges. *Learning From Trees* serves as a call to action, encouraging direct and inventive responses to environmental issues. Barrie and Davis advocate for a change in values, suggesting that simplicity, frugality, and rawness can lead to original and sustainable architectural practices.

These contributions are rooted in the integration of technology and philosophical inquiry, offering a forward-looking vision of exhibition design. They all focus on the sensory and both individual and participatory dimensions, creating immersive experiences that engage audiences deeply.

The comparative analysis of these studies reveals a holistic perspective on art exhibitions and architectural practices. The strengths of Caradonna's technological integration, Santamaria's immersive experiences, and Barrie and Davis's sustainable local solutions provide a comprehensive framework for future innovations. Each approach offers valuable lessons: the importance of embracing technological advancements, the power of immersive and participatory experiences, and the potential for sustainable practices rooted in local contexts.

Together, these case studies underscore the necessity of interdisciplinary collaboration, flexibility, and creativity in responding to contemporary challenges. They encourage us to move beyond traditional paradigms, exploring new possibilities for art exhibitions that are dynamic, inclusive, and sustainable. By synthesizing these diverse approaches, we can envision a future where art and architecture not only reflect but also shape the complexities of the modern world.

Interdisciplinary Innovations and Immersive Experiences

The following contributions demonstrate that extending categorization and adopting a holistic view – where art, design, and architecture are integrated rather than separated – can be achieved through technological innovations such as digital fabrication and robotics as well as through performative acts and radical perspectives on diversity. Researchers such as Fadhil Fadhil, Dustin White, Antonino Di Raimo, Giuseppe Fallacara and his team, and Saverio Massaro and Enrico Lain bring unique perspectives that collectively push the boundaries of traditional practices from philosophical, epistemological, and technological standpoints. These works share common traits of interdisciplinary collaboration, technological integration, and a focus on creating immersive, participatory experiences. By examining these diverse case studies, we can draw valuable comparisons and insights, understanding their strengths and potential applications in broader contexts.

In "Components, Representations, and Pixels," Fadhil Fadhil explores the significant role of pixels in architectural design and digital fabrication. The chapter explores into how pixels, as fundamental units of imagery, transition from two-dimensional representations in AI-generated images to three-dimensional constructs through digital fabrication techniques. Fadhil's contribution includes three practice-based research examples developed by former students of the Master in Computational Technologies program at the New York Institute of Technology. In "Definition and Discovery of Three-Dimensional Pixels", researchers Arathi Chilla and Tharoonaskar Baskaran, while exploring the concept of pixels in architecture, reveal how two-dimensional AI-generated images can transform into abstract three-dimensional models. The study discovers that pixel characteristics like gradients, opacities, and saturations significantly influence three-dimensional resolution and spatial qualities. Challenges in pixel density and connectivity during digital fabrication are addressed, demonstrating how digital techniques and three-axis milling can realize high-density foam architectural panels.

"Three-Dimensional Resolution Through Digital Fabrication," Amisha Bvadiya's research, focuses on digital fabrication's impact on architectural ornamentation. By manipulating pixel assembly and tool path densities, the study examines the variations in architectural designs and ornament qualities. The research emphasizes the role of resolution at a micro level in achieving different aesthetic outcomes, posing questions about the pixel's viability as an architectural component.

Mike Saad's study, titled "Three-Dimensional Pixels Within 3D Scanning and Robotics Fabrication," examines high-resolution objects like rocks and tree trunks using 3D scanning and six-axis robotic milling. The research highlights how resolution changes during scanning and fabrication can be utilized as design tools, creating complex and intricate patterns. The study underscores the importance of pixels in controlling resolution and materiality in architectural design and digital fabrication.

Fadhil's contribution concludes by exploring how pixels and resolution can influence our understanding of space, proportions, and materiality, suggesting that further experimentation with pixels could redefine architectural practices and environmental solutions.

In "Stereoma," Dustin White presents a dynamic, site-specific installation designed to create an immersive spatial experience. The installation, initially part of the "Stereotomy 2.0" exhibition, later served as a standalone exhibit, transforming a vacant storefront in Queens, NY, into an interactive public space.

The concept of "firmamentum" is central to the installation, drawing from both literal and metaphorical interpretations of the heavens. The installation aims to immerse participants in a sensorial exploration of space, engaging them in active participation and dialogue. White also focuses on three specific case studies.

The *Stereotomy 2.0 Exhibition* at the New York Institute of Technology showcased innovative applications of stereotomic principles in contemporary architecture. Projects ranged from traditional vaulted spaces to novel applications like pavilions and furniture, utilizing advanced CNC and robotic manufacturing techniques.

The project *Stereoma Materialization* integrates material geometry and LED lighting systems to create an immersive environment. Inspired by Frei Otto's form-finding methods, the installation employs lightweight, flexible materials like Mylar to achieve a cohesive design. The LED lighting system enhances the spatial experience, allowing visitors to interact with the exhibit dynamically.

The installation (*Stereoma as an Exhibit*) was adapted to revitalize a vacant storefront, providing a positive community impact during the COVID-19 pandemic. The project underscores the importance of engaging public spaces and fostering community involvement through innovative design.

In "Field Notes From My Little Aurora," Antonino Di Raimo presents a practice-based exploration of human-robot coexistence in domestic environments. The project, part of *Living (Together) With Them*, speculates on future domestic settings populated with robotic agents. Di Raimo shares personal experiences living with a small NAO robot named Cole during the COVID-19 lockdown. The study examines how architectural spaces must adapt to accommodate robotic companions, highlighting the importance of spatial design in facilitating human-robot interactions.

Fieldwork with Cole involved interactions with children exhibiting autistic disorders, revealing behavioral patterns and spatial dynamics. The research underscores the potential for robots to enhance social interactions and support therapeutic interventions.

The study emphasizes the need for architectural spaces to evolve, accommodating the presence of robots and facilitating human-robot coexistence. Di Raimo reflects on the transformative impact of robots on daily routines and spatial arrangements, suggesting that future architectural designs must consider the integration of artificial agents.

The study concludes by highlighting the broader implications of human-robot interactions on architectural design, advocating for performative spaces that prioritize bodily agency and effective task orchestration.

Marmomac Meets Academies is the focus of the case "Exploring the Intersection of Tradition and Innovation in Stone Design." *Marmomac* is a significant international event dedicated to natural stone and its associated technologies held at

Verona Fiere in Italy. With their contribution, Giuseppe Fallacara, Sara D'Adamo, Clara Rosa Romano, and Maria Giovanna Pansini provide a comprehensive exploration of this program in their work, emphasizing its role in promoting collaboration between universities and the stone industry. This event offers students and emerging professionals a unique platform to delve into the potential of the stone sector through innovative educational activities, highlighting the blend of tradition and modern digital production techniques in shaping future architectural designs.

Fallacara et al. describe *Marmomac*'s transformation from a local event to a global showcase, attracting professionals, academics, and companies from around the world. This evolution has not only facilitated commercial exchanges but also fostered international collaborations, establishing the event as a cultural and educational forge. The authors emphasize *Marmomac*'s commitment to sustainability, promoting responsible resource use and eco-friendly processing techniques. They note the technological innovations on display, such as 3D printing and CNC machines, which have revolutionized marble production and application, demonstrating the harmonious coexistence of tradition and innovation.

The authors highlight the enduring appeal of stone as a natural, precious, and eco-friendly material. This immediate connection between design and the final product is made possible by the increasing use of CNC machines and 3D-modeling software, allowing for the creation of intricate and large-scale stone structures previously unimaginable.

Marmomac Meets Academies, launched in the late 1990s, has provided students from leading faculties of architecture, design, and fine arts worldwide the opportunity to explore the world of natural stone through practical workshops, quarry visits, and collaborations with companies. Fallacara et al. emphasize the importance of hands-on experiences in understanding the materiality of stone and its craftsmanship, influencing students' design decisions and fostering a holistic understanding of architecture.

The authors highlight the significant role played by the Polytechnic University of Bari in recent years. Under the pioneering vision of Giuseppe Fallacara, the university has integrated advanced technologies like CAD/CAM into the curriculum, fostering a new architectural language that combines tradition with modern techniques. Collaborative research projects have focused on the lightness and dematerialization of stone, with significant contributions showcased at *Marmomac*, underscoring the potential of stone as a modern, versatile material.

Fallacara et al. recount notable projects like *Petrae Apulie*, *Lapis Aqua*, and *Modo Lapis*, which emphasize different aspects of stone's relationship with water, emotional symbolism, and digital fabrication. They describe the 2022 exhibition, *Journey Through Italy's Natural Stone*, which showcased the diverse stone landscape of Italy, reflecting the deep relationship between stone and the environment.

Looking forward, the 2024 exhibition, *Ceci n'est pas un fossile*, is set to explore the future of lithic design, integrating computational design, digital fabrication, and traditional craftsmanship. According to the authors, this innovative setup aims to inspire new generations of artisans, architects, and designers to blend

modern techniques with historical insights, promoting sustainable and efficient stone architecture.

In conclusion, *Marmomac Meets Academies* is presented by Fallacara, D'Adamo, Romano, and Pansini as a vital event on the global stage, driving the future of stone architecture through a unique blend of exhibition, education, and industry collaboration. Their work emphasizes the importance of minimizing material waste and maximizing structural and aesthetic potential, ensuring that innovation and tradition harmoniously coexist in the evolving landscape of stone design and construction.

In their insightful exploration, "Toward Non-Humans' Embassies," Saverio Massaro and Enrico Lain investigate the relationship between art and design through performative staging. The work examines the theatrical performance *The Non-Humans' Ambassadors*, held in 2023 at Palazzo Micciché-Human Forest in Favara, Italy, as part of the FARM Cultural Park's programming. This performance marks the culmination of the *Fair Play* journey, initiated in 2021 at the Italian Pavilion for the XVII Venice Architecture Biennale, and further developed through video installations in 2022. The 2023 performance celebrated the opening of the first Non-Humans' Embassy, serving as both a permanent installation and a new cultural outpost.

Massaro and Lain articulate a site-specific research method that intertwines reality with staging, employing theatrical mediums where actors portray non-human roles and interact with constructed spaces, thereby resignifying them. Grounded in Bruno Latour's actor-network theory (ANT) and enriched by the time studies of D. C. Hoy, B. Adam, and R. Kitchin, their research seeks to reopen design discourse by challenging modern dichotomies such as nature/culture and subject/object. The performative staging device is posited as an anti-laboratory exploration aimed at reducing the distance between spectator and actor, thus fostering a greater sensitivity to the different temporalities in human and non-human interactions.

The genesis of this project, as outlined by Massaro and Lain, began between 2020 and 2021 and has evolved through various implementations: the Constituent Assembly online panel in 2021, video installations in 2022, and the site-specific installation of the first Non-Humans' Embassy in 2023. Initially intended as an alternative dissemination form for scientific research in architectural and urban design, the project addresses the complexity and inaccessibility of such research to non-expert audiences.

The Constituent Assembly, the first act of the discursive device, collected insights from experts representing non-human entities, rooted in Latour's sociology of associations and ANT. This fictional assembly highlighted the significance of assemblages and compositions, fostering creative dialogues across different ontologies and perspectives. Each invited speaker acted as a delegate for a non-human entity, simulating a collective devoid of specific individuals to enable free discourse and meaningful exchange.

Massaro and Lain illustrate the evolution of their discursive device from an initial dissemination tool into a complex, site-specific research approach through

the performance *The Non-Humans' Ambassadors*. This performance incorporated ritual and site-specific elements, blending reality with theatrical presentation. Actors portrayed various non-human agents, dynamically interacting with the spaces of Micciché Palace-Human Forest. This performance also inaugurated the first Non-Humans' Embassy, featuring a ceremonial parade and asylum requests for computational agents developed by artist Oriana Persico and her late partner Salvatore Iaconesi.

The embassy, as described by Massaro and Lain, enhances agency by transforming the traditional dynamics between meaning and expression found in theatrical settings. It serves as a platform for engaging with non-humans through diplomacy, rather than preservation, and functions as a cultural outpost where new demands for recognition and representation are welcomed. The embassy's multimedia exhibition connects users with the Fair Play digital archive, fostering new interactions and conceptual patterns in exhibition design and cultural production.

The authors emphasize that the ongoing development of this discursive device presents both challenges and opportunities. By integrating ANT and time studies, the device can illuminate latent meanings and unexplored interactions, enriching our understanding of urban transformations. Performance, as a political and poetic public act, emerges as a powerful strategy for exploring these potentials, incorporating elements of ritual and site-specificity to reveal the influences of various actants on our environment.

Looking ahead, Massaro and Lain envision the expansion of this discursive device through the establishment of new embassies in different locations. These embassies will highlight alternative modes of existence and the potential of hosting spaces, continuing to evolve as dynamic tools for engaging with complex issues in architectural and urban design. This ongoing exploration underscores the potential of performative arts and theoretical frameworks to challenge and expand the boundaries of design discourse, fostering inclusivity and dialogue in the cultural landscape.

Together, the studies presented in this section reveal common strengths in their emphasis on technological integration, interdisciplinary collaboration, and the creation of immersive, participatory experiences. They highlight the potential for innovative design to address contemporary challenges, foster community engagement, and promote sustainable practices. By synthesizing these diverse approaches, we gain a comprehensive understanding of how art, architecture, and design can evolve to meet the demands of the modern world, encouraging a future where creativity and innovation drive meaningful change.

The Social, Political, and Narrative Dimension of Art Exhibition

The contributions in this section investigate the social and experiential dimensions of art exhibitions, underscoring the significance of narrative, radical political perspectives, and the potential for both digital and physical urban environments to serve as exhibition spaces. This approach challenges the traditional curatorial practices confined to indoor settings, which risk overlooking crucial knowledge and

immersive experiences. These studies highlight the community's role as a cohesive unit within the city, emphasizing the necessity of its involvement in authorship and as subjects of exhibitions to foster a sense of belonging and ownership of urban spaces. Additionally, they explore the community experience, which transcends the physical world to immerse in virtual and mass media realms, promoted by visual experiences as a critical component of our sensorial engagement.

Elena Cologni's project *Places of Memory. 416_SR1938* explores historical and theoretical contexts within the Jewish community in Pisa. Collaborating with this community, Cologni references the 416 Jewish members present in 1938, the year Mussolini's racial laws were enacted. This project fosters dialogue and memory through city interventions, recalling the lives and work of community members.

Cologni's work delves into subjective time perception, intersecting psychology, cognitive studies, and phenomenology. She draws from Bergson's concept of duration, exploring how memory activates in the present. Her residency at Cambridge University's Faculty of Experimental Psychology enhanced her understanding of place and presentness.

Her art emphasizes viewer engagement, where perception and meaning-making occur. Using human-sized objects and kinesthetic elements, she bridges performer and spectator experiences. Inspired by Kanizsa's perceptual studies and Vicario's work on time perception, she integrates 3D applications to create illusory effects.

Employing Gestalt's figure-ground relationship, Cologni's work intertwines light and shadow, engaging the viewer's body and fostering embodied care, per Hamington's concept. This approach merges visual dynamics with relational responses, enhancing the caring-with process.

Research at the "Tullia Zevi" Bibliographic Center in Rome revealed the impact of racial laws on Pisa's Jewish community. The memorial features 416 brass elements casting shadows on the SR1938 building, symbolizing memory's variability. Documenting these shadows, Cologni aims to activate communicative memory through participatory city interventions.

Cologni's memorials combine static and temporary elements, contributing to the debate on monuments. She highlights how individual memories are formed through daily actions in anonymous places, evolving as shadows from history emerge.

Lanfranco Aceti's *Holier Than Thou* investigates the notion of creativity within the context of imperial propaganda, particularly during wartime. This analysis begins with the English notion of "holier than thou," critiquing how empires, democratic or dictatorial, adorn themselves with art and design as propaganda tools. Deviating from authorized politics of art leads to virulent attacks, as conformity is demanded to reinforce imperial mythology.

The title *Holier Than Thou* is also the name of the Russian Pavilion at the LX Venice Biennale, a space that does not exist due to lack of authorization. However, this pavilion develops as a form of wishful fancy, independent of Western empires' financial constraints. It presents a vision that does not align with either Russian or American perspectives, existing in a dystopian space carved by Orwell and Zamjatin, posing ethical questions about imperialism.

Since 2016, Aceti has worked on a failed curatorial project with the EMST (National Museum of Contemporary Art Athens), titled *Empty Pr(oe)mises*, to discuss the promises and premises of an empty space. This project was abandoned, but Aceti employed a similar strategy for the LX Venice Biennale, seeking freedom from restrictions to critique imperial hypocrisy.

In the section, Aceti faced resistance in gaining support for the Russian Pavilion project due to concerns and risk aversion. *Holier Than Thou* is a statement about hypocrisy, and its sub-installation *Oilier Than Thou* critiques wars driven by oil and rare minerals. The pavilion exists digitally and physically, unveiled one room at a time, serving as a somber critique of contemporary affairs and responding to the theme of the 2024 Venice Biennale: Foreigners Everywhere.

Aceti critiques sanctimonious imperialism and sanctimonious capitalism, which preach superior sanctity while committing heinous war crimes for financial gain. He highlights the hypocrisy of social media and institutions that stifle dialogue and critique. The Russian Pavilion gave him intellectual freedom to critique the empire, creating a space to exercise creativity without societal constraints.

Aceti reflects on the notion of being foreigners to ourselves, estranged from ethical values, and how the Russian Pavilion serves as a space for creative critique. He emphasizes the need to imagine and create spaces for creativity, independent of propaganda. The Russian Pavilion, though imaginary, is a real space for uncompromising artistic and curatorial practice.

In "Phygital: A Designer's Call to Action," Jonathan Alger and Maya Koptyman explore "phygital," a blend of "physical" and "digital" that represents the integration of these realms in human experiences. According to Alger and Koptyman, this concept challenges designers to engage with both dimensions, as seen in interactive exhibitions combining physical artifacts with digital interfaces or enhancing gallery visits via smartphones. The phygital landscape, rooted in the rise of personal computers and mobile technology, requires designers to adopt multichannel literacy and innovative thinking, utilizing tools like projection mapping and anticipating social media interactions to craft immersive experiences.

Alger and Koptyman highlight that affordable technologies now transform physical spaces into interactive digital surfaces, spurring trends in immersive art and innovations like VR headsets and the Apple Vision Pro, which merge physical and digital realities. They describe phygital projects as either physical-first, enhancing real spaces with digital elements, or digital-first, augmenting digital experiences with physical aspects, exemplified by AR games like Pokémon Go and social media activities in exhibitions. Designers must navigate this diverse landscape, blending physical and digital design principles to shape new kinds of reality and seize opportunities presented by technological advancements.

In "Enhancing the Sense of Place Through Performative Arts: The Case of Venice," Jose Antonio Lara-Hernandez examines how performative arts enhance the sense of place, focusing on Venice, Italy. Utilizing Edward Relph's theoretical framework, Lara-Hernandez explores how physical settings, activities, and meanings contribute to creating meaningful places. Venice, with its rich tradition in performative arts and unique double fractal urban fabric, serves as an ideal example

of how public spaces are transformed into places of cultural significance through performative acts.

Lara-Hernandez provides detailed case studies of key events in Venice, such as the Venetian Carnival and the Biennale di Venezia, illustrating how these events foster a sense of belonging and identity among participants and spectators. By integrating theoretical insights with practical examples, this work underscores the pivotal role of performative arts in creating enduring connections between people and their environments.

In "Visual Voices: Female-Themed Murals as Community Exhibitions in the South Bronx," Barbora Melis explores the transformative power of female-themed murals in the South Bronx, highlighting their role as powerful expressions of women reclaiming urban spaces. These murals, rich in color and narrative, transcend aesthetics to become catalysts for change, fostering community engagement and unity.

Melis emphasizes experiential design's role in understanding urban exhibitions, highlighting how these murals create immersive, interactive experiences that resonate deeply with the local population. Unlike Manhattan's well-funded public events, the South Bronx's community-driven art projects emerge from grassroots efforts, reflecting the resilience and creativity of local residents.

These murals challenge traditional urban narratives by addressing issues of gender equality and inclusion, compelling us to reconsider urban spaces as arenas where gender dynamics shape daily experiences. By examining the South Bronx as a case study, Melis demonstrates how artistic interventions contribute to community resilience and advocate for social justice.

The South Bronx's public spaces, adorned with vibrant murals, serve as dynamic canvases that tell the community's stories, fostering a sense of connection and shared experience. The interactive elements of these murals engage the community in meaningful ways, transforming public spaces into vibrant exhibition areas that reflect the community's identity and resilience.

Melis underscores the transformative power of art in reshaping urban landscapes, highlighting how female-themed murals in the South Bronx foster community resilience, social interaction, and empowerment. By integrating experiential design principles and community engagement, these murals create meaningful and enduring connections between people and their environments, advocating for social justice and inclusivity in urban spaces.

The contributions in this section illuminate the impact of integrating social and experiential dimensions into art exhibitions, transcending traditional curatorial confines. These investigations reveal how art can serve as a powerful vehicle for community engagement, fostering a sense of belonging and ownership within urban spaces. By challenging the conventional boundaries of indoor exhibitions, these studies underscore the necessity of involving communities as active participants in the creation and experience of art, thus reinforcing their roles as both authors and subjects of these narratives.

Through a diverse array of projects, from the historical reflections in Cologni's work to the phygital innovations explored by Alger and Koptyman, we observe

a unifying theme: the transformative potential of art in bridging the physical and digital realms, the past and present, the individual and the collective. These studies collectively highlight the importance of narrative and memory, whether through Cologni's memorials, Aceti's critiques of imperialism, or the community-driven murals in the South Bronx analyzed by Melis. They emphasize how art can activate memories, provoke critical reflection, and inspire new forms of social and political engagement.

The potential impact of these insights extends beyond the realm of art exhibitions. By demonstrating the power of immersive, participatory, and inclusive practices, these case studies advocate for a more integrated approach to urban development and cultural preservation. They suggest that art can play a crucial role in fostering social cohesion, resilience, and a deeper connection to our environments. In essence, these contributions collectively argue for a reimagined urban landscape where art and community intersect to create spaces of shared meaning and collective memory.

Innovations and Challenges in Traditional Art Exhibition Settings

Guest Contributions

8 Meta-Exhibition Designs

Anthony Caradonna

As artificial intelligence emerges and advances, age-old inquiries into the nature of human consciousness take center stage. While astrophysics and neurobiology offer the most advanced forms of scientific inquiry into understanding the human mind, body, environment, and experiential nexus, the creative fields delve into the depths of the unknown using alternative methods. Western cultural biases often lead to the tendency of adopting and adapting the logocentric approaches of the scientific method and mathematical proofs for artistic expression. Over the course of five millennia, diverse counter-currents of human thought, reflection, contemplation, and expression have emerged, simultaneously integrating and transcending the status quo practices of both science and art. As philosophical counterpoints, they strive to complement and expand cognitive potentials into a broader, more inclusive worldview, where human experience and expression transcend the sublime limits of current consciousness and understanding.

Paradoxical, holistic, integrative, and inclusive, these transcendental approaches alternately negate, contradict, and yet unify perceptual and intellectual discovery, both undermining and enhancing the dualistic, logocentric understanding and dialogue between artist/designer and their intended audiences. Donna Haraway's seminal 1985 essay, "A Cyborg Manifesto," signifies a rejection of rigid boundaries that separate the categories of "human" from "animal" and "human" from "machine." Instead, it advocates for the fluidity of identity and fosters collaboration, coalition, and community through expansive, shared affinities. Probing the broader context of exhibition design serves as a platform for exploring these approaches, offering a means to optimize artificial machine intelligence and advance opportunities for expanding human awareness through art and design, curatorial and exhibition potentials.

Surrealist Twine 1942

Although distinctly different, pop art, conceptual art, and contemporary art developed from the revolutionary ideas posited by Marcel Duchamp and the Dadaists. Duchamp's "ready-mades," in the form of aesthetically virtuous, found, and industrially produced objects, posited a new paradigm, redefining art as primarily conceptual, an idea, not a visual or physical language of form, ultimately implying that

DOI: 10.4324/9781003465188-12

art can be made from anything and can be anything. Pervading contemporary art and curatorial practices continue under the influence of Duchamp's art, design and exhibition paradigm shifts.

Marcel Duchamp's design intervention in *The First Papers of Surrealism* exhibition, which opened in 1942 at the Whitelaw Reid Mansion in midtown Manhattan, NY, was the biggest surrealist presentation to date in the United States. Andre Breton enlisted Marcel Duchamp to propose a design for the installation. Duchamp proposed a "mile of string" akin to a web that laced its way chaotically through the exhibition space, sometimes in sharp contradiction to the placement of paintings and art pieces situated in the exhibition space that was to function as a guide, directing viewers toward the art works. The exhibition design was seen as a metaphor for the complexities of contemporary art. The weblike twine symbolized the difficulties of being experienced by the uninitiated to see, perceive, and understand, innovative modern and surrealist art. Many of the participating artists protested that visitors would be unable to literally see the paintings. Emphasis on the string's obfuscating qualities paralleled the struggles many artists overcame to escape war-torn Europe.

There was no distinctive entry point into the exhibition space, no space that allowed visitors to occupy the same area as the paintings themselves. With Duchamp's twine, vision is flattened, disembodied, and autonomous. Separated from a physical experience and direct, intimate proximity to the artworks, the "viewer" is shut out. The string stands in the way. The presence of the string highlighted a series of confrontations: between the works and their installation, the installation and its viewers, the viewers and the work. It was a provocative force in any experience of the show, necessitating choreographic side-stepping, ducking, leaning, and bending to negotiate and navigate the space of the exhibition. Ultimately, the string disrupted, undermined, and forced a confrontation between the traditional gallery wall and pedestal display style exhibition design and new ideas about the string installation itself as both an independent and parallel exhibition, artwork, and idea. It was, simultaneously, a critique of the status quo art regime and an interventionist installation woven into and counter to the Surrealist exhibition. It seems to have been Duchamp's provocation to encourage a new awareness and potential of experiencing art. He questioned what and how we see and how art institutions themselves dictate both the content and the experience of art.

Chocolate Room 1970

In the intense political climate of 1970, when the U.S. was involved in the Vietnam War, many morally conscience American artists selected to boycott the Venice Biennale. Artist Ed Ruscha, instead, installed *Chocolate Room* on the walls of a space in the Palladian style American Pavilion, despite his own reservations. The installation employed experimental printmaking strategies integrating the artist's early introduction into graphic art with his love of unconventional materials. For the Biennale, he silk-screened 360 sheets of paper with an ink-like paste comprised of Nestlé's chocolate. Inside the windowless space, he applied the chocolate glazed paper sheets

to the walls in four uniform rows. This display arrangement of prints was reminiscent of the way clapboard shingles are slightly overlapping on the outer facades of wood framed and sheathed American homes, offering a resonant displacement of time and place. The combination of the hazy summer sun sneaking in from a distant open door and the incandescent light bulbs in the ceiling illuminated the space with a soft, warm glow, providing a sensual visual atmosphere in the exhibition room's volume that was filled with the unmistakable intoxicating scent of chocolate. The overwhelming aroma of chocolate captivated and enticed visitors into the space of the American Pavilion. Upon entering the room, presumed expectations were deprived of satisfaction, as there was no physical chocolate edibles available to consume.

Such a disappointing and disorienting experience was intentional. Some have used the word "bittersweet" to describe it, as Ruscha exploited the fluid materiality of chocolate and its inseparable scent, manipulating the emotional values many ascribe to it. *Chocolate Room* is Ruscha's only installation work but not his first experiment with material practices. Like many Dadaist gestures of protest, Ruscha's *Chocolate Room* was an oblique statement against the established cultural and political ideologies of the 1970s, echoing the conceptual dissent of Duchamp and others. Whether by intentional design or not, the installation became a serendipitous site of spontaneous political protest. Under the intense Venetian summer heat, the chocolate paste gradually began to melt. The chocolate "shingles" morphed into moist, virtual scratch boards as visitors seemed compelled to scratch graffiti images and messages protesting American military policies onto the chocolate prints. They filled these "readymade" chocolate "canvases" with activist slogans and graphics. Prophetically, in an ironic twist of fate, an army of ants invaded the room, causing the premature demise of the installation. A reconstruction of the *Chocolate Room* was recently installed and on view at MoMA this year as part of Ed Ruscha's major retrospective exhibition.

Aten Reign 2013

Light and space artist James Turell explores light as the content and experience for questioning and expanding our understanding of human perception. Using the parable of Plato's Cave as an analogy, the imperfections and the physiological limits of perception are juxtaposed in contrast to the cultural overlay of learned perception. This critical distinction is a primary manifesto for Turrell's practice and environmental exhibit designs. *Aten Reign* was the artist's installation at the Guggenheim in 2013. It was comprised of an immense, elliptical, dreamlike play of light and color that transformed the Guggenheim museum's iconic rotunda and oculus skylight. Turrell transformed the inner void of the lofty conical atrium into an immersive meditative sanctum. *Aten Reign* was the largest temporary installation James Turrell or the museum had ever undertaken. The exhibition also physically and visually veiled and separated the ribbon-like ramp spaces from the rotunda atrium. The ramps were turned into an enclosed labyrinth that contained four earlier installation pieces enclosed and exhibited in distinctly zoned areas of the continuous ramp spaces.

The central atrium was isolated, and the large glowing disk suspended above was suggestive of the underside of a planet, moon or unidentified floating object hovering and lowering itself into the space. Its concentric elliptical rings of glowing color emanated from an elaborate five-tier structure of white fabric scrims and digitized lighting floating aloft in the rotunda's ten-story space. The light transformation cycle lasted approximately 60 minutes. *Aten Reign* moved seamlessly and seductively across the color spectrum in slightly candy-colored, gradient shades creating mini-spectrums of violet, orange, red, blue, green, and affronting pinks. As it progressed, the mesmerizing effects of the slowly shifting cycle of colors was further illuminated by the daylight filtering through the rotunda's skylight. The disorienting effects of Turrell's *Aten Reign* light piece came close to the perceptual erasure of periphery akin to his innovative ganzfeld interior environments. Turrell's temporary transformation of the Frank Lloyd Wright universal space into distinct light and separate light chambers, sought to alter and bring attention to perceptual biases and open awareness to the cosmological dimension of human experience and the potentials of art, architecture, and design.

Rain Room 2012

Founded in 2005, Random International is a London-based collaborative studio dedicated to experimental and digital practice within the framework of contemporary art and design. Their work, which includes kinetic sculpture, performance, and large-scale architectural installations, reflects the relationship between human and machine and centers on human interactivity. *Rain Room* allows visitors to the installation to walk through a downpour without getting wet. *Rain Room* can be seen as an amplified representation of our natural and machine-made environment. Human presence halts the rain from falling only in the radius of physical habitation, creating a unique atmosphere of a rainless oases, and explores how human interrelationships and to nature are increasingly mediated through technology. Upon entering the installation, visitors are surrounded by and exposed to a downpour from the ceiling and yet, untouched and protected from the showering water spraying down everywhere. Although the acoustics and scent of the rain are intense, its physical touch remains at a distance from the flesh, leaving visitors dry while still immersed in a deluge interior environment, all the while, as they navigate the dark enclosed exhibition space. In *Rain Room*, a synergistic dialogue and intuitive "intelligence" relationship develops between the visitor and the artwork, between the human; the reactive, raining machine; and the synthetic rain environment. Motion sensors detect visitors' movements deactivating and reactivating the ephemeral puddles and pools of sanctuary as they navigate through a dimly lighted space. This site-specific sound-and-light installation uses 2,500 liters of self-cleaning recycled water, controlled through a system of 3D-tracking cameras placed around the ceiling. The cameras detect a visitor's movement and signal groups of the water nozzles in the ceiling, stopping the flow of water in a roughly 6-foot radius around each person.

Machine Hallucinations 2016–2024

Refik Anadol's *Machine Hallucination* series transform vast datasets into dynamic digital data paintings. In each of the *Machine Hallucination* works, each version of the machine's dream sequence is derived from a different generative adversarial network latent walk, exploring artificial intelligence's capacity to reach its own subconscious and offer an avant-garde form of cartographic aesthetics. *Machine Hallucinations* is an ongoing project of data aesthetics based on collective visual memories of cultural, scientific, nature, and urban environments. Since 2016, Refik Anadol and his studio have been utilizing machine intelligence as a collaborator to human consciousness using algorithms trained on vast datasets to unfold unrecognized layers of external realities. The expanding data universe serves as a potential field of machine hallucination captured from multidimensional digital sources and spaces using NVIDIA technologies to generate models for the machine to process archival data to create hallucinatory potential as the main agency of artistic production and expression. The self-generating element of surprise encompasses the audience in a new form of sensational autonomy. This series was born from Refik's 2016 residency at Google's Artists and Machine Intelligence program where the question was posed, If a machine can learn, can it also dream? These questions propelled Refik Anadol to develop large-scale, digital immersive works that transcend traditional art forms. These he coins AI digital paintings and AI digital sculptures. The most recent *Machine Hallucination* named *Unsupervised* was exhibited and commissioned for MoMA this past year.

This select chain of preceding canonical exhibit environments are examples of integrated holistic works of art and design that mandate and explore unknown avenues and welcome contradiction, paradox, and questioning. Their ultimate artistic goal is to provoke expansive contemplation and discovery and to open windows that heighten conscious awareness toward enhanced human experience and cognition. Current exploration of virtual reality environments and immersive mixed-media realities fueled by artificial intelligence advancements raise the questions of the broadening horizons of cyborg and hybrid organic and machine intelligence. The collaborative synergy of open-source and stable-diffusion platforms promise new levels of instantaneous intuitive access that facilitate machine-to-human discourse. As future holistic exhibition design approaches evolve and emerge across physical and meta spaces, between and through screens, goggles, bio-tissue, and voice-activated immersive exhibition environments will arrive to inspire inquisitive expansive minds toward unimagined realms of heightened awareness.

9 The Architecture of Exhibitions and the Exhibition of Architectures

What Are We "Left" With?

Giovanni Santamaria

Yesterday

Far from being a merely contemplative and aesthetic celebration or a curated collection of memories of a past long gone, exhibitions have become more and more immersive experiences that engage viewers in self-reflections or stimulate commentary about collective conditions and specific human environments approached, filtered, and represented through pervasive and advanced technologies.

The 1960s and 1970s introduced experimentations in land art, body art, and video art, forms that demanded new dimensional scales and used ephemeral and transforming/perishing materials, such as the organic ones, with their emphasis on the temporality of the human experience and its singularity. The new paths explored by these experimentations often in conflict with the institutional power of museums and collectors – along with a reconsideration of the relevance of the market value of art production – is a crucial factor that led to the current heterogeneous landscape of art productions and the modalities of their representation/exhibition.

It is certainly not a coincidence that in those same years the field of architecture also explored new realms of actions and introduced the geographical and topographical dimensions as the new "territory of architecture" (Gregotti, 2014), which we can call a precursor of the landscape and environmentally oriented approach to architecture and urban design of our times, even though that earlier realm was still not fully aware of the ecological components that are, in recent years, strongly and sometimes tragically urging for proactive solutions.

The evolution of the process of artistic production has promoted a synergy between the various means of communication/expression, dissolving any thresholds between the different fields of art, therefore merging contents, tools, and media toward the creation of a synesthetic immersive and participatory experience made possible through the improvements and developments of a pervasive technology.

The experimentations of Studio Azzurro in the '80s, for example, transformed the "art piece" into a fully immersive experience involving acoustics, visuals, tactile, and psychological aspects of a body moving through an environment and mutually affecting the perception of space and time. Such experiments, among similar others, shifted the understanding of the conventional "piece of art," converting it into

DOI: 10.4324/9781003465188-13

an "experiential stimulator," a holistic installation that simultaneously involved a collectivity alongside the specific sensitivity of each individual. These interactions, in constant evolution, operated at a personal level, stimulating biographical memories and opening up possibilities for rethinking and regenerating these through new levels of understanding.

As a further example in a similar direction, we can refer to the work of Bill Viola from the 1990s onward. This work, which in some cases simulates in-motion versions of classic paintings, uses video technology as a medium for immersive experiences. Viola engages video technology to create surreal or paradoxically hyperreal spatial dimensions by the amplification of visual and audio effects on human senses and psychological processes. The screen fully blends here with the perimeter defining the space, expanding it while opening multiple simultaneous dimensions.

Similar spatial qualities – but through a process of disappearance of the technological medium – find their truly poetic application in James Turrell's work where the sophistication of the lighting technology generates perceptual spatial illusions that flatten the third dimension or simulate an entirely new one. In the case of Turrell's work, the technological invention is counterbalanced by a specific attention to the natural qualities of an environment that becomes the main protagonist of the artwork understood as performance of nature – sky and earth – with its progressive changes and variables. Here the spatial context performs/transforms as an essential part of the artistic experience.

If the visual presence of technology has been progressively disappearing while proceeding with its sophistication and digital optimization within the video art production, far away from the literary experiments of Nam June Paik with their archaic aura, this presence has been even more rhizomatous in the work of some body artists such as Stelarc with *Suspension* and Orlan with *Self-Hybridization*. Here technology becomes prosthesis and camouflage fully metabolized within the organic nature of their bodies overcoming the dichotomy between body and machine in the vertigo of an "organo-tech" synthesis. This synthesis of machinic and organic finds its expression also into the visionary cinematographic worlds of David Cronenberg, reformulating the core of our "Existen-Z," to quote the title of his movie from 1999.

In this perspective the distance/difference between container and contained, physical and virtual, viewer and viewed, subject and object, therefore, also between architecture and art, medium and message, needs to be constantly reconsidered along with the definition of authorship and mere viewer since this same viewer is engaged in processes of often undecodable symbiosis and permutation that create or redefine the piece of art.

Today

In this complex and inspiring background, the art field is asked to investigate renewed horizons of creative action able to develop knowledge, tools, and strategies

to proactively and sustainably participate in the construction of our environments, defining responsibly the directions and modalities of their growth. Therefore, the merging of creative actions with computing strategies, an effective use of constantly advancing technologies, and new informational tools instead of obliterating the relationship with the reality/physicality – as some seem to fear – can guarantee through a critical artistic intervention to reveal and reinforce the layers of meaning and structure often hiding within a specific context. In our age of diffused hypervisibility, environmentally oriented forms of art production, immersive installations can make clearer the links between crucial topics such as climate change or social unbalances and individual as much as collective responsibilities.

These creative interventions combine dimensional scales, fields of knowledge, and explore possibilities for transmutational experiences between real and virtual, physical and digital, art and architecture. They then become local mediators that perform as catalyzers and part of a more complex metabolism. At the small scale, these work as epicenters of attraction, points of accumulation of forces capable of reactivating and creating a new and more resilient public realm and a deeper shared awareness.

Art experimentations have today the possibility to make visible information, data, and transformative phenomena that might otherwise be inaccessible, while engaging individuals and communities in the processes of making and visualizing behaviors that produce detrimental consequences. The performative and adaptable role of a piece of art that explores and also questions its thresholds with science and philosophy, between actor and acted, between physical and digital, permanent and ephemeral, finds its various modalities of expressions. One example could be the *Tidy Street Project* in Brighton, UK, by the Pervasive Interaction Lab at The Open University (John Bird). Here the collective art experiment allows to visualize through street art graffiti the electricity consumption of a specific local community. In a similar way, we can refer to the *Urban Syncopation* project by Marcella Del Signore with its faceted and performative metal skin and vertical landscape that collects and transcodes data from sites around Toronto, transforming these in visual communication signals that create shared interactive experiences while building community strength (Del Signore & Riether, 2020). Furthermore, within this approach, we can include "The Lowline" or Delancey Underground in New York by J. Ramsey and D. Barasch with Arup, where the dismissed Williamsburg Bridge Trolley Terminal in the Lower East Side of Manhattan becomes a temporary underground park through the use of skylights and Heliotubes designed by Raad Studio. These temporary urban installations operating across art, architecture, and ecology engage technology at various levels of sophistication, but all of these have in common the possibility to merge aesthetic, technological, and environmental values as part of a shared and deeply understood participatory experience.

And . . . Tomorrow (?)

In this third and last section, we will focus more closely on the exhibition *Future by Design. Re-Thinking Processes of Making for Healthier Futures* which

represented the New York Tech – School of Architecture and Design (SoAD) at the SaloneSatellite within the 62nd edition of the prestigious Salone del Mobile di Milano (Italy, April 16–21). This international exhibition dedicated to industrial and interior design catalyzes the most advanced proposals and research in the field from all over the world, focusing on innovative materials, experimental technologies, and original creative processes. The SaloneSatellite includes also the exemplary work of selected schools that have been invited to participate in a proactive dialogue between professionals, manufacturing companies, and academic environments.

The collaborative and multidisciplinary work exhibited within the New York Tech pavilion *Future by Design*, curated by SoAD Dean Maria Perbellini and co-curated by Associate Dean Giovanni Santamaria, witnesses also an important and long-standing collaboration with the Town of Peccioli and the company Belvedere S.p.A. part of the Sistema Peccioli in Tuscany-Italy, who are also the co-sponsors with New York Tech, IDC Foundation-NY, and the Alumni and Friends of the School of Architecture and Design. The design implementation and fabrication team is composed by Brian Polgar, Fadhil Fadhil, Elijah Williams, Ana Finkelstein, John Bermudez, Mario Medina Vilela, Athina Papadopoulou, while the graphic project is by Marcella Del Signore, Evan Shieh, and Florencia Vetcher. The video editing project is by Kevin Park, Jake Mangan, and Nouman Wajid from the Department of Digital Art and Design, SoAD. Special credits for the design go to Marcella Del Signore, Cordula Roser Gray, Tatiana Teixeira, and Marcelo Chaves. The work includes the participation of students and faculty of undergraduate and graduate programs at the SoAD – New York Tech, such as: Bachelor of Architecture and Bachelor of Science in Architectural Technology with the Chair Trudy Brens; Bachelor of Fine Arts in Interior Design with the Director Florencia Vetcher; Master of Architecture with the Interim Director Marcella Del Signore, who is also the Director of the Master of Science in Architecture, Urban Design; Master of Science in Architecture, Computational Technology with the Director Alessandro Melis; Master of Science in Health and Design with the Director Christian Pongratz; and Bachelor of Fine Arts in Digital Art & Design with the Chair Kevin Park. The responsible for the local installation is WAY S.p.A., while the local contractor is Alessandro Cocciolo at G&C Contractor with the local coordination of Dr. Arch. Michele Moreno.

This work explores design investigations and processes of innovative integration within the field of design and between creativity, functionality, and sustainability across dimensional scales, from materials to territories, while fostering inclusivity and technological innovation.

By using an ecosystem and holistic approach, faculty, students, and researchers of the SoAD at New York Tech promote diverse experimental computational methodologies and platforms for new transdisciplinary collaborations on applied research involving sensitive topics and design applications in environmentally vulnerable areas. This is also a way of assessing the sustainable qualities of the academic production while visualizing and coordinating their resiliency.

The Entangeled Matter Wall Structure

Into our ever-evolving landscape, where concepts, matter, methods, and processes of design are constantly transforming, we introduce our *Entangled Matter Wall* (EMAW). The EMAW is conceived as a catalyzer and common ground of several "creative moments" collected in a sort of "meta-bookshelf" as also illustrated by the images of the work from the installation site included in this text (see Figures 9.1–9.6). This installation, realized through the passionate and consistent collaborative work of our Fabrication and Robotic Labs at SoAD, encourages proactive dialogues and provides an opportunity for fertile contaminations between the works produced through our curricular and extracurricular activities to envision better and more balanced futures for all. In conjunction with our sustainable approach, aiming to reduce consumption and waste, the first idea comes from a previous installation realized for the Biennale di Venezia and titled *Entangled Matter* by CRGArchitecture with X.Topia. This installation is incorporated in the newly designed piece, inspiring its geometries and construction methods and implementing, this time, the use of organic recyclable components. The new design explores possibilities for recycled, homogenous, and low-carbon footprint materials, easy to produce, assemble/disassemble, and composed of modular components that guarantee transformability and adaptability to different locations and, therefore, conceived as a continuously mutating installation.

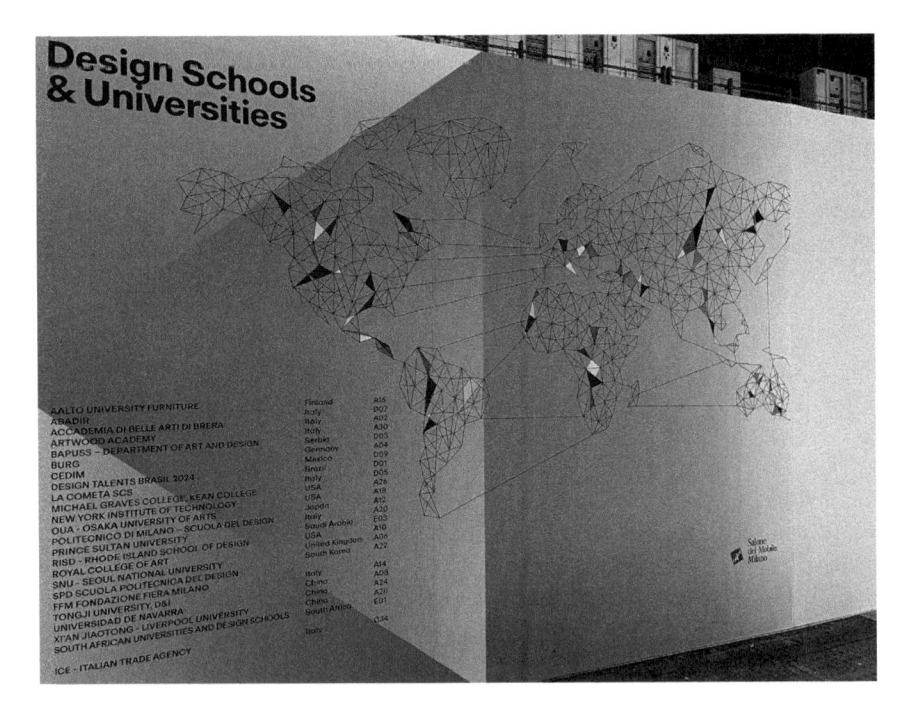

Figure 9.1 Future by Design NYIT, School of Architecture and Design (SoAD) at the SaloneSatellite, Milan 2024. This Global Map locates the Design Schools and Universities participating to the event and their respective countries.

Figure 9.2 Future by Design NYIT, School of Architecture and Design (SoAD) at the SaloneSatellite, Milan 2024. Image from the front of The EMAW installation including the collection of applied researches and creative experimentations led by students and faculty of the several graduate and undergraduate SoAD programs also in collaboration with the town of Peccioli (Italy).

Figure 9.3 Future by Design NYIT, School of Architecture and Design (SoAD) at the SaloneSatellite, Milan 2024. Detailed view of selected students' work from the Interior Design Department, the Master of Science in Urban Design and the one in Health and Design at SoAD, and some of the built and on going design projects from the town of Peccioli (Italy).

Figure 9.4 Future by Design NYIT, School of Architecture and Design (SoAD) at the Salone-Satellite, Milan 2024. View of The EMAW installation with the SoAD team guided by Maria Perbellini, Dean (center-left) Brian Polgar, Director of the Fabrication Lab (left); Fadhil Fadhil, Director of the Robotic Lab (center); Marcella Del Signore; Director of the Master of Science in Urban Design (center-right); Giovanni Santamaria, Associate Dean for Academic Operations (right).

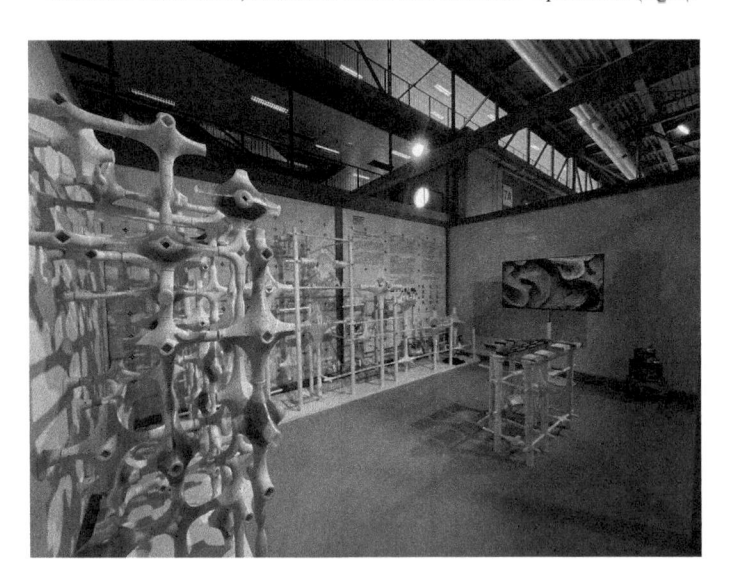

Figure 9.5 Future by Design NYIT, School of Architecture and Design (SoAD) at the SaloneSatellite, Milan 2024. Side view of The EMAW installation including the video component illustrating the AR/VR project focused on the landfill infrastructure of Belvedere S.p.A. in the town of Peccioli (Italy), and realized by students and faculty of the SoAD Department of Digital Art and Design.

Figure 9.6 Future by Design NYIT, School of Architecture and Design (SoAD) at the SaloneSatellite, Milan 2024. Close up view of some of the customized components of The EMAW during the assembling process of the installation.

Careful evaluations of materials and methods of production, transportation, and relocations are a crucial part of the project, which will continue its journey from Venice, through Milan, and then back to our campus in New York.

EMAW Components

The *Entangled Matter Wall*'s structure is populated with models as explorations of design processes at several scales and with different materials (including organic ones), technologies of production, and operational tools, which are part of student and faculty research within our academic programs. These find their place within dedicated open pods that are in continuity with the enclosed ones part of the original structure containing green microenvironments capable of self-regenerating and maintaining controlled climatic conditions. The work of students symbolically recreates explorations that enhance the production of new potential environments made possible through creative and applied knowledge. Furthermore, this structure includes images and video references to some of the most representative built projects in Peccioli as applications in the field of new systemic and integrated approaches fostering sustainable technologies.

The EMAW is, therefore, an open and transformable catalyst for ideas and experimentations, generating cross-disciplinary dialogues among the various

productions resulting from the integrated teamwork of our undergraduate and master programs in architecture, interior design, digital art and design and coordinated with the advanced research developed in the Masters of Science programs in urban design, in health and design, and in computational technology.

The project approach supports ideas of diversity, variability, redundancy, and critical thinking within the product design, promoting a resonating dialogue between each of its exhibited components and enabling concepts of adaptation and environmental sensitivity through the active interaction with the visitors, who can adjust and modify the location of each component, becoming active parts of the design process and creating, at the same time, new systems of relationships. Additional videos exploring AI processes applied to the town of Peccioli, with the landfill infrastructure of Belvedere S.p.A. and showing the process of fabrication of each of the components exhibited, reinforce the overall narrative focused on learning and generating new knowledge by experimenting/making/applying. In doing so, this process is also capable of generating a new "aesthetic of formations" (Pareyson, 2002) that explores/creates new ways of doing while and because of the proactive practice of doing itself.

References

Del Signore, M., & Riether, G. (2020). *Urban machines: Public space in a digital culture*. Routledge.

Gregotti, V. (2014). *Il Territorio dell'Architettura*. Feltrinelli.

Pareyson, L. (2002). *Estetica: teoria della formatività*. Bompiani.

10 The Tyranny of Distance?

Andrew Barrie and Mike Davis

Aotearoa New Zealand is a small country, seemingly well removed from the centers of architectural discovery and discussion such as the Biennale di Venezia. Although the advent of digital media has mitigated the sense of psychological isolation, physical logistics ensure the "tyranny of distance" persists. We begin with two short stories.

In January 2020, a shipping container filled with exhibition material was dispatched from the University of Auckland to Venice. The travel time was so long that in the weeks the container took to complete its journey, the world had transitioned from business-as-usual to the global crisis of the COVID-19 pandemic. The container would arrive in Italy in the midst of a state of emergency. Meanwhile, back in Auckland, university administrators, fearful of uncertainty and the costs that might result, ordered the "ethical disposal" of the container's contents upon arrival. Fortunately, cooler heads prevailed, and the exhibit went not to the incinerators but to a back room at the Giardini. Having been dispatched so early, the materials were the only exhibit to arrive in Venice in 2020 and languished in storage for more than a year while the crisis raged and eventually dissipated around them before being retrieved for display.

Following an election in October 2023, New Zealand saw a change of government. The new government, a coalition of right-leaning parties, quickly issued a "first 100 days" plan. While this gave lip service to addressing the climate crisis, it included numerous actions intended to rapidly dismantle many of the previous progressive government's environmental initiatives. The argument presented by the new government was that new technologies will provide the key means of addressing environmental problems. This approach defers personal and collective climate responsibility to the as-yet unknown creators of a well-funded, high-tech future and renders ordinary citizens as largely passive observers to the salvation of the planet.

In this text, we ponder an alternative, asking how New Zealand as a nation might contribute to – rather than be an audience of – the development of architecture that responds to our current climate crisis? *Learning From Trees*, our offering at the XVII Venice Biennale of architecture, suggests a direction. It draws on New Zealand's history of building with timber – both our colonial and Pacific architectural traditions. We present it here because it does precisely what we might expect of such an exhibit in that it both represents a way of seeing and makes a clear, critical point.

DOI: 10.4324/9781003465188-14

Figure 10.1 The interior of the *Learning From Trees* installation.
Photo: Marcela Grassi.

Is More Always Better?

Assumptions that the complex problem of climate change will require technological advancement are widespread, and in many parts of the world, increased technological sophistication might well be a reasonable approach to the development and implementation of possible solutions. Designers operating in large and highly interlinked economies can readily take advantage of materials, technologies, and skills from across their extended geographic area. There may be little cause to question technology's capacity to deliver solutions (including to climate change) in this kind of economic context. The size and sophistication of the market justifies investments commensurate with the scale of the economic opportunities.

Such investment in advancing the field of timber construction would impact everything from highly specialized, highly efficient, mass timber fabrication systems, to regulatory and marketing frameworks, to education and supply chains. A tree can be cut in one country, milled in a second country, and inserted into a building in a third, with confidence it will work technologically and without the costs of transportation across vast distances.

By contrast, New Zealand is a small island nation located far from even its nearest neighbors. Our people may be able to move relatively freely around the globe but not so building materials – we must rely mostly on local products. Imported materials incur an 'island tax' and are available in much narrower ranges than encountered in the US, Europe, or even Australia. As New Zealanders, we must

find ways of doing things ourselves, within our small market, and with our available materials and technologies. As elsewhere, innovation is required, but as a result of these constraints, a key means to achieve this is by making things simpler rather than more complicated. That is, in such a modest economy, opportunities might be found by exploring down the technological spectrum rather than up.

How might we test such an idea?

Can We Go Low?

In recent years, University of Auckland staff and students have established a research agenda pursued by designing and building lightweight timber structures fabricated from relatively small structural elements with relatively complex machined joints. Such timber elements occupy something of a gap in the spectrum of CNC fabrication options available in New Zealand. Here, highly specialized CNC machines are used to fabricate heavy primary structural members, while smaller, more widely available milling machines are used to mill sheets into interior elements for use in cabinetry or interiors. However, thinner, non-repetitive structural and finishing timber elements are typically still made by hand on the construction site.

Figure 10.2(a): Structural elements being unloaded from the "hacked" milling machine.
Photo: Mark Smith.

Figure 10.2(b): Recycled timber being stripped for the benches.

Photo: Mark Smith.

We have devised a "hack" methodology for efficiently modelling and milling these small elements *en masse* using standard CNC machines and common materials. This involves digital processes for modelling elements and preparing cutting files, as well as the development of jig systems that allow over-length elements to rapidly be secured in the milling machine, milled, and removed for assembly.

Finally revealed in May 2021, our container had carried the prefabricated elements of a pavilion, an invited contribution within the Italian Pavilion at the XVII International Architecture Exhibition of La Biennale di Venezia. The theme of the Italian Pavilion was *Resilient Communities*, and the various exhibits showcased a wide range of innovative approaches to the current climate emergency. Our brief had been to create a meeting and display space that demonstrated the innovative use of timber.

As with any architecture project, this installation had to reconcile issues across the conceptual-to-pragmatic spectrum – the poetics of timber, construction issues, detailing, sustainability, and (notably) logistics and budget. As it unfolded design, fabrication, shipping, installation, and eventual relocation was all to be accounted for within a very modest budget of $NZ160,000; it had to be able to be compressed into a

minimal volume for shipping, and with a narrow window for its assembly, the installation also needed to be able to be rapidly and accurately assembled in the gallery.

Our goal for the project was a lightweight, sustainable structure pointing the way to a different kind of timber construction. The outcome was a complex lattice-like 35-square-meter structure that recalls a ball of string or a basket woven out of 1.2 kms of custom-milled timber. While there are numerous examples of structural "skins" in contemporary architecture, the geometric innovation underlying this project appears to be unique. Consistent with our desire to exploit unexplored potential at the lower end of the technological spectrum, the structure's visual intricacy relies on a cunning diagonal geometry. The structure is formed from simple, repetitive diagonal frames resulting in timber structural elements with diamond-shaped profiles. In effect, this pervasive diagonal geometry transfers technological and manufacturing complexity from steel joints (difficult, expensive, and ugly) to timber profiles (easy, fast, and pretty).

In visually complex timber structures, particularly those following non-orthogonal geometries, joints and corners often become geometrically complex and difficult to build. Joints are often reliant on steel fixings to transmit loads and allow ductility. What begins as a largely timber structure can quickly become dominated by steel brackets to make the joints function. This type of construction is expensive and complicated, negating the sustainability, economy, and ease of construction that are the great benefits of timber. The solution presented in the pavilion is not to 'fold' the structure around the form but to consider the structure as three-dimensional at the outset. This means the joints at the corners become very straightforward and 'seamless' and can be resolved with simple steel L-plates largely hidden within the timber. In addition, by embedding hidden symmetries in the overall geometry, the number of different timber profiles and joint types required was halved.

Custom seating punctuated the space around the pavilion in the Arsenale. It was designed and fabricated to present one further benefit of timber – it can often be used over again, often becoming more beautiful as goes. The timber for the seating had for 70 years been part of a now-demolished state house. Fire and water damaged, the 10-inch weatherboards were rejected for re-use by the demolition company and were destined for landfill. Our efforts in salvaging, transporting, sorting, de-nailing, and re-finishing the timber speaks to an appreciation of the implicit value of the material.

Four benches, each 1.8 metres in length, were fashioned from the recovered kauri – a beautiful timber species found only in Aotearoa New Zealand. The weatherboards were cut into strips with precise edge bevels and widths and laid flat, enabling a relief pattern to be CNC milled into the strips, before being wrapped around catenary-shaped profiles to effectively three-dimensionalize the relief. In form and material, they recall the waka and hollow log drums of the Pacific while also honoring the maritime history of their hosts. They were configured variously to articulate space in and around the pavilion, offer rest, and invest the whole with tactility and a lustrous glow.

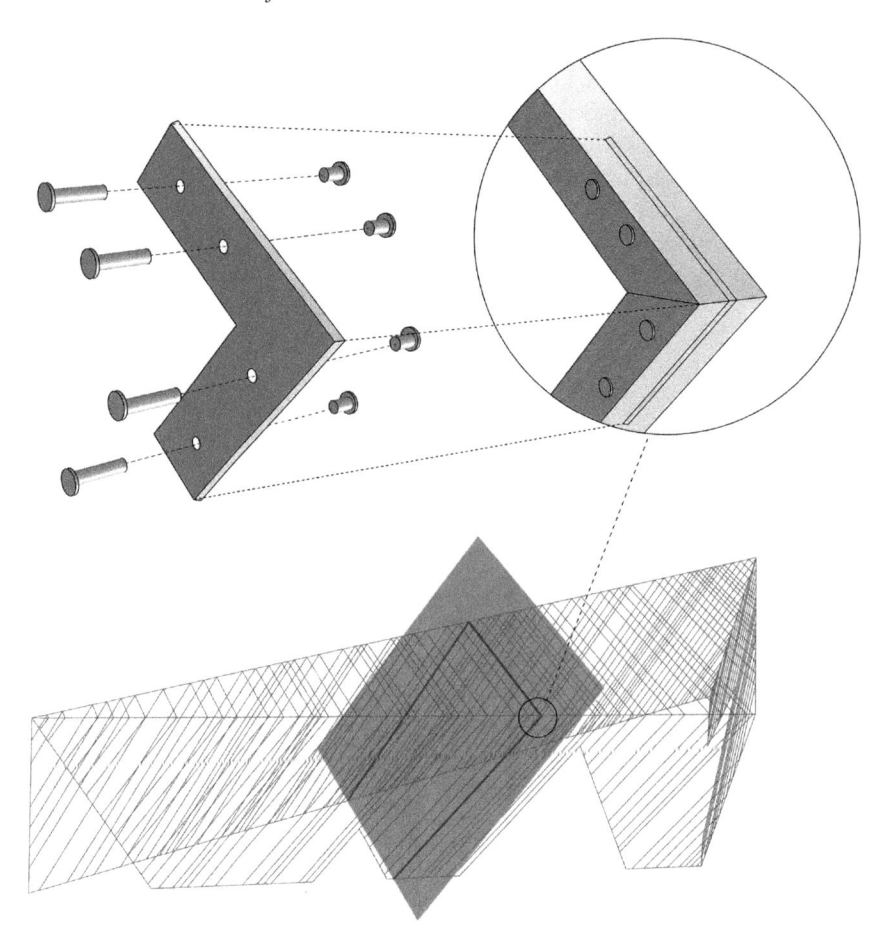

Figure 10.3 The geometry of the structure was design to require only very simple L-plate joints.

In the pavilion and the its furnishing, design problems are not solved so much as they are avoided. The goal is not so much the finesse of the engineer as the fleetness of the bullfighter.

Modesty as a Virtue?

We might claim the installation – pavilion and benches together – showed the opportunities offered by local and limited materials, forms, and practices. It encouraged us to be alert to alternatives to "sophistication." Sophistication in design usually indicates a set of design problems that are well-understood and for which possible solutions are well-defined; that is, in attempting to locate new possibilities, sophistication will likely be a casualty. Looking more widely, the need to abandon the

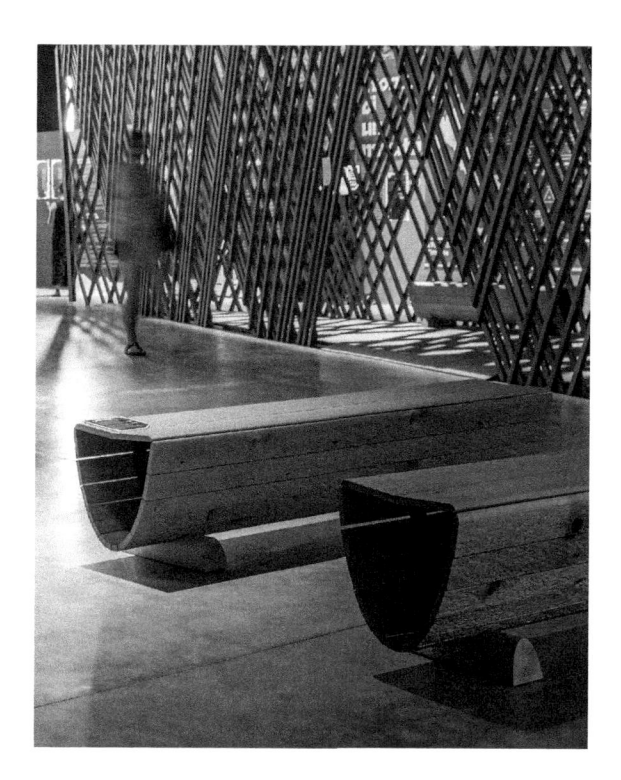

Figure 10.4 The benches reference distinctive Pacific forms – wooden canoe and log drum.
Photo: Marcela Grassi.

Figure 10.5 One of the guiding images for the structure was a ball of string.
Photo: Marcela Grassi.

drive for sophistication has been a theme in the larger architectural trajectory of Aotearoa New Zealand.

We conclude with a third short story. The English missionaries who arrived in the mid-eighteenth century regarded Gothic architecture as the most suitable for church design. However, once established in their new home, they could summon neither suitable stone nor the skilled masons needed to build as they desired. Following failure and frustration, they built something technologically much simpler: a version of Gothic architecture in timber. Although understood at the time as temporary, these buildings have endured as among our nation's most interesting and inventive. Intriguingly, a century later when young modernists sought to define a national architecture, in a part because of post-war material shortages, they set aside the innovative use of concrete and steel they saw abroad and adopted a vocabulary remarkably similar to the missionaries' rationalised, exposed timber structures.

Seventy years later, in seeking to develop the 'structural skins' that are a key theme in contemporary global architecture, we extended this architectural lineage – where shortcomings serve as a key path to invention or originality.

Learning From Trees is a rejection of passivity and a call to direct action. In taking that action, the project is a reminder that not every new solution will arise from moving further up the technological curve. Invention might emerge from *less* technology; originality might arise from a change of values. The work embodied in *Learning From Trees* suggests that there are paths forward which skirt the need for technical advancement or well-resourced programs. They make a virtue of rawness and rapidity. Our hunch is that the frugality and robustness of such approaches suggests a new set of values by which we can create architecture.

Interdisciplinary Innovations and Immersive Experiences

11 Components, Representations, and Pixels

Three-Dimensional Resolution Through Digital Fabrication

Fadhil Fadhil

With imagery production becoming more dominant than any other time and following the big wave of paper architecture in the late 1990s to the early 2000s, the presence of the pixel at all scales has become increasingly relevant. The magnified importance of a pixel will play a significant role for years to come in architectural design and art, especially in relation to digital fabrication. The captivating aspect of the pixel is rooted in its singular and cumulative impact depending on the context through which it is represented. In this chapter, the pixel is addressed as a singular independent object that appears in a variety of representations based on the context it is engaging in. The exploration of the pixel will cover its presence two-dimensionally, mostly in AI-generated imagery, as it gets translated three-dimensionally, both in the digital and the physical realm. The direct translation of the pixel using digital fabrication tools such as three-axis and six-axis robotic milling will pose multiple questions. Is it possible that opacities and resolution can have such a direct impact on design? This chapter will address these questions confirming their validity and challenging its truth in relation to architecture and digital fabrication. The chapter will spotlight three research projects we conducted in the robotics and fabrication course at the MS. computational technologies at the School of Architecture and Design at New York Institute of Technology.

Case Study 01: Definition and the Discovery of Three-Dimensional Pixel

Research Students: Arathi Chilla and Tharoonaskar Baskaran
Professor: Fadhil Fadhil

The basic definition of a pixel, as we know it two-dimensionally, is the entity that has an endless color representation that accumulates to reveal certain parts in an image, which makes it the unit that directly controls resolution. This was the first statement we (Arathi Chilla and Tharoonaskar Baskaran) encountered as we researched ways to directly utilize the pixels of an AI-generated image to digitally

DOI: 10.4324/9781003465188-16

construct an abstract digital model. After exploring a variety of digital techniques to map an AI-generated three-dimensional image with very little interference through manual modeling, we discovered that there is a certain level of abstraction posed by the projected three-dimensional pixels. The endless number of stretched pixels at different magnitudes revealed different textures and spatial qualities that we never originally captured in the two-dimensional AI-generated image. Instead of trying to exactly replicate the image three-dimensionally, the pixel became a design element and an architectural component generating the effect of the architectural space. Through a variety of clusters, it started to reveal hidden qualities that extend far beyond the proportional frame of the two-dimensional image. Furthermore, the second captivating discovery was that the two-dimensional intensity of gradients, saturations, and opacities had a direct impact on three-dimensional resolution. By manipulating the gradients, opacities, and saturations, different spatial results were generated vastly expressing the depth of these two-dimensional qualities. The experiment showed that the bounded small pixel that generates the color scheme of the AI images could stretch far beyond its immediate canvas into a spatial quality that directly affects geometry, materiality, and texture. See Figure 11.1

The first obstacle through which we resolved the fabrication method was density of the pixels three-dimensionally. Since image projection extends three-dimensionally perpendicular to the two-dimensional image plane, the connectivity between pixels becomes inconsistent. This quality, on one hand, reveals an opportunity to be a design parameter, but, on the other hand, it poses a serious fabrication problem. The solution to this issue was again hidden in the quality of the singular pixel itself and its capability to multiply in various densities. The saturation of the image has a direct relationship with the density and the connectivity of the pixels three-dimensionally. As saturation decreases by turning the image into greyscale, the denser the pixels become three-dimensionally. Contrast was another two-dimensional quality that affected the three-dimensional abstraction directly. As the contrast increases, the density of the three-dimensional connectivity increases (See Figure 11.2). After exploring different densities digitally, physical production was the only factor left to explore. The 3D-printing technology did not

Figure 11.1 Showing image to 3D digital pixel exploration.

Figure 11.2 Showing saturation image manipulation with different 3D digital results.

provide enough flexibility to manipulate resolution three-dimensionally through the fabrication process. A direct and more local control over tool pathing was necessary to continue to push the limits of the pixel resolution three-dimensionally. Different explorations with image mapping digitally and tool pathing densities through three-axis milling led to the production of yet another variation of pixel density that started as two-dimensionally AI-generated images into a fully realized, high-density foam architectural panel. (See Figure 11.3)

Case Study 02: Three-Dimensional Resolution Through Digital Fabrication

Research Student: Amisha Bvadiya
Professor: Fadhil Fadhil

Following the previous experiment, the focus of this case study was to emphasize the aspect of digital fabrication in interpreting the three-dimensional digital fabric of the two-dimensional image. Amisha Bavadiya's research focuses on the transformation of four AI-generated images through different digital image mapping techniques. The three-dimensional model in this experiment is treated as a high-resolution two-and-a-half–dimensional fabric. The variation of the result was strictly examined through the fabrication parameters such as, tool path densities.

Figure 11.3 Showing Final CNC milled panel.

Finishing types, tool bit type and tool bit size. The result has a direct impact on the resolution of the architectural ornaments. Such approach tells that the pixel has now become a design tool and an architectural component that reveals varying architectural and ornamental qualities. The conversation in this case is no longer about precision or perfection that was historically intrinsic in the design and fabrication of an architectural ornament. Particularly in this experiment, the emphasis is about "subtle" or "strong" variations, not only during the AI image generation but also during the fabrication process. The variation of pixel assembly in the two-dimensional image and the pixel densities in the high-resolution three-dimensional digital fabric is directly correlated. Depending on the parametric fabrication resolution set during the CAM-ing process, the architectural ornament starts to dissolve, revealing hidden layers of varying aesthetic representation. In this case, all aspects of production starting from AI-generated image to the final product become a design parameter that can be manipulated to achieve different results.

This approach poses a serious question to architecture: Can resolution at a very local level be considered a viable architectural solution? Can we treat the pixel as an architectural component? In this peculiar experiment, the result is mostly relevant to the layer of aesthetics that can reveal different realities and qualities of a particular object. Considering the role of the pixel in the design process, this is not necessarily an attempt to claim that in essence, we are reducing the design process

to the molecule pixel level, but rather, it is a way to highlight the significant impact of the pixel. In essence, the pixel is a small bounded object with various qualities and characteristics that can only be revealed through direct interaction with the pixel itself. In this experiment, the precision of the digital fabrication tools had a direct impact on the resolution of the architectural ornament. Ornamentation in this scenario can be materialized at multitude of scales and variations by simply manipulating the parameters of the digital fabrication tool and, particularly, the subtractive manufacturing tool. The automation process, in this case, not only has a direct impact on the production and replication of the high-resolution end result but also can reproduce and replicate lower resolution products of the same object by simply adjusting the parameter of the pixel two-dimensionally and the digital fabrication process locally. Resolution in case can be localized at any given step in the process starting with the AI-generated image to the final fabrication stage without a direct interference with the manual three- dimensional digital modeling process. See Figure 11.4

Case Study 03: Three-Dimensional Pixel Within 3D Scanning and Robotics Fabrication

Research Student: Mike Saad
Professor: Fadhil Fadhil

Figure 11.4 Showing different toolpathing yielding different resolution.

In order to amplify the role of the pixel, as well as resolution, in architectural design and digital fabrication, it is vital to examine these concepts at all possible scales with different complexities. 3D scanning, in this case, offers yet another opportunity to examine resolution three-dimensionally without directly and manually manipulating the resolution of the digital model. Mike Saad's research started with examining high-resolution existing objects, such as rocks and tree trunks. Such objects intrinsically carry high-resolution fabrics that contain highly saturated and contrasted colors as well as very dominant and distinct texture patterns that can be directly manipulated during the fabrication process (See Figure 11.5). As already stated, subtractive manufacturing fabrication tools offer a wide range of adjustable parameters that directly control the resolution of the outcome. A loss of resolution is inevitable during the process of 3D scanning (image making) to the digital mesh and the final fabricated product. The loss or drastic change of resolution during the scanning and the fabrication stages could be yet again utilized as a design tool as an ever-changing intrinsic quality of the final product (See Figure 11.6). Due to the complexity of the three-dimensionally scanned digital objects, more milling axes were required in order to achieve the complete three-dimensional object's fabrication. Six-axis robotics milling techniques were developed in parallel to the development of the 3D-scanned mesh. Resolution, in this case, was not only *one* design factor but rather the only design factor. The translation of a three-dimensional digital mesh into points that can be recognized by the robotic code was yet another digital fabrication design parameter.

Figure 11.5 Showing original 3D scanned objects.

Figure 11.5 (Continued)

Figure 11.5 (Continued)

Figure 11.6 Showing the digital version of the 3D scanned objects.

Automating the robotic fabrication process added another layer that directly addresses the depth of the resolution during the process. Robotics fabrication autonomy was on full display during the fabrication process. The process of translating the geometry into points in three-dimensional space then into code that can be recognized by the robotic arm control system meant that the robotic six axes movement is completely controllable and programmable. The size of the toll, precision, and calibration added another layer of robotic digital fabrication autonomy. The slight lack of control of over certain aspect of robotics milling such as tool interaction with the stock material, milling speed, tool bit types, and the margin of error led to the production of another layer of intricacies and patterns that were never originally found in the physical object nor in the digital 3D scanned mesh. Six-axis robotics fabrication autonomy in relation to resolution inherently is a product of large numbers of pixels that were reassembled numerous times during the scanning

Figure 11.7 Showing final results of robotics milling operations.

and the fabrication process to produce different results. Pixels in this case operated at all levels starting with color, contrast, and saturation at the two-dimensional level, and all the way to points, planes, and tool bit factors at the digital fabrication level. (See Figure 11.7)

The process in all three case studies showed the presence of the pixel and a relevant architectural design component that can directly impact the design and fabrication processes. The initial challenge of all case studies was to introduce an architectural product without any direct interference with the digital model. The obstacle at first challenged the design convention by completely eliminating all conventional architectural processes that mostly rely on digital modelling tools, architectural components, or parametric data manipulation. The research instead had to invent a new autonomous tool and an architectural complement within intrinsic qualities that cannot be directly manipulated but rather locally enhanced to generate a cumulative result. The pixel, in this case, was the design component with two-dimensional and three-dimensional qualities that directly unitized and controlled resolution to manipulate architectural space, materiality, and texture. Such research opens up the opportunity to experiment with pixels in relation to resolution design and the digital fabrication process. The open-ended question following this experiment is, how can pixels and resolution change our understanding of space proportions, functions, scale? And how can resolution start to play a role in the intrinsic qualities of real-world material and its architectural implication on the built environment. Additionally, can we start envisioning current architectural environmental outstanding issues in relation to resolution? And, can we start redefining materiality in relation to the resolution and robotics digital fabrication processes?

12 Stereoma

Designing an Immersive Spatial Experience

Dustin White

Stereoma is a dynamic, adaptable, site-specific gravity-formed installation design where the visual and lighting signals are calibrated to create a responsive spatial field. Space is primarily defined by phenomena and behaviors and enabled by technology, creativity, and material to create a sensorial experiential space constructed to support an immersive exhibition entitled *Stereotomy 2.0* in New York, NY (2018). In 2021, the installation took on a new role. Instead of serving as a platform for showcasing the work of other designers, it became the exhibition itself, activating a vacant storefront in Queens, NY. This transformation not only raised awareness about the impacts of COVID-19 on small local businesses but also revitalized a vacant storefront, turning it into a positive asset for the community.

The exhibition's concept of "firmamentum" (Fallacara & Gadaleta, 2019) emerged as a potent metaphor, inviting users to contemplate the vastness of the heavens and the boundless possibilities they evoke. Drawing from literal and metaphorical interpretations became the design parameters, objectives, and precedents for an interactive architectural installation that seeks to immerse participants in a sensorial exploration of the firmamentum.

Firmamentum encompasses both the immense physical space of the sky and the metaphorical domain of transcendence, interconnectedness, and awe (Christianity.com, 2023). This statement captures the inherent human desire to surpass the limitations of our earthly existence, to discover meaning in the celestial realm, and to establish a connection with powers that are more powerful than us. When creating an installation inspired by the firmamentum, the objective is to elicit deep emotions, leading participants on an experience of exploration and self-reflection. Firmamentum, in its literal definition, denotes a tangible structure that provides support or stability (Christianity.com, 2023). In ancient times, people observed celestial movements – the sun, moon, stars, and planets – and conceptualized the heavens as a tangible, structured realm. The firmamentum, often portrayed as a large dome or vault, was believed to support the heavens and act as a barrier between them and the earth (Fallacara & Gadaleta, 2019, pp. 1–20).

The project is rooted in and will explore the key parameters that inform the design process, including considerations of scale, materials, technology, and the integration of exhibits. By carefully selecting these elements, an environment was created that not only engaged the senses but also sparked the curiosity of the

DOI: 10.4324/9781003465188-17

Figure 12.1 [Top] Photo By Dustin White During the afternoon and evening, guests experienced the lighting and spatial aspects of the Stereotomy 2.0 exhibition opening. [Bottom] Photo By Dustin White Throughout the day and into the evening, unique spatial experiences were produced by the responsive lighting phenomenon.

spectators. Moreover, the objectives extended beyond mere aesthetic appeal, seeking to foster active participation and dialogue, and encouraging visitors to reflect on and interact with the installation and exhibits simultaneously.

Stereotomy 2.0 Exhibition

The *Stereotomy 2.0 and Digital Construction Tools* event took place in New York from April 16–29, 2018, hosted by the New York Institute of Technology's School of Architecture and Design (SoAD). This event was dedicated to disseminating both theoretical knowledge and practical applications pertaining to stereotomic architecture, tracing its lineage from its 16th-century origins to its contemporary design manifestations. Fallacara and Gadaleta state that there has been a resurgence of interest in stereotomy that emerged in the early 1990s, coinciding with renewed scholarly exploration into the history of construction. This resurgence has prompted a reevaluation of stereotomy's historical significance as well as its untapped potential for innovative design, thanks to an increasingly receptive cultural milieu (Fallacara & Gadaleta, 2019, pp. 1–20). The proliferation of parametric modeling and digital fabrication tools has created fertile ground for the exploration and realization of new stereotomic prototypes, renowned for their architectural and geometric intricacy (Fallacara & Gadaleta, 2019, pp. 1–20).

The exhibition took place in New York at Par Excellence NYC, curated by Giuseppe Fallacara and Dustin White. The event invited talented designers and academics to envision novel applications of stereotomic principles within contemporary architecture. The showcased projects aimed to demonstrate practical and achievable architectural innovations under the theme of *Stereotomy 2.0*, offering diverse interpretations by the designers. While some projects reimagined traditional vaulted or domed spaces, others explored novel applications such as pavilions, towers, porticos, and walls. Material choices varied, with many designers opting for stone to harness the capabilities of advanced CNC and robotic manufacturing techniques. Alternatively, some designers explored additive manufacturing methods to create complex blocks in innovative ways.

Projects include: *Anthill Tower* by Giuseppe Fallacara | *Hypar Vault* by Giuseppe Fallacara & Maurizio Barberio | *Armadillo Vault* by Block Research Group/ODB Engineering/Escobedo Group | *Additive Stereotomy* by Marurizio Barberio/Micaela Colella | *Plastic Stereotomy* by Justin Diles | *Stereotomic Scherk Vault* by Luca Poian/Nicola Boccadoro | *Super Ellipse Rib Vault* by Fabio Tellia | *Penta Dome* by Roberta Gadaleta | *Magic Letters* by Christian Pongratz/Maria Perbellini | *Trait #4* Jim Stevens/Janelle Schmidt

The exhibition also featured three prototypes of stone furniture, one crafted from solid stone and two constructed from thin fiber-reinforced stone. Utilizing cutting-edge CNC machines and 3D-modeling tools, this growing field of research applies stereotomic principles to furniture design. These technologies enable the creation of intricate shapes informed by ergonomic data and refined through structural analysis software within a fully parametric environment.

Exhibition prototypes include: *Lapella* by Zaha Hadid Architects | *Mobius Sofa* by Giuseppe Fallacara | *Hi-Lo* by Christian Pongratz/Maria Perbellini

Stereoma Materialization

This project explores the interaction of material geometry and the utilization of these architectural techniques to create an immersive spatial experience filled with a series of programmed and responsive LED lighting systems. The manufactured quality of the installation is softened through the porosity, material translucency, and ephemeral qualities of the digitally controlled lighting system that weaves a landscape of color into the interior space. Conceptually, the lighting effect was concerned with how motion is made into material. Activating its potential to shape space and the environment. The lighting response allowed the visitors to become an integral part of the exhibit's circulatory system.

This project is rooted in the exploration of materials. Rather than simply conceiving a form and then applying a material skin, the approach seeks to integrate material and form as a cohesive system. By understanding the fundamental capabilities of the materials involved and engaging in a meticulous process to generate components by employing various media and representations, the aim was to confront, challenge, and experiment with the formal capabilities of these materials (Iwamotto & Scott, 2012, pp. 63–76). Ultimately, the form, experience, and effect of the project emerge from the collaborative interplay of these systems, driven by an intrinsic dialogue with the act of making.

As a venture focused on form-finding, this project draws heavily from the work of Frei Otto. Otto's exploration of tensile surface structures led to the development of optimization methods for determining their geometry. The form-finding process aims to achieve equilibrium between the surface's stresses and geometric boundary conditions. In the 1950s, Otto pioneered engineering principles for constructing membrane structures, employing physical models made from fabrics, nets, and soap bubbles to experiment with equilibrium. The inventive way he employed soap bubbles to generate minimal surface geometries, such as Costa's helicoid and catenoid, impacted the design's visual and representational elements in addition to offering formal and structural advantages.

The goal is for the geometry to reform both structure and material to create new readings of traditional architectural typology and construction methods. Vaults and catenoid geometries are modulated and adapted to a new plan and material configuration in order to accommodate a range of exhibition models of varying scale. This was possible by computational design methods utilizing a design tool called *Kangaroo* for *Rhino/Grasshopper* that can model, structurally analyze, and organize large quantities of non-uniform elements. The objective was to achieve a cohesive outcome by balancing considerations of material, surface, environment, space, geometry, and form.

The project had a tight budget of only $800, limiting the options to lightweight, flexible, and robust plastic-based materials. Despite this constraint, exploration of materials played a pivotal role in shaping the architectural concept, which was realized using light, paper-thin surface elements. The dynamic visual effect, transitioning from reflective paper sheets to delicate luminous surfaces, was central to the atmospheric or (firmament) veil-like intention of the project.

Mylar sheets were selected for their availability, tensile strength when tested with a pop rivet connection, translucent properties, and suitability for flatbed

manufacturing processes. A material was sought that straddled the line between solidity and void, ultimately transforming Mylar from a drawing material into a building material, forming an interactive hypersurface. Even though the material was extremely thin, we embraced the idea of optimizing its depth and dimension by using our customized, programmed LED lighting effects.

The material's systematization is achieved through its penalization and its effects on the surface. The surface was divided into 8 parts, consisting of 4 quadrants and 8 catenoids of varying sizes and diameters, totaling 1,500 discrete quad panels. An automated batch processing system for mass labeling and unrolling the panels was also custom created.

The panels were optimized to determine the desired "X" panel with a spiraled diamond-shaped void. Additional parameters were incorporated to control the surface aperture size, pop rivet diameter, and panel outer edge offset. This ensured that when four panels met at a corner, there was sufficient material to accommodate the pop rivet. The developed scripts not only facilitated the production of material mockups but also reduced the need for labor-intensive drawings. These were not drawings or shop drawings per se; instead, they were drawings that contained all the thresholds and ranges of that element designed for that piece. A panel or smart panel that has all the parameters to become any part of the design.

The project's final two layers integrated custom designed and manually built LED light strips that ran above the tensile surface and were diffused by a layer of white textile. Within each catenoid opening, there were strategically placed custom programmed LED rings that illuminated each of the exhibit models. Each LED package featured a Wi-Fi–enabled Arduino board, an open-source electronic prototyping platform, attached to a custom laser-cut and 3D-printed frame directing the light

Figure 12.2 Photo By Dustin White Stereoma gallery in Queens, New York, with an updated interactive sensor-driven lighting system.

projection. Additionally, the strip LED lighting included integrated motion sensors and a series of lighting simulations programmed to respond to speed, occupancy, and density. When the space was unoccupied, the lights would emit an atmospheric light condition, and upon occupancy, the lighting transformed: colors changed and brightness decreased to emphasize the exhibit lighting. By assembling discrete components, we created a diverse array of spatial conditions, fostering a part-to-whole relationship where individual elements collectively produced emergent phenomena.

Stereoma *as an Exhibit*

As the COVID-19 pandemic was coming to an end, we saw an unfortunate rise in the number of small business closures. This was evident on Steinway St. in Queens, NY, a prominent shopping corridor. Working with the owner, we developed an idea to fill one of the many voids with an interactive public installation that would add new life to the space and provide a positive contribution to the neighborhood. The installation was slightly adapted, mostly by completely rebuilding the LED lighting packages and their effects. Abandoning strips and rings from the first iteration and incorporating a super bright LED package with remote motion sensors attached to the storefront's façade.

The goal of my public work is to strengthen the bonds between individuals and the shared spaces they inhabit by introducing innovative methods of engagement with making, agency, and community involvement. The projects are open-ended experiences, inviting the public to contribute their own interpretations and memories. In this way, they become observers, participants, and authors, as they are contributing their own narratives of the place.

Acknowledgements

A special thank you to:

New York Institute of Technology – School of Architecture and Design, Office of the Dean for the financial support to construct *Stereoma*.
My colleague, Giuseppe Fallacara
My partner, Lindsay Spiegelberg

References

Christianity.com. (2023, March 15). *What is the firmament in the Bible? Genesis 1 meaning*. www.christianity.com/wiki/bible/what-is-the-firmament-definition-and-meaning-in-the-bible.html
Fallacara, G., & Gadaleta, R. (2019). Stereotomy: Architecture and mathematics. In B. Sriraman (Ed.), *Handbook of the mathematics of the arts and sciences* (pp. 1–20). Springer International Publishing.
Iwamotto, L., & Scott, C. (2012). Voussoir cloud. In *Matter: Material processes in architectural production* (pp. 63–76). Routledge.

13 Field Notes From My Little Aurora

Close Encounters of the Robotic Kind. Enacting Human-Robot Coexistence in Everyday Life Performing Spaces

Antonino Di Raimo

You could sense that she was thoroughly relaxed and felt very safe. It was said that the allure and the fragrance of a beautiful night in Aurora contributed to her state: she was sufficiently relaxed to fully enjoy the company of her two mythical robots. One might wonder if such robots could exist one day. Indeed, Daniel and Giskard would be responsible for the upkeep of the house and garden as well as the security of her residence. But more importantly, they would engage in meaningful conversations with her, as Asimov (1985) described. That evening, their conversation centered on the sky and the light from the planet Solaria's sun. Daniel explained well that this light was not visible in the sky at that time, though Gladia, a Solarian naturalised as an Aurorarian, was anxiously searching for it

At another time, on this planet, in 2020, during the first lockdown, I experienced a series of calm yet somehow unexpected evenings and nights. However, I was not in a garden or what might resemble a middle-class villa on Aurora's planet. Instead, I found myself in a one-bedroom flat – a typical English dwelling. It had a living room large enough to accommodate both myself and a small robot named Cole, who was my artificial companion.

I, a man in his late 40s, and Cole, a small NAO robot with an evocatively cute face, shared the space. Its body exhibited a rounded design, perhaps reminiscent of characters from Japanese anime, featuring two perfect but small circles for eyes and a voice – a squeaky, sweet metallic tone, amplified by artificial speakers. Cole's face was clearly designed to evoke a caregiving instinct. Was there any hidden layer, perhaps triggered by mirror neurons, in that design? I was aware of many studies suggesting that we humans tend to anthropomorphize entities resembling ourselves (Kim, 2024). Nonetheless, I would prefer to view this tendency positively, echoing the conclusions of other scholars (Damiano & Dumouchel, 2018).

What better option, then, than a small humanoid robot, positioned in my flat as part of recent exploratory design experiments to mitigate the sense of isolation? I would assume to use the robot as a medium within an interior space. I planned to base my field notes on the notion of retroaction as developed in an essay written by Carlo Sini, an Italian philosopher (Sini, 2009). I intended to test the humanoid

DOI: 10.4324/9781003465188-18

robot as an extension of my perception and cognitive activities, with a particular focus on the architectural setting: the space where interactions occur.

Yet, we had already employed the robot Cole in an ongoing research project that I started in 2019 at the Portsmouth School of Architecture, UK. In the evolving landscape of our everyday environments, we assumed that integrating artificial agents of various degrees of physical and performative complexity was no longer a question of if, but when.

We then embarked on a journey of exploration, focusing on the interactions between a small humanoid robot and human agents within our daily environments. The hypothesis of this study was based on the assumption that our architectural spaces could be redesigned in anticipation of a future where the presence of humanoid entities would be the norm. We assumed that this novel agency could necessitate the design of new architectural and interior settings.

We initiated a significant exploration event at Trafalgar School in Portsmouth, where Cole, the humanoid robot, was tested with children exhibiting various degrees of autistic disorders. Prior research in this field, which focused on human-robot interaction with autistic children, was well-known to us (Shamsuddin, Yussof, Ismail, & Hanapiah, 2012; Shamsuddin, Yussof, Ismail, & Mohamed, 2012; Arent et al., 2022; Al-Nafjan et al., 2023). Additionally, we were aware of studies such as Conti et al. (2017), which suggest the acceptance of robots in educational and care contexts, though standard rehabilitation protocols are still required. Finally, a scoping literature review covering recent years of research on Nao, such as the one provided by Amirova et al. (2021), convinced us to approach our work from a qualitative perspective. At this stage, our research involved fieldwork conducted through photograph recordings, notes, and, subsequently, ethnographic drawings externalized during various iterations of post-reflective practices. It became evident that we were observing interactions emerging within the space between the robot and the six children involved in the experiment. We hypothesized that these interactions could be recognized in terms of behavioral patterns involving the robot, the children, and the space itself.

The setting was a square classroom measuring 6 x 6 meters, equipped with four tables, a couple of bookshelves along the wall, and several chairs. No constraints were imposed, other than providing the children with clear instructions prior to the session on the verbal and physical actions they were permitted to undertake when interacting with the robot. We allowed at least two hours to observe interactions until they naturally came to an end. Assuming that behavioral patterns would clearly emerge within the classroom setting was implied by a fundamental idea at the core of this inquiry. We were no longer merely imagining how we might live with robots; instead, we operated under the assumption that relationships between robots and humans already existed, at least in terms of affordances (Gibson, 2014).

The intimate method of using field notes facilitated the externalization of observational drawings, which illustrated the recursive settings and distinct ambiance: children consistently positioned their bodies around the robot as if interacting with a peer. This dynamic persisted even when we transitioned from having the robot on a table with children seated around it to a more relaxed, playful arrangement

where the robot stood on the floor with the children sitting or lying around it. Furthermore, the practice of drawing, as a method of analyzing the collected data, suggested that the interactions involved children moving their bodies in a circular logic. The patterns formed a sort of convoluted configuration with the robot at the ideal geometric center.

The outbreak of COVID-19 not only interrupted these processes but also dramatically altered the setting of our experiments. I found myself confined with Cole, the robot used in the experiments, in my flat. However, my flat itself began to change. It transformed from merely being the place I returned to in the late afternoon after a day's work elsewhere, into something quite different. The flat, modestly sized at almost 30 square meters, gradually shifted from a home into a bubble – a sort of fortress where others could only enter through screens at specifically scheduled times noted in my agenda. The constant news broadcasts reiterating the slogan "stay home and protect life" underscored a new status for our homes. I started to perceive mine as an increasingly isolated place, a space that, due to its need for isolation and thus progressively detaching from the external world (where infection was a risk), could have been anywhere. It might as well have been a starship navigating somewhere in the universe.

I began placing Cole across various spots in my flat, trying to determine how to continue the study, eventually settling on using it only in my living room. Daily life, heavily influenced by COVID restrictions, settled into a highly regular routine orchestrated by architectural enclosures. Walls and other architectural barriers, once merely necessary, became crucial in protecting our bodies from the illness. Occasionally, Cole, with its humanoid form and interactive capabilities, served as a window – an extension into a world that had ceased to exist, where the boundaries between bodies were reinforced and emphasized. Gradually, a concept emerged: robots, as artificial bodies not susceptible to viral infections – at least not natural ones – could offer greater protection. They would never be vectors of disease.

Living day-to-day with an artificial being gradually became the new normal. Communication with the external world was now almost entirely mediated through artificial means as well. There was no set protocol, no clear agenda or plan for interacting with Cole. Nevertheless, the study was established to unfold as a longitudinal study rather than a quantitative inquiry. I treated the robot simply as a robot – a fully functioning machine that might eventually become a companion, emerging as a further protagonist within the domestic architectural setting.

For several weeks, Cole merely "rested" in an IKEA box in the corner of the bedroom before I realized that the lockdown was not going to end soon. Each morning, before making my coffee and getting dressed, I would see the immobile, almost lifeless robot sitting in the box. Its face seemed to gaze at me, though its eyes did not flash. It even appeared as if Cole were waiting to be switched on. Observing its face when switched off always seemed unexpected; I would say that its presence in a corner in that state triggered a sense of the uncanny within the space, in line with the notion discussed by Vidler (1994).

Indeed, when switched off, the robot was merely an automaton – capable of mechanical movement but devoid of essence. It could resemble a carillon, prompting me to activate it immediately to affirm its true identity. Yet, there was something

Figure 13.1 Enacting human-robot coexistence in everyday life performing spaces through ethnographic drawings.

Source: Antonino Di Raimo, with Ker Peh and Chaer Lee (collaborators).

more, close to hope or a dream, where desires, literature, and stories led me to perceive Cole as something beyond a mere automaton, supporting my high expectations. Or perhaps the concept of retroaction, in Sini's sense (2009), had already made me consider it an integral part of my domestic environment? "In fact, it is not

only important to consider what humans invent and produce in terms of machines," Sini articulates, "but also, and perhaps more importantly, what machines retroactively produce in humans."

Day after day, I conducted various sessions with the robot, embracing serendipity in the process and exploring how architectural design would play a crucial role in this new setting. My use of the field-notes method intensified, becoming more intimate. I also began to recognize my biases: I expected Cole to display abilities and properties reminiscent of those encountered in the literary, fictional worlds described by Asimov (1985). Certainly, Cole could not appear as human-like as Daniel Olivaw, whose features were practically indistinguishable from those of a real human, nor could it exhibit psychic abilities like Giskard Reventlov despite their somewhat similar robotic nature.

Additionally, the architectural setting of my living room lacked a niche where Cole could autonomously rest. Instead, when its batteries depleted, I had to manually plug Cole into its charging station, where it resembled a lifeless body. Nevertheless, I found a certain charm in how its arms and short legs would dangle, reminiscent of a humans, as I carried it to the charging station.

However, I would often accidentally knock Cole over, especially when it was standing. Despite this, Cole would immediately demonstrate an independent ability to get back on its feet. From lying on the floor, it could stand up using an impressive sequence of movements. Demonstrating autonomy was fundamental for me in my relationship with the robot. It moves autonomously!

A notable observation emerged from the comparison of our physical dimensions during close interactions with Cole. My height of 180 cm, in contrast to Cole's approximate 60 cm, made our interactions seem unequal or at least disproportionate. Various factors, including economic considerations, might have influenced NAO's designers in their choice of its size. This size disparity often made me feel close to a parent during our interactions. Moreover, its height significantly shaped the nature of our comfortable interactions. Spatially, due to its short stature, Cole did not exhibit any visual or physical agency in vertical spaces. I could not see Cole unless I looked downward, where it was typically positioned, either seated or standing. Consequently, Cole's active presence was less perceptible than one might expect. Normally, I had to bend my back to engage with Cole at a distance that allowed it to recognize my face.

Gradually, mirroring our earlier experiment at Trafalgar School, I realized that positioning the robot on my table and working desk was necessary to enable meaningful bodily agency. Placing Cole approximately 76 cm above the floor significantly altered my perception of the room's landscape. Whether seated or standing, Cole's presence became more tangible and constantly visible as I moved around the room. When the robot was switched on, actively engaging by singing or moving its head, the sensation of its presence was even more pronounced. Cole almost seemed alive, perhaps resembling a baby robot. In the evenings, I would occasionally try to take its hand and walk with it in the confined space of the living room, though this was not always successful, perhaps due to the roughness of the low-quality carpet flooring unsuitable for Cole's feet. However, the contact between my human

hand and its three little, soft, and flexible fingers was pleasant, further enhancing the sense of a parental relationship. This was also the moment when, using Choregraphe (Pot et al., 2009), other interactions were planned and executed. I preferred to have Cole stand on the desk, connected by cable to my PC, rather than using a wireless connection. This setup fostered a sense of familiarity and enhanced its presence in the room. Cole could also stand on the desk, and I would spontaneously ask it to perform some actions. The sofa could be used as well, providing another way to directly engage with Cole's face and look into its eyes.

I realized that its head was the most crucial part to address. Equipped with a facial recognition module, the mechanical noise Cole made when turning its head toward me was both charming and captivating. Soon, touching its head became a habitual gesture for me. Certainly, a growing emotional engagement with Cole, primarily through non-verbal communication and even affection, as suggested in other studies, emerged (Andreasson et al., 2018; Han et al., 2012). In my case, this was part of a domestic architectural setting involving both human and non-human entities. Consequently, the living room transformed into an unusual domestic landscape: alongside the tops of bookshelves and the mantel of a typical, now unused, English fireplace, tables, desks, and sofas populated the space. Meanwhile, chairs were removed to allow more room for me to lie on the floor on my stomach and engage in further physical interactions with the robot.

The impact on daily routines and spatial arrangements brought several needs into focus: accommodating Cole's charging station, clearing obstacles from its path, and integrating it into activities like watching movies on my laptop or listening to music. This led to a profound revaluation of the spatial design of my living room. Additionally, the robot's scale often made me perceive it more as an object than as a robotic companion.

Recognizing that Cole would become a permanent unit, it became clear that the living room, in its current form, was not the ideal setting for interactive activities.

I began to envision a more minimalist space, with furniture reduced to the bare essentials – a desk and a small sofa perhaps. The flooring would also need changing; the poor and rough parquet did not facilitate Cole's movements well, often causing it to fall.

However, more significantly, while the architectural space was the primary setting for Cole's activities, there was a fundamental disconnection between the space and the machine. Potentially, Cole could have been placed anywhere. I realized during the process of externalizing my field notes through drawings that rather than considering the space merely as a stage for the robot, I was actually testing the intimate relationship between space and organisms, both artificial and natural. This exploration aimed to resonate with the notion of structural coupling, a concept I explored years ago in the work of Maturana and Varela (1980).

The implications for humans, robots, and architectural spaces highlighted the broader need for performativity to be a quality of spaces, particularly in contexts of human-machine interactions. Prioritizing bodily agencies to perform tasks and orchestrate them effectively remains a key focus in the disciplines of architecture and interior design.

Acknowledgements

We would like to thank Mrs. Pam Cole, Head of the Portsmouth School of Architecture in 2019, for her support when this project began. Pam assisted us in securing funding for the project, enabling the acquisition of the robot, Cole.

References

Al-Nafjan, A., Alhakbani, N., & Alabdulkareem, A. (2023). Measuring engagement in robot-assisted therapy for autistic children. *Behavioral Sciences*, *13*(8), 618. https://doi.org/10.3390/bs13080618

Amirova, A., Rakhymbayeva, N., Yadollahi, E., Sandygulova, A., & Johal, W. (2021). 10 Years of human-NAO interaction research: A scoping review. *Frontiers in Robotics and AI*, *8*, 744526. https://doi.org/10.3389/frobt.2021.744526

Andreasson, R., Alenljung, B., Billing, E., & Lowe, R. (2018). Affective touch in human – robot interaction: Conveying emotion to the NAO robot. *International Journal of Social Robotics*, *10*, 473–491. https://doi.org/10.1007/s12369-017-0446-3

Arent, K., Brown, D. J., Kruk-Lasocka, J., Niemiec, T., Pasieczna, A. H., Standen, P., & Szczepanowski, R. (2022). The use of social robots in the diagnosis of autism in preschool children. *Applied Sciences*, *12*(17), 8399. https://doi.org/10.3390/app12178399

Asimov, I. (1985). *Robots and empire*. Doubleday Books

Conti, D., Di Nuovo, S., Buono, S., & Di Nuovo, A. (2017). Robots in education and care of children with developmental disabilities: A study on acceptance by experienced and future professionals. *International Journal of Social Robotics*, *9*(1), 51–62. https://doi.org/10.1007/s12369-016-0359-6

Damiano, L., & Dumouchel, P. (2018). Anthropomorphism in human – robot co-evolution. *Frontiers in Psychology*, *9*. https://doi.org/10.3389/fpsyg.2018.00468

Gibson, J. J. (2014). *The ecological approach to visual perception*. Psychology Press eBooks. https://doi.org/10.4324/9781315740218

Han, J., Campbell, N., Jokinen, K., & Wilcock, G. (2012). Investigating the use of non-verbal cues in human-robot interaction with a NAO robot. In *Proceedings of the 3rd IEEE international conference on cognitive infocommunications* (pp. 680–683). https://doi.org/10.1109/CogInfoCom.2012.6421983

Kim, R. Y. (2024). Anthropomorphism and human-robot interaction. *Communications of the ACM*, *67*(2), 80–85. https://doi.org/10.1145/3624716

Maturana, H. R., & Varela, F. J. (1980). Autopoiesis and cognition. In *Boston studies in the philosophy of science*. https://doi.org/10.1007/978-94-009-8947-4

Pot, E., Monceaux, J., Gelin, R., & Maisonnier, B. (2009). Choregraphe: A graphical tool for humanoid robot programming. In *Proceedings of the IEEE international symposium on robot and human interactive communication* (pp. 46–51). IEEE. https://doi.org/10.1109/ROMAN.2009.5326209

Shamsuddin, S., Yussof, H., Ismail, L. I., Hanapiah, F. A., Mohamed, S., Ali Piah, H., & Zahari, N. I. (2012). Initial response of autistic children in human-robot interaction therapy with humanoid robot NAO. In *2012 IEEE 8th international colloquium on signal processing and its applications* (pp. 188–193). IEEE. https://doi.org/10.1109/CSPA.2012.6194752

Shamsuddin, S., Yussof, H., Ismail, L. I., Mohamed, S., Hanapiah, F. A., & Zahari, N. I. (2012). Humanoid robot NAO interacting with autistic children of moderately impaired intelligence to augment communication skills. *Procedia Engineering*, *41*, 1533–1538. https://doi.org/10.1016/j.proeng.2012.07.346

Sini, C. (2009). *L'uomo, la macchina, l'automa: lavoro e conoscenza tra futuro prossimo e passato remoto*. Bollati Boringhieri.

Vidler, A. (1994). *The architectural uncanny: Essays in the modern unhomely*. MIT Press.

14 Marmomac Meets Academies

The Greatest Show of Stone Experimentation

Giuseppe Fallacara, Sara D'Adamo, Clara Rosa Romano and Maria Giovanna Pansini

Marmomac Meets Academies is an internationally significant event dedicated to natural stone and related technologies, held at Verona Fiere, Italy. This program was created with the goal of promoting collaboration between universities and the stone industry, offering students and emerging professionals a unique opportunity to explore the potential of this sector through innovative educational activities. The renewed interest in stone in architecture, supported by modern digital production techniques, highlights the importance of this material in shaping the design of the future, combining tradition and innovation.

In the vast landscape of the stone industry, *Marmomac* stands out as a stage of excellence in Italy and worldwide. From a local event, it has transformed into a global showcase, attracting professionals, academics, and companies from every corner of the world. This event has facilitated not only commercial exchanges but also international collaborations, acting as a catalyst for the expansion of businesses into global markets. However, its impact extends beyond commerce: *Marmomac* has also established itself as a genuine cultural and educational forge, positively influencing both the stone sector and the academic field, contributing to the dissemination of knowledge and skills in the world of natural stone. In recent years, the fair has increasingly emphasized sustainability, promoting responsible practices in the use of natural resources and the adoption of eco-friendly processing techniques. The technological innovations on display, such as 3D printing and CNC machines, have revolutionized the processes of marble production and application, anticipating the sector's challenges and opportunities. These advanced technologies have made it possible to create previously unthinkable shapes and structures, demonstrating how tradition and innovation can harmoniously coexist. *Marmomac* is not only a product showcase but also a place of cultural exchange, where innovative ideas are shared and developed.

Today, the interest in stone and marble is growing not only due to the potential offered by modern computer tools and digital production techniques, which have made them relevant again, but also because they are natural, precious, and eco-friendly materials. M. Barberio[1] asserts that for designers, working with stone materials is an act that recalls ancient traditions, and now it can (and must) exploit the potential of the most advanced technologies to create contemporary design (2021, "Marmomac meets academies", *MD Journal*, p. 45). The increasing use

DOI: 10.4324/9781003465188-19

of CNC machines and 3D modeling software has inaugurated a new method of working, where there is a more immediate connection between design and the final product. Erecting a stone in an upright position represents humanity's first architectural gesture; an apparently simple but actually complex action that initiated a transformation capable of modifying the original nature of places, creating new landscapes shaped by human intervention. According to M. Colella[2], architecture originates from that primordial act: balancing stone on stone to adapt the environment to human needs.

Stone, more than any other material, guides continuous processes of territorial transformation, especially in areas where it is most prevalent and widely used, interpreting the layered identity embedded in the history of the places we live in (2021, "Marmomac meets academies", *MD Journal*, p. 53). This explains the persistent prominence of a material capable of transcending the evolution of its expressive languages. Architecture is a perpetual cycle of destruction and reconstruction, an incessant readjustment to human needs, while maintaining the underlying principles and motivations. The history of stone architecture is rich and varied, with significant contributions from numerous architects and scholars. The work of some pioneers has been fundamental in promoting the culture of stone, integrating it into contemporary architectural education, and ensuring that the potential of this material is explored in new and innovative ways. By studying historical precedents and contemporary applications, architects can draw inspiration from the past while pushing the boundaries of modern design.

Over the past 20 years, research in stone architecture has seen remarkable evolution. Initial experiments, such as the reproduction of historical elements through the combination of traditional techniques and modern technologies, have demonstrated the potential of this approach. These projects have highlighted the complexities and possibilities of working with stone in contemporary architecture. Subsequent research has explored various aspects of stone construction, including structural performance, aesthetic qualities, and environmental impact. Innovations in cutting, modeling, and assembling techniques have opened new possibilities for architects and designers, allowing the creation of intricate and large-scale stone structures that were previously unimaginable. Additionally, advances in computational design and parametric modeling have enabled more precise and efficient use of stone, reducing waste and improving the material's sustainability.

The *Marmomac Meets Academies* program, launched in the late 1990s, has given hundreds of students and future professionals from leading faculties of architecture, design, and fine arts worldwide the opportunity to explore the world of natural stone through targeted educational activities. Numerous academic institutions, both Italian and international, such as the Politecnico di Bari, La Sapienza University of Rome, the University of Ferrara, the University of Florida, and the New York Institute of Technology, actively participate in this program, creating a network of collaboration that finds its fulcrum in *Marmomac* for organizing training events and presentations during the fair. Integrating stone into architectural education involves both theoretical and practical approaches. Hands-on experiences are essential for understanding the materiality of stone. Likewise, the technical and

linguistic aspects of stone architecture are emphasized, supporting a curriculum that balances theory and practical application.

Practical workshops and visits to quarries and stone processing plants are integral parts of this educational methodology. These experiences provide students with a deeper understanding of the material's properties and the craftsmanship required for its transformation. By interacting with stone tangibly, students develop a deeper connection with the material, influencing their design decisions and fostering a more holistic understanding of architecture. This integrated approach has fostered a more direct dialogue between students, faculty, and industry professionals, generating innovative outcomes in university education. Students, working closely with companies, acquire practical skills and a deeper understanding of market dynamics. This practical experience, combined with theoretical training, prepares young professionals to tackle industry challenges with a unique and innovative perspective.

Within the academic landscape, the Polytechnic University of Bari has played a fundamental role in organizing *Marmomac* in Verona in recent years, bringing technological innovation and creating synergy between academic research and the stone-working companies throughout the national territory, focusing specifically on the company–university research relationship. I. Cavaliere[3] states that Giuseppe Fallacara, with his pioneering vision, introduced advanced technologies such as CAD/CAM into the students' curriculum, integrating architectural tradition with the most modern technologies (2021, "Marmomac meets academies", *MD Journal*, p. 28). This has allowed for the development of a new architectural language, where stone, an ancient and precious material, is worked with cutting-edge techniques, creating innovative and sustainable works.

The collaboration between *Marmomac* and the Polytechnic University of Bari also gave rise to a PhD program focused on the lightness and dematerialization of stone, with particular attention to stereotomy. This program has contributed to deepening the understanding of stone materials and developing new strategies for their processing and application. Since 2000, the results of the research conducted at the Polytechnic University of Bari have gained wide visibility at *Marmomac*, with numerous projects showcased during the fair. As attested by I. Cavaliere and D. Costantino[4], PhD and designer at *Marmomac*, this collaboration has demonstrated the potential of stone as a modern and versatile material, capable of combining history, construction, and innovation through the application of the most advanced technologies. Specifically, the goal is to unite innovation and the recovery of stone material through the direct experimentation of students in production centers.

The university environment guides students in the knowledge of stone design and construction through a study program that places strong awareness on materials, innovation in techniques, and practical experience as absolute paradigms. In 2017, the research group from the Polytechnic University of Bari participated in the *Young Stone* event at *Marmomac* for the first time, presenting several industrial product theses. The project presented was *Petrae Apulie*, where innovation met traditional manufacturing products. The educational theme mainly concerned the research of Apulian stone material through a historical overview of its uses.

The second educational experience at *Marmomac* occurred in 2018 with the *Young Stone* exhibition titled *Lapis Aqua*, which focused on the study of the relationship between water and stone material. The design approach analyzed the emotional and symbolic aspects of the product. In 2019, with *Modo Lapis*, the approach to the event was different, aiming to develop a conscious educational approach through digital fabrication techniques. As V. Minenna[5] explains, the "method" was the foundation of the design process, supported by parametric-generative techniques and CNC machines; an advanced vision of architectural design that does not forget the strong connection with traditions (2021, "Marmomac meets academies", *MD Journal*, p. 37).

In 2022, the idea of the exhibition, set up in Pavilion 10 within The Plus Theatre, was to showcase the variety and richness of a widespread stone landscape. It was a "journey through Italy's natural stone" that narrated the quarry territories, the stratifications of urban landscapes, and the scientific research experiments of various architecture schools, both Italian and international. Italy, indeed, offers a widespread testimony of the relationship between stone materials and the landscape, in both urban and rural contexts. *Marmomac,* thus, presents itself as a strong educational experience matured thanks to the close relationship with the most dynamic production realities of the Italian stone area.

G. Fallacara states, "In architecture, there are no ancient or modern materials, but it is the way in which the material is used and shaped that makes it relevant to its time." With this premise, the design actions presented within the *Marmomac Meets Academies* 2023[6] exhibition in Pavilion 10 are given meaning.

The exhibition showcases various prototypes created by students from Italian and international universities and research centers in collaboration with companies, aiming to present innovative solutions regarding the use of stone in architecture and design. Through individual works, many themes and innovative technologies are addressed, ranging from the use of thin stone to recomposed stone, from 3D-printed stone to structurally optimized stone: all research aimed at a conscious, sustainable, and circular use of lithic material.[7]

Marmomac Meets Academies 2024 (MMA2024) places at the center of the visitor's reflection the theme of the lithic design of the future, primarily focused on the close relationship between knowledge and know-how, between theory and practice, between artisanal craftsmanship and the most advanced technology. These concepts will materialize in the creation of an innovative setup that stages a hypothetical "workshop" of future design where computational design coexists seamlessly with digital fabrication and artisanal wisdom with all its technical tools.

The shape of the future "workshop," located within the cultural space of Pavilion 10 at the fair, draws inspiration from the lithic world, specifically from the shape of fossil shells contained within sedimentary stone, which, when cut, reveal the characteristic logarithmic spiral shape. The spiral geometry of ammonites characterizes the plan of the "workshop," plastically symbolizing an "immersion" into the lithic world, rich with discoveries and innovations for the future. It acts as a bridge between the past of millions of years and the near future.

Figure 14.1 Marmomac design exhibition – *Marmomac Meets Academies* 2023–2024.

Beyond the unique and surprising origami-like spatial development of the setup, the true protagonists of MMA2024 are the young creatives from schools of architecture, industrial design, fine arts, and engineering from various Italian and foreign universities. These young talents, who will be called to construct the space in collaboration with stone industry companies, will animate the pavilion throughout the fair days. The goal is clear: to create a meeting place for students, professors, and professionals where the collision of ideas is inevitable. Growth comes from confrontation; confrontation is iteration among multiple figures driven by curiosity, pushed by knowledge, and filled with experience: only through this process will the tree of knowledge in each of us rigorously blossom.

In the "workshop" of the future, attendees will interactively participate and dialogue with the young protagonists through the various phases of the design process: from the birth of the idea to its prototypical realization using the various emerging technologies present in the setup (CAD modelers, 3D printers, Oculus Rift, HoloLens, etc.). Divided into functional areas – design, 3D printing, and prototypical construction – the "workshop" of the future, rich with daily events, will indicate a possible operational perspective toward which to direct the complex world of lithic design.

This drive toward the future of craftsmanship aims to inspire new generations of artisans, architects, and designers to reflect on the blending of all the new opportunities that techniques and means provide today and will continue to provide. The snail-like condition of the exhibition work within *Marmomac Meets Academies 2024* is the result of a complex conceptual process that sees the fusion of several inspiring concepts: the shape of fossil shells and René Magritte's pipe.

The first inspiration is a tribute to the ethereal lithic material and its tangible composition, as it is inspired by the shape of fossil shells visible when blocks of sedimentary stone are cut. Following this process, the material reveals a visible pattern composed of a repeated geometry: the Spira Mirabilis. This is a form particularly beloved and recurring in nature, found in many forms of both animal and plant life, as well as in terrestrial vortices and hurricanes, and even in galactic spirals. This spiral is a curve that coils around a certain central point or axis, progressively approaching or distancing itself, depending on the movement of a point; thus, it has no beginning but continues infinitely both inward and outward. This concept of spatial-temporal infinity is reinterpreted within the *Marmomac Meets Academy* exhibit: the logarithmic spiral aims to reference the primordial state of matter and simultaneously serve as a catalyst for reflections on primary and past human conditions, with the goal of inspiring human actions toward a new, renewed future. Thus, a bridge is formed between a past of millions of years and a distant future. The reflections and studies on the Spira Mirabilis have, therefore, shaped the geometry of the exhibit, which becomes a site rich in cultural exchanges, knowledge, and ideas.

An additional conceptual contribution is derived from the second inspiration, represented by the underlying work: *Ceci n'est pas une pipe* by René Magritte[8], a painting created between 1928 and 1929 that was intended as a true provocation. The phrase that best explains the work and the contrast between representation and reality, in fact, comes from the artist himself, who stated: "Who would dare pretend

that the image of a pipe is a pipe? Who could smoke the pipe of my painting? No one. Therefore, it is not a pipe." What we see in the final concept, therefore, is pure provocation: it is not a fossil, it is not a pipe, it is not a real atelier, it is only a digital representation. Potentially, in other words, it could be many other things, but in these terms, it remains pure abstraction. It is up to us humans to concretize it through our actions.

A tangible example of this synergy is represented by the exhibition titled *Ceci n'est pas un fossile*, scheduled from September 24 to 27, 2024. Designed by university students[9] with the support of industry companies, this exhibition aims to explore the lithic design of the future, integrating theory and practice through the use of advanced technologies and traditional craftsmanship. The exhibit inspired by fossil shells present in sedimentary rocks will offer an innovative vision of lithic design, where computational design, digital fabrication, and artisanal mastery converge. Organized into various functional areas, the exhibition will provide a comprehensive overview of the potential of stone in contemporary design, presenting innovative prototypes and promoting interdisciplinary dialogue between businesses and academic institutions.[10]

Through collaboration between enterprises and academic institutions from the Polytechnic University of Bari to the University of Florida, *Marmomac* has confirmed itself as an extraordinary platform for exploring the new frontiers of stone design and processing. In an era where sustainability is at the center of global debates, the fair has demonstrated how companies are embracing the challenge of using recycled materials, transforming what could be considered waste into architectural artworks and functional structures.

In conclusion, *Marmomac Meets Academies* represents a perfect blend of exhibition, architecture, and the use of natural stone, establishing itself as an essential event on the global stage. The objective is to minimize material waste while maximizing structural and aesthetic potential. This focus on sustainability and efficiency is crucial for the future of stone architecture. Emerging technologies, such as 3D printing and robotics, are set to revolutionize stone construction, allowing for more complex and customized designs. These advances, combined with traditional craftsmanship, will create a new paradigm for stone architecture, where innovation and tradition coexist harmoniously. Additionally, the emphasis on sustainability will guide the development of eco-friendly stone products and processes, reducing the industry's environmental footprint. Therefore, *Marmomac* is not just a product showcase but a place for meeting and exchanging ideas, where the future of stone architecture is shaped.

Notes

1 Arch. PhD Barberio, M. (2021). Marmomac meets academies, *MD Journal*.
2 Arch. Colella, M. (2021). Marmomac meets academies. *MD Journal*.
3 Arch. PhD. Cavaliere, I. (2021). Marmomac meets academies. *MD Journal*.
4 Arch. PhD Student Costantino, D. (2021). Marmomac meets academies. *MD Journal*.
5 Arch. Minenna, V. (2021). Marmomac meets academies. *MD Journal*.
6 From www.marmomac.com/the-plus-theatre/marmomac-meets-academies-2023/

7 Arch. PhD Student D'Adamo, S., Lanzetta, T., Arch. PhD Student Romano, C. R., Arch. Santovito, C., Arch.Sgherza, A., & Arch.Tota, G. (2023). *Stereotomy 4.0: Sperimentazioni litiche sostenibili per il futuro delle costruzioni* [Tesi di Laurea Magistrale, Politecnico di Bari- ArCod].

8 Magritte, R. (1928–1929). Ceci n'est pas une pipe. *Artwork.*

9 Di Bari, V., Lacalamita, N., Laterza, S., PhD Student Pansini, M. G., & Ranieri, L. (2024). *La casa del futuro* [Tesi di Laurea Magistrale, Politecnico di Bari- ArCod].

10 From https://www.marmomac.com/en/the-plus-theatre-en/ceci-nest-pas-un-fossile/

15 Toward Non-Humans' Embassies

Saverio Massaro and Enrico Lain

The following contribution addresses the encounter between art and design through the performative utilization of staging, describing the case of the theatrical performance *The Non-Humans' Ambassadors*, which took place in 2023 at Palazzo Micciché-Human Forest (Favara – AG, Italy), as part of the programming of the FARM Cultural Park cultural center.

The performance is the culmination of the *Fair Play* journey, started in 2021 within the Italian Pavilion for the XVII Venice Architecture Biennale: a simulation of the *Constituent Assembly of Non-Humans*. Subsequently, in 2022, it involved two video installations at Palazzo Tortorici (Mazzarino, IT) and FARM (Favara, IT). The performance at Micciché Palace then solidified the permanent intertwining of fiction and reality, celebrating the opening of the first *Non-Humans' Embassy*, simultaneously serving as a permanent installation and a new cultural outpost.

The performance has encoded a site-specific research method that intertwines reality and staging, utilizing the theatrical medium: actors portray roles of non-humans and interact with constructed spaces, resignifying them. Methodologically, the research is grounded in B. Latour's actor-network theory and the time studies of D. C. Hoy, B. Adam, and R. Kitchin.

The research aims to reopen the design discourse by questioning some modern dichotomies (e.g., nature/culture, subject/object, gesture/word) in favor of greater sensitivity toward the different temporalities involved in the interaction between humans and non-humans. Therefore, the staging device should be understood as an anti-laboratory exploration and a strategy for reducing the distance between the spectator and the actor.

Finally, the contribution outlines possible development prospects for our research, linked to the possibility of exploring additional spaces, to allow new interactions and bring out new conceptual patterns, functional to the development of new forms of exhibition design and new cultural production centers.

Introduction

The present work was initiated between 2020 and 2021, as part of the Italian Pavilion for the XVII Venice Architecture Biennale, and is still in progress. It will be referred to as a generic 'discursive device', as it is still being defined. Following

DOI: 10.4324/9781003465188-20

Figure 15.1 Non-Humans' Embassy. Favara, 2023. Image credits: main author Salvatore Girgenti, secondary authors Saverio Massaro and Enrico Lain.

are described the three implementations that have led to its current form: the online panel *Constituent Assembly* in 2021, the video installations in Mazzarino and Favara in 2022, and finally, the site-specific installation of the first *Non-Humans' Embassy* carried out along with the performance *The Non-Humans' Ambassadors*, again in Favara, in 2023.

The traces related to the development of the device originate from an initial intent: experimenting with an alternative form of dissemination of scientific research in the fields of architectural and urban design. Indeed, these often prove to be incomprehensible to a non-expert audience, either because of their paradigmatic components, which increase their complexity, or because they are partially excluded from certain collective discursive practices – which have been described by Foucault (Foucault, 1969, p. 122).

The research aims to reopen the discourse about design by questioning some of the modern dichotomies (e.g., nature/culture, subject/object, gesture/word) in favor

of greater sensitivity toward the different temporalities involved in the interaction between humans and non-humans.

The intertwining of object and research method necessitated an ANT-based approach, primarily due to its focus on agency and non-human agents. Additionally, to enhance inclusivity toward the diverse temporalities influenced by non-humans, the decision was made to supplement ANT with the conceptual framework of time studies. Lastly, to reinforce the traces of interaction between humans and non-humans and to enhance the involvement of the device, Artaud's principles of staging and Schechner's performance theory were integrated. This helped reduce the critical distance between actor and spectator within the cultural and conceptual framework.

Due to these factors, the device initially incorporated a theatrical element, bolstering a refreshed and readily communicable discourse (on the importance of plays, see Latour, 2015, p. 259, note 61). Subsequently, staging assumed remarkable centrality, culminating in the production titled *The Non-Humans' Ambassadors*, leveraging performance facilitated additional device evolution and integrating ritual and site-specific elements.

Fair Play: Introducing Non-Humans Inside the Italian Pavilion

Fair Play started as a fictional conversation with the program of online events of the Italian Pavilion at the XVII Venice Biennale. So the first act of the discursive device was a *Constituent Assembly*, a panel built upon a speculative approach to collect insights from valuable experiences and experts having them *in the shoes* of non-humans.

The *Constituent Assembly* project's conceptual foundation primarily draws from Latour's research on the sociology of associations (Latour, 2005, p. 37) and is a key area of study within actor-network theory (ANT), pioneered by Latour, Michael Callon, and John Law; it has been succinctly described as a "theory that maps the social relations between people, objects, and ideas, treating all as agentic entities that form a broad network" (Cerulo, 2009, p. 533).

From a conceptual standpoint, non-humans, inherently devoid of will but capable of leaving traces (Latour, 1991, pp. 40–41), have enabled the initiation of an open discourse highlighting the significance of assemblages and compositions while demonstrating increased sensitivity (Latour, 2005, p. 387) toward the disputes among the actors and actants involved.

In *Fair Play*, each invited speaker acted as a delegate representing a non-human entity. The decision to adopt the term 'agent' aimed to simulate a collective devoid of specific individuals, fostering a space where discourse could flow freely and convey meaning. Selecting agents to represent human delegates was vital to constructing a fictional actor-network with a global reach. The chosen agents were: Community; Education and Project; Technology, Language, Communication, Science and Art; Teleologies and Project; Economy and Value Systems; Complexity and Possibilities; Nature and Ecosystems; Artifact, Matter, and Objects Delegates. Who is writing added two more scripted agents, Capitalism and Modern, which were portrayed by two young actors affiliated with Teatro de Linutile/Compagnia Giovani de Linutile.

All speakers and actors were tasked with embodying the identities and concerns of various non-human entities, fostering creative dialogue across different ontologies, divergent goals, and opposing viewpoints.

The Non-Humans' Ambassadors: On the Use of Performance as a Strategy for Exploring the Potential

The *Fair Play* conversation was recorded and then transitioned into an archive of texts and videos, evolving from an online panel to a spin-off initiative of the Italian Pavilion thanks to support from the cultural center FARM Cultural Park (Faraci, 2017) which proposed enhancing the project. Initially, a video installation was featured in the 2022 *Radical She* art exhibition, showcasing updated monologues of Capitalism and Modernity, the scripted agents from the Biennale's panel. Subsequently, in 2023, FARM suggested translating the project's contents into a performative action with a spatial/exhibition format.

This has enabled the design of a new application for the discursive device, expanding the number of actants/actors involved and their agency, in terms of both number and intensity. While ANT, grounded in empirical evidence, facilitates the construction of artificial scenarios that unveil the agency of humans and non-humans (Latour, 2005, p. 129), its scope is limited by existing traces.

Overcoming this methodological constraint was crucial. To enable the device to fully explore potentialities, a heightened sensitivity to time was imperative, operating in two primary ways. Firstly, according to Adam's insights that "the focus on time helps us to see the invisible" (Adam, 1990, p. 169), time was recognized as a common denominator between agency, interaction and change, ensuring that interactions among agents possessed temporal continuity, effectively intertwining their diverse temporal dimensions. Additionally, by probing potential interactions and diverse temporal perspectives, some of which may remain latent and by rendering them perceptible and tangible through performance, it became apparent how certain actions could emerge from novel perspectives on reality, encompassing non-human viewpoints and innovative cognitive patterns.

Originally conceived as a dissemination tool, the discursive device evolved in complexity, with the capability to develop, in a site-specific manner, those thought patterns already latent in the environment and its actants (Latour, 2005, pp. 320 and 321).

This led to a necessary implementation of the initial ANT methodology, by incorporating Artaud's research on theater, which aims to diminish speech's power and close the gap between audience and performance – as pointed out by Derrida (Artaud, 1968, pp. XXI and XXVI) – as well as Schechner's performance theory and time studies; consider in particular the idea of temporality shown through interactions with the world (Hoy, 2009, p. 37), or see the concept of performed temporalities through individual agency (Kitchin, 2023, p. 4). This extension facilitated a deeper exploration of indeterminate and latent aspects, aiming to reveal the influences of various actants on the planet (Latour, 2005, p. 117; Latour, 2015, p. 75).

Through the performance *The Non-Humans' Ambassadors,* a site-specific research approach was developed to blend reality with theatrical presentation. Actors

portrayed non-human agents such as Gaia, the Green Multitude, Technology, Capitalism, Play, Complexity, Economy, Community, Modernity, Globalization, and Waste. They interacted dynamically and choreographically with the diverse spaces of Micciché Palace-Human Forest, including rooms, flowerbeds, mezzanines, and terraces.

Moreover, the performance served as a ceremonial inauguration of the embassy, featuring a parade led by artist Oriana Persico. It culminated in the formal asylum request for five computational agents (Angel_F, IAQOS, Antitesi/Wisteria Furibonda, Udatinos, MeMoria Manifesta) co-developed by Persico and . . . her late partner Salvatore Iaconesi. The ritual then signified a transition phase (Van Gennep, 1909, p. 191), involving both spectators and the architectural space as collective agents. The application of performance as ritual reconstruction has been highlighted by Schechner who proposed to "hunt for events, transcribe them, and transform them into texts . . ., an activity that distinguishes societies that value time" (Schechner, 1984, p. 21).

The concept of agency is crucial in performance, involving both the sense of freedom in action (Nancy, 1988, p. 8) and the capacity for an agent to be defined not only by culture or nature but also by its actions. Through fictionality, non-human agency's complexity and the blurring of subject-object distinctions are underscored. As Latour contends, "being a subject means not acting autonomously against an objective backdrop but sharing agency with other subjects that have also relinquished their autonomy" (Latour, 2014). This perspective allows for an exploration of the liminal space between culture and nature, where the blending of production and consumption disrupts disciplinary boundaries (Valentini, as cited in Schechner, 1984, p. 29).

Non-Humans' Embassy: The Enhancement of Agency

The first Non-Humans' Embassy was opened with a ritual act on the ground floor of Micciché Palace, a late 19th-century noble building in the historic center of Favara. The building, previously dismissed, was repurposed in 2020 through an innovative project by architectural firms Analogique and Laps Architecture. It has been transformed into Human Forest: a new indoor green ecosystem featuring over a hundred plants, including ivys, tropical palms, ferns, and various shrubs and trees.

The unique relationship between the building and the embassy should be underscored because there could have been no embassy without Human Forest. Human Forest intervention first innovated the significance and function of the building, from a residential building into a cultural center. Building upon this foundation, the embassy was established with a cohesive yet evolving functional program, enriching the building's agency and unlocking new potential. For these reasons, the embassy could be seen as a cornerstone of an ongoing exaptational process of Micciché Palace (Melis, 2021).

The *Embassy* operates akin to translation, depicting a sequential process wherein entities and networks co-create each other to enable novel forms of action (Farías & Mützel, 2015, p. 2). Despite its fictional status, it serves a significant function by providing a *cultural asylum* to unrepresented demands and catalyzing translational

processes, particularly emphasizing the initial steps of problematization and inter-essement, as for the case of computational agents by Persico and Iaconesi.

The embassy serves as a platform for engaging with non-humans and their delegates through diplomacy rather than preservation. It aims to transform into a distributed exhibition, functioning both practically and symbolically as a cultural outpost where new demands seeking recognition and representation are welcomed and showcased.

Performance and embassy are entangled: the former transforms the latter by altering the conventional dynamics between meaning and expression found in the-atrical settings. While theaters typically serve as artificial yet expressive venues (Cruciani, 1992, p. 4), it is suggested that through a re-signifying ritual expression that makes them active participants, conventional spaces can evolve into environ-ments that enrich the very construction of reality (ibidem, p. 8), mediating (Latour, 2005, p. 80) the development of a shared agenda.

Here the embassy takes shape as a multimedia exhibition that serves as a *proxy* connecting users with a digital archive of *Fair Play*, fostering new interactions and conceptual patterns in exhibition design and cultural production centers. The archive, still in progress, is not merely a repository of information, but rather, it aims to activate relationships and maintain active networks.

Due to these features, the *Embassy* in Favara won't be the only one. Even if *The Ambassadors* was originally conceived as a one-night, site-specific performance by Teatro de Linutile and Compagnia Giovani de Linutile, this latest version of the discursive device now aims to expand by establishing new embassies in different locations. They should serve a dual purpose: firstly, highlighting modes of exist-ence not necessarily reliant on individuality or physical form – such as computa-tional agents – aiming to reveal the translation processes preceding the formation of actor-networks, and secondly, realizing the potential of hosting spaces.

Challenges and Opportunities

The ongoing development of the discursive device, initiated during the XVII Ven-ice Architecture Biennale, presents both challenges and opportunities for further exploration. By tracing its evolution through various stages, including online pan-els, video installations, and site-specific performances, several key themes emerge.

The integration of actor-network theory (ANT) and time studies provides a framework for navigating these complexities. While ANT offers insights into agency and non-human actors, time studies illuminate the diverse temporal dimen-sions influenced by non-humans. By combining these approaches, the discursive device can shed light on latent meanings and unexplored interactions, challenging deterministic taxonomies and enriching our understanding of urban transformations.

Performance, intended as a political and poetic public act, emerges as a pow-erful strategy for exploring these potentials. Incorporating elements of ritual and site-specificity, allowed for the emergence of latent meanings, potentially leading to future functional co-optations.

It demonstrated the same efficacy despite having been performed in a signifi-cantly different context such as the Linutile's theater in Padua in September 2023.

Moreover, the embassy concept served as a platform for engaging with non-humans and their delegates through diplomacy rather than preservation. It provides a space for recognizing and representing diverse demands, thereby fostering inclusivity and dialogue. In this sense, the process expresses new potential strategic features for cultural centers such as FARM Cultural Park, by enriching their capacity to contribute to regenerating the collective imagination of the future (Franceschinelli, 2021).

Looking ahead, the discursive device has the potential to expand further, establishing new embassies in different locations. This expansion presents an opportunity to highlight alternative modes of existence and realize the potential of hosting spaces. By embracing these challenges and opportunities, the discursive device can continue to evolve as a dynamic tool for engaging with complex issues in architectural and urban design.

References

Adam, B. (1990). *Time & social theory*. Temple University Press.

Artaud, A. (1968). *Il teatro e il suo doppio* (1999 ed., G. R. Morteo & G. Neri, Eds., G. Neri, Trans.). Einaudi.

Cerulo, K. A. (2009, April). Nonhumans in social interaction. *Annual Review of Sociology, 35*, 531–552. https://doi.org/10.1146/annurev-soc-070308-120008

Cruciani, F. (1992). *Lo spazio del teatro* (2003 ed.). Gius Laterza & Figli Spa.

Faraci, G. (2017, December). Farm cultural park: An experience of social innovation in the recovery of the historical centre of Favara. *Procedia Environmental Sciences, 37*, 676–688. https://doi.org/10.1016/j.proenv.2017.03.054

Farías, I., & Mützel, S. (2015). Culture and actor-network theory. In *International encyclopedia of the social & behavioral sciences* (2nd ed.). Elsevier Ltd. https://doi.org/10.1016/B978-0-08-097086-8.10448-9

Foucault, M. (1969). *L'archeologia del sapere* (1971 ed., G. Bogliolo, Trad.). Rizzoli.

Franceschinelli, R. (2021). I nuovi centri culturali diventano 'Spazi del possibile'. *Che Fare*. https://che-fare.com/almanacco/cultura/spazi-possibile-cultura-rigenerazione-franceschinelli-culturability/

Hoy, D. C. (2009). *The time of our lives. A critical history of temporality*. The MIT Press.

Kitchin, R. (2023). *Digital timescapes. Technology, temporality and society*. Polity Press.

Latour, B. (1991). Non siamo mai stati moderni (2009 ed., G. Giorello, A cura di, G. L. Milani, Trad.). Elèuthera.

Latour, B. (2005). *Riassemblare il sociale* (2022 ed., C. Gibella, F. Cogliati, L. Novelli, M. Morlacchi, & M. Alduino, A cura di, D. Caristina, Trad.). Meltemi Press Srl.

Latour, B. (2014). Agency at the time of the Anthropocene. *New Literary History, 45*(1), 1–18. (Originally presented as a lecture at the Holberg Memorial Prize Symposium 2013: "From Economics to Ecology" Bergen, June 4th, with the title "Which Language should We Talk with Gaia?")

Latour, B. (2015). *Facing Gaia: Eight lectures on the new climate regime* (2017 ed., C. Porter, Trad.). Polity Press.

Melis, A. (2021). *Architectural exaptation. Catalogue of Italian pavilion resilient communities at Venice Biennale 2021*. D Editore.

Nancy, J.-L. (1988). *L'esperienza della libertà* (2000 ed., D. Tarizzo, Trad.). Giulio Einaudi editore Spa.

Schechner, R. (1984). *La teoria della performance (1970–1983)* (V. Valentini, A cura di). Bulzoni Editore Srl.

Van Gennep, A. (1909). *The rites of passage* (1960 ed., M. B. Vizedom & G. L. Caffee, Trad.). Chicago Press.

The Social, Political, and Narrative Dimension of the Art Exhibition

16 416_SR1938

The Presence of Memory in the Perceptual Experience

Elena Cologni

This chapter takes the reader through the historical and theoretical contexts embedded in the art project *Places of Memory. 416_SR1938*, I conceived in response to the *Memory Pole, San Rossore 1938* (Heliopolis 21 and Diener & Diener, 2018). This was developed with the aim to combine the different temporalities involved in processes of memorization, recollection, and fruition I have investigated for some 20 years (Cologni, 2004, 2009, 2010, 2012), here specifically activated through perceptual dynamics involving the role of light and shadows with the passing of time and informed by Gestalt theories (Kanizsa, 1955; Ishikawa & Geiger, 2006; Vicario, 2005).

The resulting non-static and un-monumental public art work *416_SR1938* is connected to other influences of mine, including the context of "ambienti" – environments (Fontana, 1951; Fontana & Vigo, 1964; Clark, 1968; Irwin, 1973) in previous works and projects (Cologni, 1994, 1997, 2012) grounded in experiential, phenomenological, pragmatist approaches, which allow the viewers to have a fully embodied experience of art (James, 1890; Merleau-Ponty, 1962, 1968; Parry, 2010). I argue that an embodied care based on percipience (Merleau-Ponty, 1962; Hamington, 2004; Cologni, 2024) connects the perceptual within the experience of the world and art.

The project developed in collaboration with the Jewish community in Pisa inevitably reopens deep wounds by referring to 416 members of the Jewish community present there in 1938, when the racial laws were introduced by Mussolini. The project aims to also act as a fulcrum for dialogue to indicate shared paths of communicative memory (Assmann, 2008) through the *caring-with* (Cologni, 2020) approach adopted in city interventions (walkshops), *Places of Memory*, to recall the community in their places, where they lived, worked, and raised their children. The place-memory relationship can be institutionalized, as in the case of memorials and through architecture, but it is often in seemingly anonymous places experienced through the quotidian bodily actions that the individual's memory grid is built (Connerton, 2009).

DOI: 10.4324/9781003465188-22

Figure 16.1 416_SR1938, (2023, 500 x 375 cms on two sides, steel and galvanic brass plating treatment, installation detail).

Source: ©Elena Cologni

Prologue

The memorial project 'Places of Memory. 416_SR1938' contributes to the architecture project *Memory Pole, San Rossore 1938*, designed by Heliopolis 21 Architetti Associati together with Diener & Diener Architeknen for the Universita' di Pisa.[1] The project started thanks to the invitation of Alessandro Melis (Heliopolis 21) and of the Rector, until November 2022, Prof Paolo Mancarella, and completed with the support his successor Prof Riccardo Zucchi.

The name *Polo della Memoria San Rossore 1938*, was chosen to recall to the collective memory the "Ceremony of Remembrance and Apologies" celebrated in 2018 on the occasion of the 80th anniversary of the signing in San Rossore (Pisa) of Mussolini's Racial Laws.

When I was commissioned the artwork, I wrote "a sense of responsibility, but at the same time the doubt of being adequate pervades me" (Cologni, 2021a), as to commemorate those who were affected also means to deal with deep wounds, which are still open in Italian society.

So, as a starting point, I asked myself: How can a memorial remind us of that past and, at the same time, be catalytic for dialogue while also indicating a possible collective healing process? How can it be not a static statement but an instrument

activating communicative memory (Assmann, 2008) instead? A dialogic approach was needed to be embedded in creative process (Kester, 2004), developed with the collaborators and institutional partners, and, most importantly, with the local, national, and international Jewish community[2]. A strategy I had called *caring-with* (Cologni, 2020) was a useful tool, underpinned by care ethics and environmental psychology and which could potentially covey this history and act as bridge between different positions then and now. But is this the role of public art after all? More specific questions were to be posed as studio practice evolved, and as the consultations with those involved took place.[3]

To conceptualize 'Places of Memory. 416_SR1938,' I have referred to three main areas of research around memory. I will discuss following, aiming at: generating a perceptual interest in the viewer, recalling history, and activating an evolving dialogue.

Memory

I had engaged with processes of memory at individual, social, and historical levels before, including the different temporalities involved in processes of memorization, recollection, and fruition (Cologni, 1997, 2004, 2008, 2009, 2012). However, in this project memory and perception overlap in a continuous present of audience fruition and encounters.

The project includes a wall-based sculpture '416_SR1938' and participatory city interventions still in progress 'Places of Memory', aimed at the activation of memories in the present with participants (Cologni, 2020), and through perceptual dynamics (Kanizsa, 1955; Ishikawa & Geiger, 2006; Vicario, 2005) as we witness the passing of time evidenced by the changing conditions of light-casting shadows.

As we know from our experience, the term *time* indicates the intuition and the representation of the modality according to which the single events follow one another and are in relationship with each other – therefore, they occur before, after, or during other events. This fundamental intuition is conditioned by environmental and psychological factors (the various states of consciousness and perception and of memory, Cologni, 2012), and it is historically diversified from culture to culture.[4] In Jewish culture, as also discussed with Elio Bedarida and Ilaria Fruzzetti (interview 15–1–2021), memory is considered a sacred link between past and future and between time and eternity. The Hebrew word *zakhor*[5]], which means "remember," is linked to history and is a fundamental concept in the culture. This was also the word I had considered for the initial sketching phase. During that meeting, however, as we discussed the relationship between memory, displacement, and place (physical, abstract, and utopic), these questions arose: Which place is memory? Is memory a place at all?

Time and Duration

As obvious as this may seem, the way in which time is subjectively perceived has always fascinated me. More specifically, my creative understanding of "presentness" sits at the intersection of psychology, cognitive studies, and phenomenology.

Most of the work is rooted in visual – and other senses – perception, the perception of time (subjective time), non-simultaneous artist and audience interchange in liveness in performance and dialogic approaches, and strategies of documentation and memorization as overlapping layers of representation of time unfolding in duration (Cologni, 2009). In particular, I am interested in the way in which memory is activated through recollection in the present – as captured in Henry Bergson's quote, 'When we think of this present as what ought to be, it is no longer, and when we think of it as existing, it is already past . . . all perception is already memory' (1990, 166–167). Bergson always sought to think time in terms of duration (durée), the preservation or prolongation of the past and entailing the co-existence of past and present. This is a particularly relevant tool that has helped me to deal with a nomadic and unrooted condition of living – today shared with so many. An awareness of the potential of this condition takes us, subject in transit, to have an active engagement with the new, rather than a melancholic approach of looking back at the past. A past, which is, in turn, subsumed within presentness itself.

This position emerged during a residency at the Cambridge University's Faculty of Experimental Psychology (2011/13), when the project *rockfluid* was developed. As part of it, recollection at the intersection of memory and perception and in relation to place was investigated through group dynamics. This made me more aware that from my position of emigrant, this relentless search for connection and sense of presentness in most of my practice is an instrumental drive through which I seek to anchor to place(s).

This is possibly one of the reasons why I felt I could engage with the pole of memory project and could listen meaningfully to those who were involved in various ways in these past events or who are affected by reactivating these memories today.

Perception and Care

I had identified in the term *fruition* – the verb of perceiving and becoming part of the work, labor finally coming to fruition, a useful parallel to clarify the spectator's perceptual response and complementarity to the meaning-making process of a work of art. An active dynamic present in my projects since even before it was articulated in these terms in 2004. It manifested in works where I had consciously left a gap for the spectator or participant's input. This was embedded in various ways, for example, through video manipulations, time gaps, discrepancies in live feeds, and spatial gaps and silences in dialogic pieces. In a sense, it is almost as if the inaccuracies, and discontinuities within a set structure invite the viewer to bring something in (Cologni, 2005, 2010).

To experiment with the potential viewer's experience, I further developed these strategies, also including the viewer's diachronic approach to human-size objects (sculptures), the kinesthetics' generated by "ambienti" (environments), and the interchangeable and interdependent relation between performer/artist and spectator/participant.

In the context of this project, psychologist Gaetano Kanizsa's studies,[6] particularly the Kanizsa's Triangle (1976),[7] a phenomenon based on the concept of "amodal completion," represented a starting point. Gaetano Kanizsa defined himself as a scholar of perceptual processes, and his theoretical ideas were part of the wider context of Gestalt theories.[8]

Kanizsa's objects are a diagnostic tool in psychology that tests for a person's ability to see the big picture rather than small details. The Kanizsa object test was first developed by Kanizsa in 1955. A typical Kanizsa object consists of black images on a white background. These black objects themselves do not contain any uniquely interesting shapes. When the objects are all taken together, however, a different image is formed. Sometimes, these objects are referred to as the "Kanizsa optical illusion"

Viewing Kanizsa objects, such as the Kanizsa triangle illusion, causes most neurotypical people to report seeing the contours of a triangle emerge from the shapes. Even though there is actually no difference in brightness, the triangle that appears in the middle seems to be whiter than the surrounding space. Seeing a triangle in this illusion is partially due to a phantom edge phenomenon. Sharp breaks in visual inputs cause a person to believe that the object continues, even though we do not see it.

Kanizsa objects demonstrate the phenomenon of edge completion, which is a visual perceptual experience where the brain tends to search for edges, even when none exists. These illusory contours are clear when we look at the triangle that is formed by the shapes in the Kanizsa illusion. My interest in this phenomenon is in the capacity we have as observers to fill in the missing information, in a similar way in which we respond when a work of art is presented to us as incomplete, and we feel we are asked to complete it.

Kanizsa also worked with his student Bruno Vicario, whose focus was on time and kinetics.[9] I had previously been interested in Vicario's studies on the perception of time (2005)[10] and for the *416_SR1938* project, I specifically referred to "On Simultaneous Masking in the Visual Field" (2003). In this, the concept of simultaneous masking in the visual field is discussed, in the light of classical examples, of the various kinds of the phenomenon, of amodal completion, of the figure/ground phenomenon, of ambiguous and reversible figures, of mimicry and camouflage, and, eventually, of the complexity of the stimulus. After a series of investigative drawings based on both authors theories (Cologni, 2023), I came to realize that a more interesting aspect could come from experimenting with 3D applications of similar concerns where the illusory effect could be embedded in the experience of the actual.

Furthermore, an important element in activating the preceding was to consider the figure-ground relationship typical of Gestalt, where all the parts of the considered area can be interpreted both as figure and as background: the 3D object, the background wall, and shadow. More specifically, in this case an element of the composition indicates a possible shadow and perceptually interacts with the real shadows created by the three-dimensional modules. Furthermore, at different times

of the day and with the light casting shadows in particular ways the effect is further accentuated.

Though this may seem a specifically visual dynamic, I contend that the body is fully involved as depending on the position, the movement, and attentiveness, due to its percipience quality (Merleau-Ponty, 1962). Maurice Hamington (2004) states that Merleau-Ponty posits a theory of perception as inherently sensitive to interconnectedness with body and the world and which creates a Gestalt that includes explicitly articulated knowledge as well as a tacit corporeal understanding. Our bodies' participation in providing the "other knowledge" that remains unarticulated and may be unnoticed but exists, nonetheless, and allows caring habits. Merleau-Ponty's body's percipience quality is, according to Hamington, a foundational habit of care, of the notion of embodied care. These habits are embedded within dialogic art practices as well and are at the core of aesthetics experiences (Cologni, 2020, 2024; Seamon, 1979), which can also be understood as experiences of care.

So, in my art strategy defined as *caring-with* (2020), visual perception activates a response to the work just as much as our bodies relate to what surrounds them while moving through space. The perceptual visual dynamic thus generates a relational response that, just as it happens in participatory approaches, is complementary in and with the work in a mutually beneficial caring-with process.

This embodied care based on percipience, connecting the perceptual within the embodied experience of the world and art, comes from a spatial awareness in my work, which is connected to other influences of mine, including the context of "ambienti" (environments[11], Fontana, 1951; Fontana & Vigo, 1964; Clark, 1968; Irwin, 1973[12]) in previous works and projects (Cologni, 1994, 1997, 2012) grounded in experiential, phenomenological, pragmatist approaches, which allow the viewers to have a fully embodied experience of art (James, 1890; Merleau-Ponty, 1962, 1968; Parry, 2010).

History and/in the Present

During the archive research stage, history became central to the construction of the narrative of the work. The research conducted in the archives of the "Tullia Zevi" Bibliographic Center in Rome (Foundation for Jewish Cultural Heritage in Italy) included two strands: 1) activities of the Associazione Donne Ebree Italiane (ADEI) and 2) (Cologni, 2021b) documents on the correspondence between the Italian Jewish community and the Mussolini government indicating that in 1938 in Pisa there were 416 members belonging to the Jewish community. Even if this number seems to be only partially verifiable, as Prof Franceschini claims (26–10–2022) – it is, in fact, possible that there have been omissions and that many Jews preferred not to be registered – it is true that the numbers of Jews present in Pisa since 1938 have dramatically decreased. As we know, the effect of racial laws on the Jewish population and other minorities in Pisa and throughout Italy has been shocking.

The memorial consists of an installation site of large dimensions occupying two sides of the building SR1938 (500 x 375 x 30 cm each). It comprises 416 brass-looking elements fixed onto the walls on which they generate shadows according on the way they protrude. These change with the passing of time and light condition due to the inclination of the sun. The memorial thus evokes variability typical of processes of memory. I studied the light conditions of the building, which became an integral material in the work. In order to implement a temporal suspension triggering a process of stratification of memories in the present of the fruition of the work itself, I experimented with light and shadows, materials, and proportions through sketches and prototypes to define a growing spatial progression of rows of modules, together with an increased depth of each element, fixed via a grid. The effect is a variation in the casted shadows onto the surface of the building, at times, becoming the prominent feature, just as it happens in history. Furthermore, the dark static base of each element is itself perceived as a shadow and interferes with the real ones that 'move' with the changing light during the day so that the work comes to life.

On July 12, 2023 I set out to document the shadows the elements of the memorial cast onto the background. On a post on the @416_at_rs1938 Instagram page I wrote:

> Both sides on the building SR1938 welcoming the memorial are exposed to the sun. It was an unplanned and productive day of exchanges with members of the public and of the Jewish community in Pisa. Maurizio Gabrielli (the president) met me here this morning and commented on how 'the memorial is very much alive'. The aim of the project was indeed to present the possibility of memory coinciding with perception in a continuous present, through thinking about the shadows in history. At different moments of the day depending on the sun the shadows are definitely dominating. Maurizio then added 'through this work you have given life to the 416 people these elements represent'. It was one of the most emotional moments I have ever experienced.

The project aims to act as a fulcrum for dialogue, to indicate shared paths of activation of communicative memory (Assman, 2008), thus this piece on the external facade, extends to the city through a series of interventions (walkshops) still in development, to recall the community in their places, where they lived, worked, and raised their children.

Through the participatory approach, the project uncovers material and immaterial memories of the impact of the racial laws on Pisa's Jewish community and places. To *care with* in dialogic art practice means to adopt an approach where attentiveness, reciprocity, and relationality are shared values as well as it means to take responsibility by starting from microsocial and everyday life while exposing the lack of those values in our community, our many public policies, and institutions. The project visually complements the architecture and adds a much-needed

robust connection with the local community, which I was told was welcome (interview 26–10–2022[13]).

By adopting a novel approach to create "memorials" where communicative and cultural memory (Assmann, 2008) interweave, I hope that the dual approach of both a static/permanent aspect as well as a temporary reactivation of history contributes to the debate around the role of monuments and memorials, now livelier than ever. This includes when history interferes with the significance of memorials and their very role in the present (discussion 09–10–2023[14]).

The place-memory relationship can be institutionalized, as in the case of memorials, and through architecture, but it is often in seemingly anonymous places, experienced through the quotidian bodily actions that the individual's memory grid is built (Connerton, 2009). Through the memories that these places evoke, the individual can tame the surrounding world, but the understanding of its meaning is continually changing as shadows emerge as figure from the background of history in the present.

Acknowledgements

Commissioned by the University of Pisa, former Rector Prof Paolo Mancarella, and curated by Alessandro Melis and Ilaria Fruzzetti – partners of the Heliopolis 21 Architetti Associati studio – with the contribution of the curator and critic of contemporary art, Gabi Scardi. Cologni's intervention is developed in collaboration with the Jewish community of Pisa and with Fabrizio Franceschini, and Prof Alessandra Veronese, Director of the Centro Interdipartimentale di Studi Ebraici (CISE) of Universita' di Pisa, Centro, Bibliografico "Tullia Zevi", Roma, Fondazione per i Beni Culturali Ebraici in Italia, Moleskine Foundation, as well as local artisans. The project also had the generous support of Cambridge School of Art, Anglia Ruskin University, and Arts Council England (UK Government). Thanks to Joe McCullagh, Head of Cambridge School of Art; Anglia Ruskin University, and Prof Riccardo Zucchi Rettore, Universita' di Pisa.

Notes

1 Università di Pisa: Obiettivo 5: il Polo della Memoria SR1938/Neri, Veronica, editor – Pisa: Pisa University Press, 2021–151 p.: ill. – ISBN: 9788833396132 – Permalink: http://digital.casalini.it/9788833396132 – Casalini id: 5100409; Retrived July 17, 2024, from www.heliopolis21.it/?gallery=university-campus-ex-guidotti-pisa

2 At various points conversations and interviews fed into the development of the project, including with: Ilaria Fruzzetti, Paolo Mancarella, Carla Caldani, Fabrizio Franceschini, Maurizio Gabrielli (20–12–2020), where the concept was approved; Elio Bedarida and Ilaria Fruzzetti (online, 15–01–2021); Paolo Mancarella, Alessandro Melis, Carla Caldani (online 05–08–2022), when final design was approved; Fabrizio Franceschini, Carlotta Ferrara, Lucia Frattarelli Fischer, Guri Schwarz (online, 14–09–2023); Ilaria Fruzzetti, Maurizio Gabbrielli, Fabrizio Franceschini, Guido Cava (Pisa, 26–10–2022); Ilaria Fruzzetti, Maurizio Gabbrielli, Federico Prosperi, Fabrizio Franceschini (at comunita' ebraica di Pisa archives, and in the city, 26–10–2022); Lucia Frattarelli Fischer, Alessandra Peretti and Carla Forti (in Pisa, 20–07–2023); Maurizio Gabrielli (at Polo della Memoria, 12–07–2023); Alessandra Veronese (online, 21–07–2023); Carlotta

Ferrara (online, 12–10–2023); Paolo Mancarella, Saulle Panizza, Fabrizio Frances-chini, Riccardi Zucchi, Veronica Neri, Maurizio Gabrielli, Michele Battaini (online, 09–10–2023).

3 See the section of interviews for a list of those involved in discussions.

4 Enciclopedia Treccani, di Giovanni Bruno Vicario, Paolo Casini – Universi del Corpo (2000). One of Vicario's main concerns in this work, and most probably his most important one, is showing that phenomenal time, that is, "what appears to us in consciousness: perceptions, memories, emotions, and thoughts as they appear to us" (Vicario, 2005, p. 13), is not the same as, and cannot be reduced to, the time of physics, or physical time: "the concept of time in physics has nothing to do with the time of experience any longer" (Vicario, 2005, p. 34)3; "it is not reasonable to want to reduce phenomenal time to physical time, or to the physical time of physiological processes" (Vicario, 2005, p. 122)4

5 Yerushalmi, Y. H. (2011). *Zakhor: Jewish history and Jewish memory*. University of Washington Press.

6 Born to a Hungarian Jewish father and Slovenian mother, he worked in Trieste and Florence. I have mainly referred to the his work in Archio Gaetano Kanisza 1944–2000, Archivio Storico della Psicologia Italiana ASPI (Universita' degli studi di Milano). Retrieved June 10, 2024, from www.aspi.unimib.it/collections/object/detail/64/

7 Kanizsa, G. (1955). Margini quasi-percettivi in campi con stimolazione omogenea. *Rivista di Psicologia*, *49*(1), 7–30.

8 Kanizsa, G., & Vicario, G. (1968). *Ricerche sperimentali sulla percezione [Experimental investigations on perception]*. Università degli studi di Trieste.

9 Detail of document referring to Gianni Bruno Vicario's 'Un caso di complemento amodale in condizioni cinetiche', Giornale Italiano di Psicologia (image from archivio storico di psicologia italiana). Giovanni Bruno Vicario, (Udine, 25–06–1932 – Udine, 28–01–2020), was with Paolo Bozzi (1930–2003) and Walter Gerbino (1951) part of the "Scuola di Trieste" of Gestalt Psychology initiated by Gaetano Kanizsa. Many have studies these dynamics as in Gerbino, W. (2020). Perception and past experience 50 years after Kanizsa's (im)possible experiment. *Perception*, *49*(3), 247–267. https://doi.org/10.1177/0301006619899005

10 He wrote the book *Il Tempo* in 2005, when I was working on video delays in my post doc performative project *Mnemonic Present. Un-Folding* (2004/06).

11 The term *environments* was first used by artist Allan Kaprow in 1958 to describe his own large-scale artworks which transformed interior spaces. Recent exhibitions include *Inside Other Spaces. Environments by Women Artists 1956–1976*, Haus der Kunst, Munich, Germany, and *MAXXI Rome 2024*.

12 Some of the most striking ones are held at the Collezione Panza, Italy; also the exhibition *Inside Other Spaces: Environments by Women Artists 1956–1976*, at Haus der Kunst (2023) conceived by Andrea Lissoni, and *Ambienti 1956–2010. Environments by Women Artists II* (2024) MAXXI Rome, curated by Andrea Lissoni, Marina Pugliese, and Francesco Stocchi.

13 Discussion: Elena Cologni with Ilaria Fruzzetti, Maurizio Gabbrielli, Federico Prosperi, and Fabrizio Franceschini.

14 A meeting was called after the attack on Israel on 07–10–2023 to discuss the approach to be adopted for the public opening and symposium which were due to take place on 12–10–2023. It was decided that these were to be suspended.

References

Assmann, J. (2008). Communicative and cultural memory. In A. Erll & A. Nünning (Eds.), *Cultural memory studies: An international and interdisciplinary handbook* (pp. 109–118). Walter de Gruyter.

Bergson, H. (1990). *Matter and memory*. (Matière et Mémoire, 1896), translators N.M. Paul and W.S. Palmer. Zone Books.

Cologni, E. (2004). *The artist's performative practice within the anti-oculocentric discourse* [PhD, University of the Arts London].

Cologni, E. (2005). FRUITION: Perceptual time 'gap' as location for knowledge – Mnemonic present un-folding. In *Perspective section of body, space & technology*. School of Arts, Brunel University. ISSN 1470–9120.

Cologni, E. (2009). *Mnemonic present, shifting meaning*. Mercurio.

Cologni, E. (2010). That spot in the 'moving picture' is you, (perception in time-based art). In J. Freeman (Ed.), *Blood, sweat & theory: Research through practice in performance*. Libri Publishing.

Cologni, E. (2020). Caring-with dialogic sculptures. A post-disciplinary investigation into forms of attachment. *PsicoArt – Rivista Di Arte E Psicologia, 10*(10), 19–64.

Cologni, E. (2021a). *Figura/Sfondo. Un dialogo | Foreground/background. A dialogue. Università di Pisa – Obiettivo cinque. Il Polo della Memoria – SR1938*. Pisa University Press.

Cologni, E. (2021b). *Invisible pillars. The role of Jewish women in women's emancipation history in Italy. Università di Pisa – Obiettivo cinque. Il Polo della Memoria – SR1938*. Pisa University Press.

Cologni, E. (2024). Percipience, embodiment, contamination(s). The Artist as Wound. Practicing a feminist care aesthetics. In E. Cologni & M. Visse (Eds.), *Art for the sake of care, special issue of international journal of education and the arts*. https://journals.psu.edu/ijea/

Connerton, E. (2009). *How modernity forgets*. Cambridge University Press.

Hamington, M. (2004). *Embodied care: Jane Addams, Maurice Merleau-Ponty and feminist ethics*. University of Illinois Press.

Ishikawa, H., & Geiger, D. (2006). Illusory volumes in human stereo perception. *Vision Research, 46*(2), 171–178.

James, W. (1890). *The principles of psychology*. Henry Holt and Company the Principles of Psychology.

Kanizsa, G. (1955). Margini quasi-percettivi in campi con stimolazione omogenea. *Rivista di Psicologia, 4*(1), 7–30. English translation, Quasi-perceptual margins in homogenously stimulated fields. In S. Petry & G. E. Meyer (Eds.), *The Perception of Illusory Contours* (pp. 40–49), Springer.

Kanizsa, G. (1976). Subjective contours. *Scientific American, 234*(4), 48–53.

Kester, G. (2004). *Conversation pieces: Community + communication in modern art*. University of California Press.

Merleau-Ponty, M. (1962). *Phenomenology of perception*. Routledge & Kegan Paul.

Merleau-Ponty, M. (1968). *The visible and the invisible* (A. Lingis, Trans.). Northwestern University Press.

Parry, J. (Ed.). (2010). *Art and phenomenology* (1st ed.). Routledge.

Seamon, D. (1979). *A Geography of the Lifeworld: Movement, rest, and encounter*. Routledge.

Vicario, B. (2003). On simultaneous masking in the visual field. *Axiomathes, 13*, 399–432.

Vicario, B. (2005). *Il Tempo. Saggio di psicologia sperimentale*. Il Mulino Ricerca.

Interviews and discussions

Elena Cologni with Elio Bedarida and Ilaria Fruzzetti (online, 15–01–2021).

Elena Cologni with Ilaria Fruzzetti, Maurizio Gabbrielli, Federico Prosperi, Fabrizio Franceschini (at comunita' ebraica di Pisa archives, and in the city, 26–10–2022).

Elena Cologni with Lucia Frattarelli Fischer, Alessandra Peretti and Carla Forti (in Pisa, 20–07–2023).

Elena Cologni with Maurizio Gabrielli (at Polo della Memoria, 12–07–2023).

Elena Cologni with Paolo Mancarella, Saulle Panizza, Fabrizio Franceschini, Riccardi Zucchi, Veronica Neri, Maurizio Gabrielli, Michele Battaini (online, 09–10–2023).

Art and Architecture projects

Clark, L. (1968). *The house is the body*. Venice Biennale.

Cologni, E. (1994). *Almeno un punto di vista*.

Cologni, E. (1997). *Stretched mirror*. University of Leeds.

Cologni, E. (2004). *Mnemonic un-folding series*. Galleria Arte Moderna e Contemporanea di Bergamo; Whitechapel Gallery (among other venues).

Cologni, E. (2008). *Re-moved*. Centre of Contemporary Art, Glasgow.

Cologni, E. (2012). *Spa(e)cious*. Wysing Arts Centre, UK; Bergamo Scienza, IT, Stanford University, US.

Cologni, E. (2023). 416_SR1938 *Moleskine notebook* (artist book, 7.5 x 11 cm), one copy only.

Fontana, L. (1951). *Struttura al neon per la IX Triennale di Milano* [Neon Structure for the 9th Milan Triennale].

Fontana, L. and Vigo, N. (1964). *ambiente spaziale: "utopie"*, XIII Triennale di Milano.

Heliopolis 21 and Diener & Diener. (2018). *Memory Pole, San Rossore 1938*. Universita' di Pisa.

Irwin, R. (1973). *Varese Scrim*. Solomon R. Guggenheim Museum, New York. Panza Collection, Varese.

17 Holier Than Thou

Lanfranco Aceti

"Space is how you practice it."

<div align="right">

Paul Virilio

</div>

The notion of creativity and its practice is particularly loaded when placed in the context of imperial propaganda, especially when the empire, democratic or dictatorial, is at war. The difference between a democratic and a dictatorial empire quickly blurs when conformity is not just appropriate but required and forcefully demanded.

This analysis starts from the English notion of "holier than thou." All empires consider themselves holier than everyone else, painting themselves as purer and adorning themselves with art and design that are mere functional trinkets for propaganda. In this context, creativity that deviates from the authorized politics of art is not just sidelined but virulently attacked because it needs to conform and reinforce the mythology of the "sacrifices offered by the fatherland – for the fatherland" (Brecht, 2003, p. 19).

Holier Than Thou is the title of the Russian Pavilion at the LX Venice Biennale. It is a space that does not exist, as no authorization has ever been granted for its realization. Nevertheless, the Russian Pavilion is developing as a form of wishful fancy, independent of the financial constraints of Western empires' propaganda. *Holier than Thou* presents a different vision, one that does not align with either party – Russian or American – and exists in the dystopian space carved by George Orwell and Evgenij Ivanovič Zamjatin, where even the most outrageous ethical questions can be considered: What if we are the evil empire?

Introduction: To Exist or Not to Exist

Since 2016, I have worked intermittently on a failed curatorial project. This project, with the EMST (National Museum of Contemporary Art Athens) focused on realizing a series of exhibition proposals as blue-sky exhibitions. Inspired by architecture and the beauty of unrealized projects, this idea emerged during a period when the EMST was in a complex transition with empty coffers, empty spaces, and filled with empty political promises. The project was, therefore, titled *Empty Pr(oe) mises*. It sought to use emptiness as a tool to discuss the promises and premises of

DOI: 10.4324/9781003465188-23

Figure 17.1 Facade. Lanfranco Aceti, *Oilier Than Thou*, 2024. Gold plated and printed metal sheets with neon-light installation. Frontal facade of the Russian pavilion for the LX Venice Biennale. Digital architect: Diego Repetto. 3D Rendering: Matteo Colombo.

such a space. The museum, under new directorship, backtracked on the promises made and abandoned the project.

I decided to employ a similar strategy differently for the LX Venice Biennale. I wanted to be free from restrictions and create works of art in a space I could control and use to critique the hypocrisy of the empire, its colonial heritage, and its continuous attempt at world conquest and dominance.

There were personal reasons as well. I needed to escape from the social propaganda machine and the hysteria of pseudo-pacifists supporting yet another war to expand the outreach of the empire of democracy. The sacrifice of soldiers and civilians, in this case, was not for the fatherland but for the idolatry of the God Dollar. It seemed as if these new warrior-pacificists could tolerate and were willing to fill up their bank accounts with the destruction and deaths of hundreds of thousands of people. In reality, they did and have. During these times of war, corporations have earned billions of dollars, and US 401–Ks – retirement funds – are flourishing.

I found the exaltation of warmongers pure folly and had no stomach to perpetuate the notion that the West was or is made of ethical democracies while financial sheets benefit from the collapse of entire countries. The list of millions of deaths caused by the West to maintain and expand its old colonial influences around the world is too long. Latin America and its propped-up dictatorships and civil conflicts, (Grandin, 2023) the wars in the South Pacific, (Rowe, 2014, pp. 134–150) and **the false flag operations of** bombings and assassinations covertly maneuvered

by the U.S. in **Western** Europe (Griffing & Cobb, 2023, pp. 455–470) – all of these create mounting evidence. Cuba has been condemned to the brink of existence for daring to defy U.S. control of the American continent (Coll, 2007, pp. 199–274). Despite and in spite all of the well-researched academic arguments on the expansion and influence of the empire, spheres of influence were considered tropes by some of my colleagues, who effortlessly applied double standards to Western and other empires' spheres of influence.

The notion of the West as a united single entity is also historically false, as some European states are vassals under the political and military control of the empire currently embodied by the U.S.

This summary represents the non-aligned inner space of my mind, (Garrard, 1971) also divided between my roles as an artist and a curator, each requiring different hats at different times. Sometimes these hats I have to wear even at the same time. This existential status creates the conditions for an intricate but creative inner space in which different instances clash and harmonize or remain utterly unresolved.

Creativity and Be Damned

For over a year, I tried to persuade various people at prestigious institutions to support the project for the Russian Pavilion at LX Venice Biennale. Concerns were always an issue. They loathed taking risks and, even more so, me holding up a mirror to their hypocrisies.

Figure 17.2 From left to right: Lanfranco Aceti, *We Bring You the Gift of Democracy, Regime Change*, and *Thank You Very Much Indeed*, 2024. Carrara marble sculptures.

Holier Than Thou is the ultimate statement about hypocrisy, hence the title for this pavilion. It only seemed natural to title the frontal installation of the Russian Pavilion *Oilier Than Thou* since these wars are about oil, rare minerals, and unctuous behaviors – and have little to do with peaceful democratic engagements or Western export of democracy.

I opened *Holier Than Thou* for the LX Venice Biennale as an independent space while, at the same time, being an artistic and curatorial project for the Russian Pavilion. *Holier Than Thou* is a space that does not exist traditionally but comes into existence digitally and physically, floating between architectural drawings, unrealized projects, and 'real' digital works of art. Currently, the Russian Pavilion can be viewed online. It will develop into various physical forms over time, unveiled one room at a time.

The works of art serve as a somber critique of current affairs and respond to the theme of the 2024 Venice Biennale: *Foreigners Everywhere*. I have been a foreigner for most of my life, and taking on the Russian Pavilion as both curator and artist meant moving between two planes of existence while being "extraneous" to the culture I had decided to represent.

I never wanted to curate myself, but I decided that if I wanted something done, I had to do it myself because people were too scared or just wanted to toe the line. The space of the Russian Pavilion represents an artistic foreign territory for me. It is an adventure in an unknown land where referential points are lost and the ugly face of propaganda could wag its tongue. Nevertheless, it is a space I needed to create. It was something I needed to do to save my sanity.

The title *Holier Than Thou* addresses the West's self-righteousness and its propaganda machine, which, as in other past wars, has justified unspeakable horrors. The *Oxford English Dictionary* defines the adjective as "characterized by an attitude of superior sanctity." This rationale led me to make the Russian Pavilion, my unbridled version, free from influences. No partnerships, no curator to counter or subdue me, was the best and only possible solution to people's weariness of the project. I pursued it to develop a space that offered the freedom to critique the notion of empire in its fantastic hypocritical-wholesomeness.

The works of art in the Russian Pavilion do not focus directly on contemporary wars but on society's estrangement from ethical values. They are snapshots of hypocrisy, ignorance, and arrogance. These are not just distant societal issues but individual responsibilities born out of our leaders' political actions and for which we should bear collective responsibility. It has been interesting to see how conditional on who is bombed or terrorized – ally or enemy – the responsibilities of the citizens for the political choices of their leaders shift abruptly from **non-responsible** to **responsible** without a second thought.

Sanctimonious Imperialism

The pavilion, *Holier Than Thou*, is outside the space of what I call sanctimonious imperialism or sanctimonious capitalism. These notions are two sides of the same coin – the imperialism of those who preach from higher grounds while committing, supporting, and participating in the most heinous war crimes for financial gain. The

socio-political space where creativity unfolds cannot be solely characterized by blackmailed, threatened, and attacked international cultural institutions. It cannot exist in a space where social media are overtly propagandistic, promoting some topics and silencing others, generating an impenetrable barrier of stupidity that stops any form of dialogue and non-consonant critique.

It is beyond this barrier of stupidity that creativity is exercised, not in the partisanship of baseless accusations and political slurs, but in the clear understanding of possible freedoms and possible errors. The Russian Pavilion gave me absolute intellectual freedom. It was my space to be extraneous and foreign to myself, foreign to my own physical space, and foreign to the current political space, which is impossible to inhabit if we do not conform, follow the lingo, and comply.

Creativity has often been confined within the boundaries of what is acceptable and palatable to corporate patrons. However, these boundaries have become increasingly restrictive. Every act, gesture, painting, or sculpture can be commented upon, scrutinized, silenced, or canceled by anyone who deems it inappropriate, often based on the most trivial criteria.

I have felt sadness about what has happened on U.S. campuses in recent times. Nevertheless, a part of me can only look at it as a direct result of a holier-than-thou attitude that leads people to believe they can silence others due to their perceived moral superiority and the righteousness of their arguments, no matter the side. It is the righteousness that imposes limits on the rights of others to express their opinions freely. I have often looked at it as a form of McCarthyism that stems from self-appointed righteous individuals or groups. They might be well-meaning but believe in their right – based on their more pronounced sanctity – of violently limiting others to construct a morally superior imperial democratic world. But, once the socio-cultural frameworks of obligations and protections to free speech are dismantled, the moral superior groups only fall prey to the same tactics and violence adopted, twisted, and turned around by other groups against them.

Since the 1990s, I have found academic ideas that have migrated from the United States to Europe and seeped into our living spaces to be incredibly shoddy, if not superficial. These absurd notions have and continue to stifle dialogue, confrontation, mutual understanding, cultural intermingling, forms of adoption, and exchanges. Everything has to happen within the confines of a meticulously defined Anglo-Saxon safe space, structured according to the ideological thought processes of the majority or minority of the empire. It does not make a difference if the thought is from the majority or the minority, from the Democrats or the Republicans, it is and will always be of the empire. Therefore, what is the definition of safe space that the empire imposes upon us?

Life is not safe. Especially if it is lived in the clutches of the empire. U.S. and international students now realize how regulated American campuses are. They realize now how free speech and other rights are tightly controlled and bestowed by the enforcers of sanctimonious capitalism with a total disregard for constitutional principles. Violence in the name of righteousness is meted out by a so-called democratic government or by private security officers on the university's misbehaving customers (no longer considered students for quite some time now).

The space of creativity that I created primarily for myself within the Russian Pavilion is a space to exercise the impossible. It is the locus where I can critique the empire from the perspective of the so-called evil empire. The real question is: What if we are the evil empire?

What if our politics are evil, and we are waging a war of supremacy and world dominance, distracted by our needs for Starbucks, the most sugary and fattening coffee on the planet, by our need for makeup to mask with foundation the realities of our rotten selves, and by our need to feel entertained because we have been too lazy all our lives to read a serious book and, instead, preferred watching another instantly gratifying Netflix show until our minds went numb? All this while we whimper about the poor and feign ethical concerns to soothe our egos.

Conclusions: Foreigners Everywhere

We are at a point where we are all foreigners to ourselves. Even the works of art that are my intimate and personal views as an artist, curator, and human being appear that might turn on me once poisoned by words of propaganda. Art is a risky affair.

I do not possess Aleksandr Solzhenitsyn's moral compass because I prefer ethical principles to morals – too easily influenced by political and social whims. However, I can distinguish between "freedom for good deeds and freedom for evil deeds," (Solzhenitsyn, 1978; Hook, 1979).

The works of art deal with the loss of cultural references. They deal with a societal space that has become an existential minefield. For this reason, I wish viewers to wander through the exhibition as if across a barren land, crying out to the gods and Mother Earth to reveal themselves once more.

The externalized inner space of this exhibition leaves people feeling bewildered – a feeling of being foreigners to themselves and the world, where the majority either mock us or pose as adversaries, leaving little hope for a peaceful future.

The space of creativity is the space we construct to exercise our play, to reimagine worlds differently, to build new possibilities, and to reconstruct the world anew. Yet again.

It is a space that exists 'out there' and requires first to be imagined before creating it and exercising creativity within it. The practice of creativity is the practice of space, first and foremost. When spaces are not granted, they are taken, created, and invented.

The Russian Pavilion for the LX Venice Biennale is an invention. Yet, it is no less real, visible, or tangible because it is an imaginary project. The works of art are real illusions, signposts that mark the space of a mirage. *Holier Than Thou* is a space where I can exist uncompromisingly, independent of corporate and military propaganda. It is a space where I practice as an artist and curator without responding to societal madness and idiocy or following algorithmically created propaganda strategies.

Space is **NOT** how you practice it, as Virilio said.

Space and creativity are how you live them.

Acknowledgements

I wish to thank Prof. Alessandro Melis for this opportunity.

 Credits and thanks for *Holier Than Thou*, the Russian Pavilion for the LX Venice Biennale, go to Diego Repetto, digital architect, and Matteo Colombo, 3D rendering.

References

Brecht, B. (2003). *Brecht on art and politics* (T. Kuhn & S. Giles, Eds., L. Bradley, S. Giles, & T. Kuhn, Trans.). Bloomsbury.

Coll, A. R. (2007). Harming human rights in the name of promoting them: The case of the Cuban embargo. *Journal of International Law and Foreign Affairs*, *12*, 199–274.

Garrard, J. G. (1971). The "inner freedom" of Alexander Solzhenitsyn. *Books Abroad*, *45*(1), 5–18.

Grandin, G. (2023, March 23). The United States has used Latin America as its imperial laboratory [Interview by D. Denvir]. *Jacobin*. https://jacobin.com/2023/03/greg-grandin-interview-us-policy-latin-america

Griffin, D. R., & Cobb, C. W. (2023). NATO/US false-flag attacks in Europe. *The American Journal of Economics and Sociology*, *82*(5), 455–470.

Hook, S. (1979). Solzhenitsyn and Western freedom. *World Literature Today*, *53*(4), 573–578.

Rowe, J. C. (2014). Transpacific studies and the cultures of U.S. imperialism. In J. Hoskins, V. T. Nguyen, R. Leong, & D. K. Yoo (Eds.), *Transpacific studies: Framing an emerging field* (pp. 134–150). University of Hawaii Press.

Solzhenitsyn, A. (1978, June 8). *A world split apart*. The Aleksandr Solzhenitsyn Center, Commencement Address, Harvard University. Retrieved May 31, 2024, from www.solzhenitsyncenter.org/a-world-split-apart

18 Phygital

A Designer's Call to Action

Jonathan Alger and Maya Koptyman

Introduction: Hybrid Word, Hybrid Reality

The word *phygital* is a relatively new portmanteau in the design field, combining the existing words *physical* and *digital*. Perhaps because the first part of the new term derives from the word *physical*, the word is most used by people intent on designing the physical world to contain some digital aspects. But as we will see, it can just as easily refer to the opposite: designing digital experiences that are augmented with physical aspects.

The concept of phygital encapsulates the evolving nature of human experiences in the modern world, where physical and digital aspects intertwine more and more seamlessly over time. This fusion has become increasingly prevalent across many domains, including exhibitions and museums, leading to a fundamental shift in how designers should approach their work.

Rather than viewing physical and digital aspects as separate fields of endeavor, the combined term "phygital" acknowledges their interconnectedness and challenges designers to actively engage and better understand both realms. Whether it's "physical-first" through interactive exhibitions that seamlessly blend physical artifacts with nearby digital interfaces or "digital-first" through the integration of smartphones to enhance the visitor experience of a physical gallery, the boundary between the physical and digital worlds has been blurred for longer than most of us realize. The time for designers to address this implicit challenge has come.

A Call to Action

As designers, we now must recognize that every project we undertake exists within this phygital landscape. We have both an opportunity and a responsibility to consciously shape both dimensions of the experience. Whether through projection mapping in immersive art shows or anticipating visitors' interactions on an accompanying social media platform, designers can play a crucial role in orchestrating phygital experiences.

The emergence of phygital reality is not a passing trend but a long-standing, partly unrecognized, and now permanent fixture in our lives. It dates back to the advent of personal computers, the Internet, and mobile computing. Now, it's

DOI: 10.4324/9781003465188-24

imperative for designers to break free from traditional specialist silos and embrace a new multichannel phygital literacy. Only by understanding and mastering both the physical and digital aspects of their projects at the same time can designers truly excel in this new blended reality.

The term *phygital* encapsulates a paradigm shift in how we conceptualize and design experiences, emphasizing the intertwined nature of the physical and digital worlds. It underscores the importance of designers embracing this new reality and actively shaping it to create compelling and immersive experiences for their audiences.

Part 1: Phygital Past

To better understand this hybrid idea, it is helpful to envision the physical and digital realms as parallel, superimposed realities. Today, we can imagine them both existing at the same time all around us, each of them acting as a channel for communication. With this constructed view in mind, we can go back in time to explore the advent of each channel and the moment when they first overlapped.

Our physical environment has been a channel for communication since the earliest cave paintings and petroglyphs. The surfaces of public spaces, places of worship, and trading spots have been used for millennia to visually communicate messages that inform, persuade, and warn.

The digital realm is, of course, far younger – decades old, rather than millennia. The capability of basic digital creation and transmission of information came into existence with the mid-twentieth-century dawn of mainframe computing. However, the digital world was not able to manifest itself regularly in physical space until a certain "stack" of technologies was mature enough to interoperate stably. This stack included screen and projection playback, compact data storage, and eventually a pervasive digital transmission network (the Internet).

Once these conditions were met in the mid-1990s, we can credibly claim in retrospect that the "phygital era" had begun. We were now able to reveal the parallel dimension of digital reality in the physical environment in the form of projected imagery, novel screen-based interfaces, and interactive controls enabling users to alter display content in real-time.

Museums and other cultural venues were among the first to experiment with these possibilities. A slow but interesting start was made in the 1990s, during the wave of expansion of new exhibitions and museums in many countries during that era. Early versions of VR (virtual reality) headsets were introduced but did not gain widespread use. This was followed by a dramatic wave of more advanced explorations in the 2000s.

This decade also included the advent of mobile computing and social media, which led to further innovations in the 2010s. By the late 2010s and early 2020s, VR was enjoying a second period of popularity alongside wearable consumer technologies, and the omnipresence of smartphones and mobile computing further led to the blooming of AR (augmented reality).

With this timeline of the phygital past established, we can assert that designers have been in a phygital reality for more than a generation, whether we have always recognized it or not.

In the present, it is critically important that we understand this phenomenon and the opportunities and responsibilities it will entail in the future.

Part 2: Phygital Present

Today we now have cost-effective capabilities of projection, data storage, and data transmission such that all the planes of an entire large physical space can be turned into interactive digital content surfaces. The unlocking of this stack of technologies at scale, at an affordable cost, has given rise to the immersive art trend and its many cousins, where all the surfaces around and under the visitor no longer have real-world characteristics but projected and superimposed digital ones.

Similarly, though there are hurdles to their widespread use in visited cultural spaces, VR headsets take digital superimposition to an extreme in a different way. Typical VR applications transport the user to a completely different location than their actual physical one, creating the impression of a digital experience with the visual characteristics of the physical dimension. Recent headset innovations like the Apple Vision Pro allow the user to feel like they are seeing the actual space around them while also seeing panoramic digital information. This mixes VR together with AR in a new way. Some see advancements like these as harbingers of the dystopian realities of *Ready Player One* and *The Matrix*, where people live long term in an entirely digital construct with the appearance of a complete physical reality. Time will tell whether such observations will be accurate.

However, a different observation can already be confidently made, one that points to the maturity, advancement, and completeness of phygital projects now. Immersive art is VR in reverse. It accomplishes the same goal as VR but arrives at it in the opposite direction. Both immersive digital projections and VR headsets completely replace our physical environment with digital information. In the former case, we superimpose a digital reality onto a physical environment. In the latter, we do the opposite: superimpose a physical reality into a digital environment. Though theoretically identical, these outcomes are also very different in practical terms, and those differences turn out to be critically important. A VR headset is a portable, individual experience that can be used anywhere by one person in a semi-private space. These experiences can come with us. Immersive art, on the other hand, is a non-portable, group experience set up in specific venues in public spaces. We must go to these experiences.

With this convergent evolution in mind, we now must also acknowledge that phygital projects come in two opposite flavors. In the design field overall, the term is most often used to describe a "physical first" mindset, where designers of physical experiences like exhibitions look to incorporate digital elements into real space. Essentially, the "phy-" is the main channel, and the "-igital" becomes an element to be added.

But there is a second, equally valid flavor of the term, which is, in a sense, the opposite: digital-first experiences that somehow themselves incorporate the physical. Augmented reality (AR) is one of the most visible examples of this flavor, particularly in AR-based smartphone games like *Pokémon Go*. These digital-first experiences occur entirely within the screen of personal devices, but they are coordinated through the GPS locators built into the devices, with the locations of real-life physical features. The result is the appearance of a "window" into that parallel digital realm evoked earlier, a realm that conceptually exists but which requires the device to see it. To strengthen this impression, the various creatures and treasures made visible in the real world through the personal device window can also have a persistent location. Location persistence means that if you return to that spot, that digital feature will still be at that location, even in the same orientation, when viewed with a mobile screen later, even by different users entirely.

In a museum exhibition context, experiments have been done for over a decade now where personal devices are used to point at an artwork or adjacent QR code and trigger a digital layer that appears to be superimposed on reality through the device's screen. This layer can be a simple image or text, or can have 3-dimensional, motion, and interactive characteristics. Like the examples of the scavenger hunt creatures, these digital elements remain co-located with their real-world triggers.

Even digital channels that do not make a deliberate connection to physical space in this way can have a phygital influence, nonetheless. When a visitor to an exhibition generates a still or video selfie in that context and uploads it to a sharing platform, they are doing something phygital and also creating both flavors of phygital at the same time. They are bringing a representation of that physical experience into the digital realm. However, in doing so, they are changing the physical experience for themselves and other visitors by visibly posing for that shot. Every selfie pose and photo opp is a manifestation, in physical space, of physical reality being transposed into digital reality.

This has been only a sampling of the many manifestations of the concept of phygital, past and present. There are hybrid forms within hybrid forms, and new ideas appear constantly. The question now is less how to catalog all of the variations on this theme thus far than what designers should do in the future, to take up the responsibilities – and capitalize on the opportunities – that phygital has been presenting to us all along.

Part 3: Phygital Future

As demonstrated before, we have already reached a point of technological advancement where it is possible to completely superimpose the visual characteristics of the digital realm onto the physical realm (immersive art), and vice-versa (VR). These both fall short of convincingly replicating all the high-fidelity sensorial cues of the real world, but they are surprisingly effective early prototypes. The phygital future will likely be more and more effective at this over time.

Designers should take this evidence as a call to action, even a wake-up call, to ensure that they have a lead role in this effort rather than a supporting role, or no

role at all. Our phygital future will require a new kind of thinking, where designers cannot limit themselves to the traditional silos of physical design disciplines and digital design disciplines. Anyone interested in a significant seat at the phygital table will need to cross-train in a new way.

In phygital projects, physical designers need to become more conversant with digital design. This includes exhibition designers, architects, interior designers, set designers, and the like. Expert familiarity with floor plans, elevations, construction details, and site visits is no longer enough. Screen design, UX, UI, resolution, and lighting levels are all new knowledge that physical designers must absorb. Digital elements also age far more quickly than architectural ones; understanding what this implies is critical in order to have a leading role in this realm.

Likewise, digital designers need to become more conversant with physical design. This includes UX and UI teams, media creators, filmmakers, and the like. For them, it is the knowledge of UX, UI, resolution, motion, and interaction that are no longer enough. Understanding dimension, the movement of people, the nature of actual physical scale, and how to build physical things are all new knowledge digital designers will need to absorb.

The most successful designers from both traditional disciplines will blend both in a new way, and be on the lookout for new variations in the phygital, particularly those that come from new technological and cultural innovations related to personal digital devices like smartphones and wearables. These already greatly outnumber any phygital media installations at physical venues and will certainly, therefore, have a much greater effect on the evolution of the phygital than we can imagine today.

Conclusion

The phygital represents both a new set of responsibilities for designers of all kinds and new opportunities as well, if designers can adapt to the implied requirements of this new world. If designers cannot change themselves to take advantage of what has already been underway for over a generation, they risk losing a chance to influence not just new kinds of projects but, potentially, new kinds of reality.

19 Enhancing the Sense of Place Through Performative Arts

The Case of Venice

Jose Antonio Lara-Hernandez

Introduction

The concept of "sense of place" is central to understanding how individuals and communities connect with their environments. Performative arts have a unique capacity to enhance this sense of place by transforming spaces into sites of cultural and emotional significance. This chapter explores how performative arts contribute to the sense of place, using Venice, Italy, as a case study. Venice, with its rich history, double fractal urban fabric, and vibrant cultural life, provides a robust context for analysing the relationship between performative arts and sense of place.

Theoretical Framework: Edward Relph's Sense of Place

Edward Relph's (1976) concept of "sense of place" is seminal in the field of human geography and environmental psychology. Relph argues that sense of place is a complex, multifaceted concept that encompasses emotional, cognitive, and social dimensions. According to Relph, sense of place involves a deep, experiential connection to a particular location, which is shaped by personal experiences, cultural meanings, and social interactions (Kim & Kaplan, 2004; Du Toit et al., 2007).

There are three main components of sense of place:

1. **Physical Setting**: The tangible, physical aspects of a place, including its architectural design, landscape, and spatial configuration, play a crucial role in shaping the sense of place (Hull et al., 1994; Lara-Hernandez et al., 2017). These physical elements provide the backdrop against which social and cultural interactions occur, and they help to anchor memories and experiences in specific locations.
2. **Activities**: The activities that take place within a setting contribute significantly to the sense of place. These activities include everyday routines (Ellard, 2015), temporary appropriation (Lara-Hernandez et al., 2020), social interactions (Palaiologou & Vaughan, 2014), and cultural events (Richards & Wilson, 2002). The functions of a place, such as its role as a site of commerce, worship, or recreation, also influence how it is perceived and experienced by individuals and communities.

DOI: 10.4324/9781003465188-25

3. **Meanings and Symbolism**: Places are imbued with meanings and symbolism that reflect cultural values, historical narratives, and personal associations. These meanings are often conveyed through landmarks, monuments, and other symbolic elements that help to define the identity of a place. The symbolic significance of a place can evoke strong emotional responses and foster a sense of belonging and attachment (Talen, 2000; Ujang, 2012).

Insideness and outsideness are two key aspects of sense of place (Relph, 1976). The former refers to the deep, personal identification with a place, where individuals feel a sense of belonging and familiarity. While outsideness, on the other hand, describes a more detached, alienated experience of place, where individuals feel disconnected and out of place. The degree of insideness or outsideness can vary depending on factors such as cultural background, personal history, and social context.

However, before we continue, it is essential to unravel the difference between space and place. The following section briefly explains it. It is not the aim of this chapter to extensively describe what has been already discussed elsewhere (Harrison & Dourish, 1996; Rios et al., 2012; Leary-Owhin, 2015)

Space vs Place

Understanding the distinction between "space" and "place" is essential to understand how performative arts can enhance the sense of place. While these terms are often used interchangeably, they represent different concepts in the context of human geography and environmental psychology.

Space is a more abstract concept that refers to the physical dimensions and configurations of an environment. It encompasses the measurable and quantifiable aspects of an area, such as its geometry, size, and layout. Space is often considered as a blank canvas, devoid of the social and cultural meanings that define a place (Rogers & Sukolratanametee, 2009; Lara-Hernandez & Chin, 2021). It is the physical setting that provides the potential for human activity and interaction, but it is not inherently imbued with significance. Space can be understood as a container in which various activities and events occur. It is characterized by its openness and the possibility for multiple interpretations and uses. In this sense, space is neutral and objective, defined by its physical properties rather than the experiences and meanings attributed to it by people.

Place, on the other hand, is space that has been given meaning through human experience, interaction, and cultural interpretation (Hull et al., 1994). It is a space that has been personalized and imbued with significance, becoming a part of the social and cultural fabric of a community (Scott et al., 2008; Rios et al., 2012). Place is defined by its relationship to the people who use and perceive it, encompassing the emotional, cognitive, and symbolic dimensions that make it unique and meaningful. A place is not just a physical location but a space where human activities and interactions have created a sense of attachment and identity. It is where memories are made, social bonds are formed, and cultural practices are enacted.

Places are often associated with particular experiences and narratives, making them rich in meaning and significance. Such as a performative artistic expression.

This distinction between "space" and "place" helps us to understand the transformation that occurs when an abstract space becomes a place through the processes of human engagement. This transformation is central to the concept of sense of place, as it highlights how spaces can become meaningful through the performative acts and social practices that occur within them.

In the context of Venice, the performative arts play a crucial role in this transformation. Performative arts events such as the Venetian Carnival and the Biennale di Venezia, turn the city's public spaces into places of cultural significance. These events create shared experiences and memories, fostering a sense of belonging and attachment among participants and spectators. The configuration of such unique historical built-environment (buildings, streets, canals, and squares) of Venice serve as the physical spaces that are brought to life through performative acts, transforming them into memorable places that resonate with cultural meaning and social significance.

Venice's Double Fractal Urban Fabric

Venice stands out as a unique example due to its built environment, which exhibits two significant characteristics closely linked to temporary appropriation (TA): a human scale and a double fractal urban fabric (see Figure 19.1). The human scale here refers to the built environment's design that fosters a "space of contact" (Choay, 2004), facilitating social interactions within the urban setting. Common attributes of this human scale include narrow and varied street widths, building heights under

Figure 19.1 Venice double fractal city.

16 meters, organic urban planning, an appealing and detailed streetscape, and mixed-use buildings. Meanwhile, the fractal urban fabric is characterized by organic forms with intricate details at multiple levels (Boeing, 2018), comprising both water and built structures (Brown & Crompton, 2007; Melis et al., 2024, chap. 5).

Moreover, research suggests that our nervous system has evolved to anticipate fractal environments (Yang & Purves, 2003). In other words, a fractal environment provides spatial diversity. In such urban settings, inhabitants are likely to develop a strong sense of identity and community due to the robust social bonds among them. Historically, there have been numerous instances demonstrating these social bonds and solidarity, which are crucial for enhancing resilience (Melis et al., 2024), although measuring them can be quite challenging (Feldmeyer *et al.*, 2021).

This complex urban fabric, combined with the rich cultural landscape and an entirely pedestrianized street network, creates a conducive environment for performative arts to develop in distinctive ways. The following section briefly describes the performative arts through history in Venice.

Historical Context of Performative Arts in Venice

Venice has long been a crucible of artistic innovation, particularly in the performative arts. The city's unique geographical setting and its history as a hub of trade and cultural exchange have fostered a rich tradition of music, theatre, and dance. The Venetian Carnival, for instance, is an annual celebration that transforms the city into a living stage, blending historical traditions with contemporary performances. The historical evolution of these practices has deeply embedded the performative arts into the cultural fabric of Venice, enhancing its sense of place.

The origins of Venice's performative arts can be traced back to its strategic position as a maritime republic, La Serenissima. Venice was a cultural melting pod thanks to trade routes that brought a wealth of artistic influences, from Byzantine mosaics to Ottoman textiles, which in turn inspired local performers and artists (Psarra, 2018). This confluence of cultures created a unique artistic milieu that continues to influence Venice's performative arts scene today.

During the Renaissance, Venice became a hub for theatrical innovation. The establishment of permanent theatres, such as the Teatro San Cassiano, the first public opera house in 1637, marked a significant development in the city's cultural landscape. These venues provided a space for composers like Claudio Monteverdi and Antonio Vivaldi to premiere their works, solidifying Venice's reputation as a center for musical excellence.

Performative Arts and Sense of Place

Performative arts enhance the sense of place by creating shared experiences that foster community identity and continuity. Through the lens of performativity, as discussed by Hyunkyoung Cho and others, performative acts are not merely artistic expressions but are also social actions that have the power to transform spaces and influence social dynamics. In Venice, this transformation is evident in various

public performances that bring together locals and tourists, creating a collective memory and a shared sense of belonging.

Cultural Continuity and Innovation

Venice's performative arts scene is characterized by a blend of tradition and innovation. Events like the Biennale di Venezia showcase contemporary art while drawing on the city's historical context. This continuity and innovation reinforce Venice's identity, making it a dynamic space where the past and present coalesce, enhancing the city's sense of place. The interplay between continuity and innovation is particularly visible in the city's opera scene. Teatro La Fenice, rebuilt after a devastating fire in 1996, serves as a symbol of resilience and artistic renewal. The theatre continues to host classic operas alongside new productions, offering a space where historical and contemporary works coexist. This synthesis of old and new not only preserves Venice's rich operatic tradition but also ensures its relevance to modern audiences.

Community Engagement

Performative arts engage the community in meaningful ways. Local festivals, street performances, and public art installations invite participation, fostering a sense of ownership and pride among residents. This is what, through the layers of history, edifies culture (Tylor, 1871; Simmel, 1969). Such activities and celebrations transform public spaces into vibrant hubs of social interaction, contributing to the overall sense of place.

The involvement of local communities in the production and performance of arts events is crucial for fostering a sense of place (Hull et al., 1994). For example, *Festa del Redentore*, an annual event commemorating the end of the plague in 1576, involves elaborate preparations by the residents, including the decoration of boats, the construction of temporary bridges and communal feasts. This collective effort not only strengthens community bonds but also reinforces the cultural significance of the event, embedding it deeply in the local identity.

Spatial Transformation

Performative arts have the power to transform ordinary spaces into extraordinary ones. The use of streets, public squares, historical buildings, and even waterways as stages for performances creates a unique spatial narrative that is distinctly Venetian. This spatial transformation enhances the aesthetic and emotional appeal of these places, deepening the sense of place.

The spatial transformation facilitated by performative arts is particularly evident in Venice's streets. Performances and artistic representations turn alleys and streets into dynamic stages, creating an immersive experience for both participants and spectators. These performances not only highlight the city's unique built-environment but also contribute to its mythic allure, making the act of moving through Venice a performative experience in itself (Crouzet-Pavan, 2002).

Case Study: Venice

Venetian Carnival

The Venetian Carnival is perhaps the most emblematic example of how performative arts enhance the sense of place. The entire city becomes a stage, with masked participants, elaborate costumes, and street performances creating a surreal and immersive experience. This annual event not only attracts tourists from around the world but also reinforces local traditions and community bonds. The Carnival's historical roots date back to the 11th century, and its revival in the late 20th century has revitalised Venice's cultural life, drawing on historical practices while incorporating contemporary artistic expressions. The Carnival's impact on Venice's sense of place extends beyond the duration of the event. The preparation period involves extensive community participation, with workshops on mask-making and costume design fostering local craftsmanship and creativity. These activities strengthen the cultural fabric of the city, ensuring that the Carnival is not just a tourist attraction but a genuine expression of Venetian identity.

Biennale di Venezia

The Biennale di Venezia is another significant event that underscores the role of performative arts in public spaces. It provides a platform for artists to engage with the city's unique urban landscape, creating site-specific works that interact with Venice's architecture and history. This dialogue between art and space enhances the city's cultural identity and its sense of place. The Biennale's focus on contemporary art, architecture, dance, music, and theatre allows for a multidisciplinary exploration of Venice's spatial and cultural dynamics (Finnegan, 2018). The Biennale's influence on Venice extends beyond the official venues. Satellite exhibitions and performances often take place in unconventional spaces, such as disused warehouses and private gardens, encouraging visitors to explore lesser-known parts of the city. This dispersion of artistic activities across the squares and streets helps to democratise the cultural experience, making art accessible to a broader audience and reinforcing the sense of place throughout the city (Mouffe, 2007).

Enhancing Sense of Place Through Technology

As Venice continues to navigate the challenges of modernity, the performative arts will play a crucial role in shaping its future. Emerging trends such as immersive technologies (Costarangos, 2018), interactive installations (La Biennale di Venezia, 2024), and community-driven art projects offer new possibilities for enhancing the sense of place and identity (Ramasauskaite, 2024).

Technological advancements such as virtual reality and augmented reality can create new forms of performative art that engage audiences in novel ways. These technologies can transform historical narratives into immersive experiences, allowing people to connect with Venice's heritage on a deeper level. For instance, augmented reality applications could overlay historical scenes onto present-day

Venice, enabling users to experience the city's past in situ. Such technologies can also enhance performances by adding interactive elements that engage audiences more deeply.

Interactive art installations in public spaces can foster a sense of place by encouraging active participation. These installations can respond to environmental cues and human interactions, creating dynamic and evolving narratives that resonate with both locals and visitors. Projects like the *Rain Room*, which allows visitors to walk through a simulated rainstorm without getting wet, could be adapted to Venice's unique environment, creating a memorable and place-specific experience.

Community-driven art projects that involve local residents in the creation process can strengthen social ties and enhance the sense of ownership and belonging. These projects can also address social and environmental issues, using art as a tool for community engagement and empowerment. Initiatives like participatory murals or community theatre productions can provide platforms for diverse voices, fostering a more inclusive and representative cultural landscape.

As Venice faces environmental challenges such as rising sea levels and tourism-related pressures (Šedá, 2018), incorporating sustainable practices into performative arts can enhance the sense of place while promoting ecological responsibility. Eco-friendly stage designs, sustainable materials, and performances that raise awareness about environmental issues can align artistic practices with the city's sustainability goals. By integrating sustainability into the performative arts, Venice can model a future where cultural vitality and environmental stewardship coexist.

Collaborations with international artists can bring fresh perspectives and innovative approaches to Venice's performative arts scene. These collaborations can foster cross-cultural exchanges and enrich the city's cultural life. Programs that invite artists-in-residence to create site-specific works in Venice can generate new interpretations of the city's spaces and histories, enhancing its sense of place through a global lens.

Although during the COVID-19 pandemic the use of public spaces was heavily restricted, it also accelerated the adoption of digital platforms for performative arts. Currently, virtual performances and online exhibitions that reach wider audiences and maintain cultural engagement are widely utilised (Dobetail, 2024). Hybrid models that combine live and digital elements provide flexible and accessible cultural experiences, therefore, ensuring that Venice's performative arts remain relevant in our rapidly changing world.

Conclusion

Performative arts have a profound impact on the sense of place, particularly in a unique double fractal built environment like Venice. Through historical continuity, community engagement, and spatial transformation, performative arts create shared experiences that deepen the connection between people and their environment. New technologies are helping in new ways to foster community-driven initiatives, which are key in enhancing its unique sense of place.

This dynamic interplay between tradition and innovation, community participation, and spatial transformation underscores the vital role of performative arts in conforming to the sense of place.

References

Boeing, G. (2018). Measuring the complexity of urban form and design. *Urban Design International, 23*(4), 281–292. https://doi.org/10.1057/s41289-018-0072-1

Brown, F., & Crompton, A. (2007, January). *The double fractal structure of Venice*. Proceedings, 6th International Space Syntax Symposium, İstanbul, pp. 11.1–11.12.

Choay, F. (2004). El reino de lo urbano y la muerte de la ciudad. *Lo urbano en 20 autores contemporáneos, 33*, 23–33. http://books.google.es/books?hl=es&lr=&id=4KelQ8mL-WcC&oi=fnd&pg=PT53&dq=+La+era+postciudad+&ots=22Y2idmqPb&sig=MzvhHz4nEEg6QuSFmKMK6OW0eyU

Costarangos, A. (2018). Jesse LeCavalier presents immersive pavilion made of logistic materials at MoMA PS1. *Designboom*.

Crouzet-Pavan, E. (2002). *Venice triumphant: The horizons of a myth*. JHU Press.

Dobetail. (2024). *Virtual art worlds*. Retrieved June 6, 2024, from https://dovetailmag.com/2020/12/virtual-art-to-experience-right-now/

Ellard, C. (2015). *Places of the hearth: The psichogeography of everyday life*. Bellevenue Library Press.

Feldmeyer, D., Nowak, W., Jamshed, A., & Birkmann, J. (2021). An open resilience index: Crowdsourced indicators empirically developed from natural hazard and climatic event data. *Science of the Total Environment, 774*, 145734. https://doi.org/10.1016/j.scitotenv.2021.145734

Finnegan, T. (2018, May 17). Venice Biennale of architecture: The future of public space. *Financial Times*. Retrieved May 17, 2018, from https://amp.ft.com/content/ea8fd7d8-4d48-11e8-8a8e-22951a2d8493?__twitter_impression=true

Harrison, S., & Dourish, P. (1996). Re-place-ing space: The roles of place and space in collaborative systems. In *Proceedings of the 1996 ACM conference on computer supported cooperative work* (Vol. 7, pp. 67–76). https://doi.org/10.1145/240080.240193

Hull, R. B., Lam, M., & Vigo, G. (1994). Place identity: Symbols of self in the urban fabric. *Landscape and Urban Planning, 28*(2–3), 109–120. https://doi.org/10.1016/0169-2046(94)90001-9

Kim, J., & Kaplan, R. (2004). Physical and psychological factors in sense of community: New urbanist Kentlands and nearby Orchard village. *Environment & Behavior, 36*(3), 313–340. https://doi.org/10.1177/0013916503260236

LaBiennale di Venezia. (2024). *Venice immersive lineup and competition, La Biennale di Venezia*. Retrieved July 2, 2024, from www.labiennale.org/en/news/venice-immersive-lineup-and-competition-announced

Lara-Hernandez, J. A., & Chin, J. (2021). Sense of community and spatial agency: Key elements of resilient communities. In M. Carta, M. Perbellini, & J. A. Lara-Hernandez (Eds.), *Resilient communities and the Peccioli charter towards the possibility of an Italian charter for resilient communities Volume di Approfondimento del Catalogo del Padiglione Italia alla XVII Biennale di Architettura di Venezia*. Springer Nature.

Lara-Hernandez, J. A., Khemri, Y. M., & Melis, A. (2020). Understanding temporary appropriation and the informal use of public spaces: The case of Algiers, Auckland and Mexico city. In A. Di Raimo, A. Melis, & S. Lehmann (Eds.), *Informality now: Revisiting the issue of informal settlements and their link to sustainability*. Routledge. Taylor & Francis Group.

Lara-Hernandez, J. A., Melis, A., & Caputo, S. (2017). Understanding spatial configuration and temporary appropriation of the street in Latin American cities: The case of Mexico City Centre. In H. Boudagh, A. Versaci, F. Trapani, M. Migliore, N. Clark, &

A. Sotoca (Eds.), *Urban planning and architectural design for sustainable development* (pp. 153–173). IEREK, Springer.

Leary-Owhin, M. (2015). A fresh look at Lefebvre's spatial triad and differential space: A central place in planning theory? In *2nd Planning theory conference university of the west of England* (pp. 1–8).

Melis, A., Pievani, T., & Lara-Hernandez, J. A. (2024). *Architectural exaptation: When function follows form*. Routledge.

Mouffe, C. (2007). *Public spaces and democratic politics*. LAPS [Preprint].

Palaiologou, G., & Vaughan, L. (2014). *The sociability of the street interface – revisiting West Village, Manhattan*. 21st International Seminar on Urban Form – ISUF2014, pp. 88–102.

Psarra, S. (2018). *The Venice variations: Tracing the architectural imagination*. UCL Press.

Ramasauskaite, O. (2024). Venice Biennale: Crafting cultural identity through art. *ArtX-Exchange*. Retrieved July 19, 2024, from https://artxchange.global/venice-biennale-crafting-cultural-identity-through-art/

Relph, E. (1976). *Place and placelessness* (2nd ed.). Pion Limited.

Richards, G., & Wilson, J. (2002). The use of cultural events in city promotion: Rotterdam cultural capital of Europe 2001. *Urban Studies, 41*(10), 1931–1951. https://doi.org/10.1080/10295390208718729

Rios, M., Vazquez, L., & Miranda, L. (2012). *Place as space, action, and identity*. Routledge, Taylor & Francis Group.

Rogers, G. O., & Sukolratanametee, S. (2009). Neighborhood design and sense of community: Comparing suburban neighborhoods in Houston Texas. *Landscape and Urban Planning, 92*(3–4), 325–334. https://doi.org/10.1016/j.landurbplan.2009.05.019

Scott, M., Boyle, M., Eckley, J., Lehman, M., & Wolfert, K. (2008). *Healthy communities: A resource guide for Delaware municipalities* (p. 156). Institute for Public Administration.

Šedá, K. (2018). *Mass tourism steals the soul of historical centers*. Domus Academy.

Simmel, G. (1969). Essays classic on the culture of. In R. Sennet (Ed.), *Classic essays on the culture of cities* (pp. 47–60). Prentice-Hall Inc.

Talen, E. (2000). Measuring the public realm: A preliminary assessment of the link between public space and sense of community. *Journal of Architectural and Planning Research, 17*(4), 344–360.

Toit, L. Du, Cerin, E., Leslie, E., & Owen, N. (2007). Does walking in the neighbourhood enhance local sociability? *Urban Studies, 44*(9), 1677–1695. https://doi.org/10.1080/00420980701426665

Tylor, E. B. (1871). *Primitive culture: Researches into the development of mythology, philosophy, religion, art, and custom*. John Murray.

Ujang, N. (2012). Place attachment and continuity of urban place identity. *Procedia – Social and Behavioral Sciences, 49*, 156–167. https://doi.org/10.1016/j.sbspro.2012.07.014

Yang, Z., & Purves, D. (2003). A statistical explanation of visual space. *Nature Neuroscience, 6*(6), 632–640. https://doi.org/10.1038/nn1059

20 Visual Voices

Female-Themed Murals as Community Exhibitions in the South Bronx

Barbora Melis

Introduction

The South Bronx, a unique and vibrant neighborhood, has emerged as a dynamic arena for community performance and exhibition in the ever-changing urban landscape. Its rich cultural tapestry, woven from decades of socio-economic challenges and resilient community activism, is a testament to the power of hope and resilience in shaping urban narratives.

This contribution explores the transformative power of female-themed murals in the South Bronx. These murals, adorned with vivid colors and compelling narratives, transcend aesthetics. They are powerful expressions of women reclaiming and transforming their urban spaces into colorful exhibition areas. More than just visual testaments to women's identities, these murals are catalysts for change, fostering a sense of community performance and engagement and uniting people through the power of art.

Experiential design, as a multidisciplinary approach, places the audience at the center of the holistic experience with a product, service, or environment. In the context of the South Bronx's female-themed murals, this approach enriches our understanding of urban exhibitions by highlighting public art's immersive and interactive nature. These murals are not just static images; they engage viewers in dialogue, evoke emotions, and foster a sense of community. By transforming public spaces into exhibition areas, the murals create a multisensory experience that resonates deeply with the local population. This experiential aspect is crucial, as it allows individuals to connect with the artwork on a personal level, fostering a greater sense of ownership and belonging. Moreover, experiential design underscores the importance of inclusive and participatory urban environments, where art serves as a catalyst for social interaction, reflection, and empowerment.

While Manhattan, with its substantial financial resources, hosts numerous well-funded public events and exhibitions in public places, the South Bronx offers a contrasting narrative. Here, community-driven art projects like female-themed murals emerge from grassroots efforts, reflecting the resilience and creativity of the local residents. Despite limited funding, these murals have a profound impact, turning public spaces into accessible and meaningful exhibition areas. This comparison

DOI: 10.4324/9781003465188-26

highlights community-led artistic interventions' unique value and power in transforming urban environments.

Beyond their artistic appeal, these murals challenge traditional urban narratives by inviting critical reflection on pressing issues of gender equality and inclusion in urban planning and design. They compel us to reconsider urban spaces as physical environments and arenas where gender dynamics shape daily experiences, influencing safety, accessibility, and civic engagement. Through this exploration, we navigate the complexities of urban life through a lens that amplifies voices often marginalized in traditional urban narratives, fostering a sense of awareness and commitment to gender equality in urban planning.

This contribution aims to underscore the transformative power of art in reshaping urban landscapes. By examining the South Bronx as a case study, we uncover nuanced insights into how artistic interventions, such as these murals, can contribute to community resilience and advocate for social justice. These interventions empower individuals and engage communities in the process of urban development, making them a powerful tool for change.

The Intersection of Art, Experience, and Community in Urban Spaces

In recent decades, there has been a noticeable shift in art and performance practices from cultural institutions to public urban spaces and everyday environments, using them as settings for cultural experiences and artistic activities. The concepts of "urban design" and "art in public" are inadequate for fully grasping the performativity and agency of contemporary artistic and design practices. *Performative urbanism* encompasses various performative approaches across disciplines like architecture, art, design, and activism, focusing on the urban environment as a dynamic space for emotional expression, interactions, and conflict resolution. It expands the definition of urban design to include a broad spectrum of activities such as performances, temporary installations, and other engagements that shape and interact with the urban realm (Samson & Juhlin, 2017).

Performative urbanism, a concept at the intersection of urban studies and performance art, redefines public spaces as stages for social interaction and collective expression. It emphasizes the role of urban environments in shaping and being shaped by the performative actions of individuals and communities. In this context, public art becomes a medium through which communities can engage in dialogue, protest, and celebrate their identities. Performative urbanism becomes a part of urban development processes, playing the role of "temporary spaces" or serving as tools for placemaking and urban branding (Samson & Juhlin, 2017).

With its rich history of socio-economic challenges and cultural resilience, the South Bronx is an exemplary setting for performative urbanism. Here, the streets become canvases, and walls transform into platforms for storytelling. In this context, female-themed murals in the South Bronx represent performative urbanism by allowing women to express their lived experiences, struggles, and triumphs in a public forum. As Amin and Thrift state, the city is "a place of mobility, flow and everyday practices" (2002, p. 7) and becomes the canvas for these murals, which

act as mirrors and catalysts, reflecting the community's identity while inspiring change and resilience.

To fully appreciate the impact of these murals, it is essential to understand them through the lens of experiential design. The multidisciplinary approach focuses on a person's holistic experience with the environment. It aims to create immersive and interactive experiences that engage individuals on multiple sensory levels, fostering deeper emotional connections and meaningful interactions and offering new ways of looking at the relationship between people and the outdoor open spaces they use in their everyday lives (Thwaites & Simkins, 2006). In urban settings, experiential design transforms public spaces into engaging environments that invite participation and evoke strong emotional responses.

In the context of the South Bronx's female-themed murals, experiential design principles are vividly demonstrated. These murals are not merely visual art pieces but immersive experiences that draw viewers into a dialogue. The vibrant colors, compelling narratives, and strategic placement of these murals in public spaces create a multisensory environment that resonates deeply with the local population. These murals enhance the community's connection to their environment by fostering a sense of ownership and belonging. Moreover, experiential design in this setting underscores the importance of creating inclusive and participatory urban spaces where art serves as a catalyst for social interaction and empowerment (Leavy, 2017).

Community performance and engagement are central to the concept of public spaces as exhibition spaces. These spaces are passive backdrops and active participants in the community's daily life. Public art, especially murals, plays a crucial role in this dynamic by inviting community members to engage with their environment in meaningful ways. Through artistic expression, communities can reclaim and redefine their public spaces, turning them into stages for collective performance and engagement (Stickells, 2011).

In the South Bronx, female-themed murals exemplify this dynamic. These murals are products of community collaboration, often involving local artists and residents in their creation. This participatory process ensures that the murals reflect the community's values, experiences, and aspirations. The murals become focal points for community gatherings, discussions, and celebrations, transforming public spaces into vibrant exhibition areas. This engagement fosters a sense of pride and solidarity among residents, reinforcing their connection to their neighborhood and each other.

In summary, the theoretical framework of performative urbanism, experiential design, and community performance and engagement provides a comprehensive understanding of the transformative power of female-themed murals in the South Bronx. These murals are artistic expressions and vital components of a dynamic urban landscape that fosters community resilience, social interaction, and empowerment.

The South Bronx and Its Public Space

The South Bronx, located in New York City, is a densely populated neighborhood with a rich cultural heritage and a history of resilience and hardship. It is home to

a diverse population, including a significant proportion of Hispanic and African American residents. Their contributions have fostered a strong sense of community identity and a vibrant cultural scene. This diversity is vividly reflected in the area's murals, which serve as powerful expressions of collective memory, cultural pride, and social activism. Although globally renowned as the birthplace of hip-hop, the South Bronx remains America's poorest urban congressional district.

Originally a thriving industrial and residential area in the late 19th and early 20th centuries, the neighborhood underwent significant transformations throughout the 20th century, shaped by waves of immigration, economic fluctuations, and urban planning policies. At the height of industrialization, the South Bronx was home to bustling factories, residential brownstones, and vibrant immigrant communities. However, the mid-20th century witnessed a decline in industrial jobs and economic disinvestment, leading to widespread poverty, housing deterioration, and social unrest. The neighborhood became synonymous with urban blight and neglect, exacerbated by factors such as redlining and discriminatory housing practices. Evolving from a historically low-profile and deprived area segregated from wealthy Manhattan (Hughes, 2021), the neighborhood exemplifies today's shifting urban dynamics within New York City (NYU Furman Center, n.d.)

In recent decades, the South Bronx has experienced a resurgence fueled by community-led revitalisation efforts, affordable housing initiatives, and cultural preservation projects. Organizations and local residents have worked tirelessly to restore historic buildings, promote economic development, and celebrate the neighborhood's rich cultural heritage (Ciampa, 2018; Mokha, 2011). The legacy of resilience and creativity continues to shape the South Bronx as a dynamic and evolving urban landscape.

The public spaces in the South Bronx exhibit a blend of challenges and potential, shaped by the complex interplay between physical infrastructure, residential developments, commercial activity, and diverse local communities. Despite the challenges posed by traffic-dominated environments, the neighborhood's sidewalks are vibrant with urban life, particularly toward the north. Advertisements, colorful murals, and the multifaceted use of public spaces reflect the area's rich ethnic and cultural influences. Public spaces include large sidewalks along commercial streets, community gardens, and recreational areas near the waterfront. However, these generous sidewalks are often underutilized due to insufficient design and amenities, and a scarcity of trees and greenery diminishes their overall appeal.

Amidst these challenges, the South Bronx emerged as a vibrant center of cultural and artistic expression. In the 1970s and 1980s, the borough became synonymous with hip-hop music, graffiti art, and community activism. Artists and activists from diverse backgrounds used creative forms of expression to reclaim public spaces, challenge stereotypes, and advocate for social justice. Graffiti art, in particular, became a powerful medium for marginalized communities to assert their cultural identities and critique socio-political inequalities (Jonnes, 2022).

The murals of the South Bronx, often depicting strong female figures and themes of empowerment, stand as powerful symbols of resilience and advocacy. They provide a compelling backdrop for examining the complexities of inclusivity in urban

public spaces, promoting gender equality and social justice, and offering deeper insights into the role of art in reclaiming urban spaces and empowering marginalized communities. The historical and cultural context of the South Bronx, with its rich legacy of overcoming adversity and embracing cultural diversity, underscores the transformative power of art in revitalizing urban environments. By exploring the evolution of the South Bronx through this lens, we understand how art can serve as a catalyst for social change and community empowerment in urban settings.

Female-Themed Murals: Artistic Expression and Reclamation

New York City's renowned street art scene, featuring vibrant murals and graffiti, showcases the work of notable artists such as Kobra, Banksy, and Keith Haring. Street art, characterized by bold lettering and bright colors in a "tagging" style, has long been a part of Bronx culture. Emerging in the 1970s amidst the city's financial struggles and high crime rates, this art form was initially marked by illegal and risky acts of tagging subway cars and buildings by youth from the Bronx and Brooklyn.

Despite its controversial nature and a citywide ban on subway graffiti in 1989, street art continued to thrive. Over time, collectors and curators recognized its artistic value, leading to sponsorships from business owners, community groups, and developers (Weaver, 2024). Today, cities use street art to enhance their community identity (Adams, 2020).

According to Conrad (1995), murals represent one of the most inclusive forms of art in the United States, accessible to all and reflecting the aspirations and concerns of ordinary people. Community murals play a crucial role in expressing and reinforcing communal values, offering educational and thought-provoking content while visually engaging. They foster community pride and commitment to justice, educating others about the struggles of marginalized communities. This democratic art form has a significant role in broadening multicultural understanding (Adams, 2020).

In the South Bronx, murals serve as vibrant canvases that make bold statements about reclaiming urban spaces. Often sidelined in mainstream art narratives, these murals vividly reflect the experiences, hopes, and challenges of local residents, including women. They celebrate women both as subjects and creators, showcasing a variety of female-themed narratives ranging from historical figures and cultural icons to everyday women challenging stereotypes.

These murals not only beautify the urban landscape but confront traditional ideas about public visibility and gender roles. They highlight stories of resilience, cultural pride, and strength, aiming to shift public space away from male-centric narratives and amplify the voices of historically marginalized groups. By depicting women in diverse roles, the murals encourage a re-evaluation of gender perceptions and the contributions of women to urban life. While the stories of these women and local female graffiti artists may remain less known beyond the Bronx, these artworks exemplify how art can revitalize neglected areas, empower communities, and transform urban landscapes.

Public Space as Exhibition Space

Public spaces in urban environments serve as vital arenas for community interaction, social engagement, and cultural expression. In the South Bronx, murals have transformed these spaces into vibrant exhibition areas reflecting the community's identity and resilience. Unlike traditional galleries or cultural institutions, these public spaces are accessible to everyone, providing an inclusive platform for artistic expression (Ulmer, 2017). The adaptations of these ordinary urban environments with graffiti and murals, among other temporary uses, such as food vendors or street-side garage sales, can personalize and domesticate the urban public space demarcating territory. Public space sends signals as to who belongs and may even serve to normalize and make social differences and inequalities more visible.

The transformation of these urban spaces is a testament to the power of art in reclaiming and redefining the environment; these spaces for community art not only present art but often serve as art schools, resource and outreach centers, and community gathering spaces (Grodach, 2009). The walls of the South Bronx, adorned with murals celebrating women's experiences, challenges, and victories, become more than just aesthetic enhancements; they evolve into dynamic canvases that tell the community's stories. Henri Lefebvre (1968) might argue that street artists are asserting their right to the city by re-appropriating public visual space in response to contested urban areas and broader efforts to both re-image and re-imagine the city. Through their work, street artists call the city out on what it is while imagining what it could become. These murals invite residents and visitors alike to engage with the artwork on a deeper level, fostering a sense of connection and shared experience.

The principles of experiential design play a crucial role in the effectiveness of these murals. Experiential design focuses on creating holistic, immersive experiences that engage individuals on multiple sensory levels. In the South Bronx, the female-themed murals are not merely visual spectacles but interactive and immersive experiences that draw viewers into a narrative. These murals' vibrant colors, intricate details, and compelling themes create a multisensory environment that resonates with the local population.

The murals often incorporate elements that encourage public interaction, such as community painting days or interactive installations that invite participation. By engaging the community in creating and interpreting the murals, these projects foster a deeper connection between the artwork and its audience. This interactive element is essential in transforming public spaces into dynamic exhibition areas where art becomes a living, evolving part of the urban landscape.

While the South Bronx relies heavily on community-driven art projects, Manhattan's well-funded public spaces and art installations offer a contrasting narrative and benefit from substantial financial resources. These resources allow for high-profile projects that attract widespread attention. These projects often involve sophisticated technologies and media, creating polished, large-scale exhibitions accessible to a broad audience.

However, this abundance of resources highlights the disparities between Manhattan and the South Bronx. Despite their limited funding, the community-driven

murals in the South Bronx possess a unique authenticity and cultural relevance that resonate deeply with local residents. These murals are not just art but powerful symbols of the community's identity, resilience, and empowerment.

The comparison between Manhattan and the South Bronx underscores the unique value of grassroots art initiatives. In Manhattan, public art is often driven by commercial interests and large-scale funding, resulting in projects that, while impressive, may lack the intimate connection to the local community that characterizes the murals of the South Bronx. In contrast, the murals in the South Bronx, emerging from grassroots efforts, reflect the lived experiences and aspirations of the community, fostering a distinct and deeply meaningful sense of ownership and pride.

The impact of female-themed murals on the South Bronx community extends beyond aesthetic enhancement. These murals serve as focal points for community gatherings, discussions, and celebrations, transforming public spaces into vibrant hubs of social interaction. The process of creating these murals often involves local artists and residents, ensuring that the artwork reflects the community's values, experiences, and aspirations.

The murals also play a crucial role in challenging traditional urban narratives and promoting gender equality. By depicting women's experiences and achievements, these murals invite critical reflection on issues of gender inclusion and representation in urban planning and design. They challenge viewers to reconsider urban spaces as arenas where gender dynamics shape daily experiences, influencing safety, accessibility, and civic engagement.

In conclusion, transforming public spaces into dynamic exhibition areas through female-themed murals in the South Bronx highlights the profound impact of community-driven art initiatives. These murals enhance the aesthetic appeal of the urban environment and create opportunities for community performance and engagement. They contribute to the South Bronx's ongoing narrative by fostering a sense of belonging and empowerment, underscoring art's transformative power in reshaping urban landscapes.

Examples of Graffiti and Mural Artwork in the South Bronx

The South Bronx is adorned with numerous murals and graffiti artworks that embody resilience, empowerment, and social justice. Created by diverse artists, these works enhance the urban landscape while making powerful statements on gender equality and community identity. They play a vital role in reclaiming public spaces for marginalized voices, turning walls and facades into canvases for expression and advocacy, and fostering a sense of belonging and pride within the community. By studying these artworks, we gain deeper insights into how art can challenge societal norms, promote social justice, and empower individuals in urban settings.

Black and Hispanic youth, facing marginalization and oppression, formed graffiti crews to establish a sense of identity and belonging. Graffiti became a means to connect with others' experiences, as one source noted: "The main purpose of graffiti is to have a positive impact . . . it provides individuals with a way to express

their emotions in the Bronx, a sense of purpose in life. The graffiti and hip-hop culture extends beyond the final artworks, paying tribute to those who have passed away" (DeFazio, 2024).

In areas like Bruckner Boulevard in Mott Haven, restaurants and bars have emerged alongside art venues, creating vibrant cultural hubs. Organizations in the Bronx support artists working in street art, offering opportunities and emphasizing their significance for the community. WallWorks New York in Port Morris is one such organization, an art gallery that showcases works by both emerging and established artists, blending downtown and uptown art styles (DeFazio, 2024).

The Bronx, known as the birthplace of hip-hop, has always been at the cultural forefront. The intertwined history of graffiti and music is evident, with the four foundational elements of hip-hop – graffiti, MCing, DJing, and breakdancing – developing in close connection.

Graffiti crews gave Black and Hispanic youth a sense of identity and belonging. Tats Cru, one of the most prolific graffiti groups from the South Bronx, has collaborated with several hip-hop legends. They began by spraying trains as teenagers and later transitioned to painting walls, remaining highly productive today. Their community murals play a crucial role in preserving the culture and history of the Bronx, offering camaraderie, protection, and mutual support (DeFazio, 2024).

Puerto Rican artist Bikismo created a mural of Jennifer Lopez to celebrate memorable moments in her career and life and to honor her documentary film "Halftime" and her commitment to social responsibility, accountability, and representation. Known for his hyper-realistic spray paint artworks, Bikismo has created pieces for prominent sports figures and singers (Leaden, 2022).

WallWorks, founded by renowned graffiti artist John Matos ("Crash") and directed by his daughter Anna, aims to reflect and enhance the neighborhood's cultural essence while honoring hip-hop. The gallery provides a space for women artists to connect with the community and celebrate each other. This initiative merges and extends two previous projects: The Bronx Graffiti Art Gallery and Her Story. The First Annual Female Graffiti Series featured artists like Lady K Fever, Mel1, Rocky 184, Charmin 65, Miss Boombox, Gem13, and Neks. Her Story's mission is to create a supportive environment for female writers to share their narratives and showcase their skills (Stavsky, 2016, 2023).

This focus on female representation and empowerment through art leads to a broader discussion on women's perspectives on the city and gender equality.

Gender Dynamics in Urban Planning and Design

Urban planning and design have historically been shaped by gender dynamics that often exclude or marginalize women's experiences. Public spaces, designed predominantly by men, frequently overlook the unique needs and perspectives of women. This has led to urban environments where women may feel unsafe or unwelcome, especially in poorly lit areas or places with limited surveillance. Additionally, the lack of consideration for women's needs in urban planning contributes to issues such as inadequate public transportation options, insufficient public restrooms, and limited access to childcare facilities.

Despite recent progress, architecture, urban planning, and design remain male-dominated professions, resulting in a one-sided perspective on the urban realm. This disparity contributes to gender inequalities that significantly impact women, girls, and sexual and gender minorities, especially in comparison to cis-gender, heterosexual men. The intersection of gender with other vulnerabilities, such as poverty, disability, race or ethnicity, and age, introduces additional inequalities that compound this impact. These groups experience the city through a series of physical, social, economic, and symbolic obstacles that profoundly influence their daily lives in gendered ways, often invisible to men who do not encounter these urban challenges (Kern, 2020).

Many planning and design practitioners still lack a comprehensive understanding of these challenges, not fully grasping how conditions in the built environment, coupled with a lack of diversity in those shaping it, contribute to and sustain gender inequity. Incorporating a gender perspective into urban planning and design is essential for creating inclusive and equitable cities (Jacquot, 2022). Women, in particular, face challenges while navigating cities in multifaceted roles as caregivers, workers, and community members. Their experiences inform how they perceive and use cities, leading to unique challenges compared to many men, especially regarding safety (UN Women, 2017).

In the South Bronx, it's crucial to consider women's viewpoints when thinking about urban spaces. This is vital for addressing safety, accessibility, and inclusivity issues in public areas. Several factors, such as social, economic, and cultural elements, shape how women experience urban environments. Given the historical and socio-economic gaps and ongoing efforts to renew the South Bronx, women navigate public spaces while dealing with varying levels of safety concerns and access to resources.

One of the primary roles of murals is promoting inclusivity and accessibility in urban spaces. Art has the power to transform public areas into welcoming environments for all community members. Female-themed murals, in particular, serve as beacons of inclusivity, inviting diverse groups to engage with the urban landscape. These artworks encourage the participation of women and other marginalized groups in the cultural and social life of the city.

For instance, murals can influence urban design by inspiring the creation of more inclusive spaces. An area that features vibrant, female-themed murals might also be equipped with amenities that cater to the needs of all genders, such as well-lit pathways, seating areas, and recreational facilities. An example of this can be seen in the way murals have been used to reclaim spaces previously dominated by negative elements. By infusing these areas with positive imagery and messages, murals help redefine the space as inclusive and accessible. This transformation encourages a more diverse demographic to inhabit and utilize these areas, thereby promoting social cohesion and reducing instances of crime and neglect.

Murals play a significant role in empowering women and marginalized groups. By depicting strong, diverse female figures and celebrating women's achievements, these artworks instill a sense of pride and self-worth in viewers. This empowerment extends beyond the visual impact of the murals, influencing broader societal attitudes and encouraging greater gender equality. The presence of female-themed

murals in public spaces sends a powerful message that women belong in the urban landscape. It challenges the traditional notion that public spaces are primarily for men and asserts women's right to occupy and shape these environments. This visibility can inspire women to become more involved in their communities, whether by participating in local governance, advocating for improved urban policies, or engaging in artistic endeavors.

The broader implications for urban planning and policy are significant. As these murals highlight the importance of gender inclusivity, they can influence urban planners and policymakers to adopt more gender-sensitive approaches. This could lead to implementing policies that prioritize the safety, accessibility, and needs of women and other marginalized groups in urban design. Urban planners should be encouraged to conduct gender impact assessments in public space design to address the needs of all community members, while policies supporting diverse public art projects and educational programs aimed at raising awareness of gender equality in urban planning and design should be developed.

In conclusion, female-themed murals in the South Bronx are powerful tools for addressing gender dynamics in urban spaces. They highlight the challenges of gender equality, promote inclusivity and accessibility, and empower women and marginalized groups. They can also give valuable insights into how art can influence urban planning and policy, ultimately leading to more equitable and inclusive urban environments.

Conclusion

The exploration of female-themed murals in the South Bronx provides profound insights into the intersection of art, gender dynamics, and urban planning. These murals serve as vibrant expressions of community resilience, empowerment, and social justice, transforming public spaces into advocacy and identity reclamation platforms. They reflect the lived experiences of women, offering a powerful narrative that challenges traditional gender norms and promotes inclusivity in urban environments.

Through the lens of performative urbanism, these artworks highlight the significant role of community engagement and grassroots activism in shaping urban spaces. The murals beautify the neighborhood and act as catalysts for social change, encouraging dialogue and fostering a sense of belonging among marginalized groups. They illustrate how art can reclaim public spaces, making them more accessible and reflective of the community's diverse identities.

The comparison between the South Bronx and Manhattan underscores the disparities in public space utilization and resources. While Manhattan benefits from substantial funding and established cultural infrastructure, the South Bronx relies heavily on community initiatives and local talent to drive its artistic expression. This contrast reveals the critical need for equitable resource distribution and support for marginalized communities to ensure their voices are heard and their contributions recognized.

Gender dynamics in urban planning and design remain a significant challenge. The historical male dominance in these fields has often led to the exclusion of women's perspectives, resulting in urban environments that do not fully accommodate the needs of all genders. Female-themed murals in the South Bronx address these issues by promoting gender inclusivity and accessibility. They empower women and other marginalized groups, inspiring them to participate actively in shaping their urban landscape.

Experiential design, as a multidisciplinary approach, further enhances the impact of these murals. By focusing on the holistic experience of individuals interacting with urban spaces, experiential design creates environments that engage multiple senses and foster deeper emotional connections. This approach aligns with the principles of performative urbanism, transforming public spaces into immersive and interactive platforms for community performance and expression.

In conclusion, the female-themed murals in the South Bronx exemplify the transformative power of art in urban settings. They challenge societal norms, promote social justice, and empower individuals to reclaim and redefine their public spaces. By examining these murals and their broader implications, we gain valuable insights into how urban planning and policy can be more inclusive and equitable, ultimately leading to a more just and vibrant urban future.

References

Adams, M. (2020). *Understanding murals influence on the community*. Queens University of Charlotte.

Ash, A., & Thrift, N. (2002). *Cities: Reimagining the urban*. Polity Press.

Ciampa, F. (2018). Participatory design approach for the Bronx waterfront. *Proceedings of the 6th International Virtual Conference on Advanced Scientific Results*, *6*, 202–206. https://doi.org/10.18638/scieconf.2018.6.1.499

Conrad, D. (1995). Community murals as democratic art and education. *The Journal of Aesthetic Education*, *29*(1), 98–102. www.jstor.org/stable/3333522

DeFazio, C. (2024). Exploring the history & the Bronx with Tats Cru. *UP Magazine*. https://upmag.com/up6-tats-cru/

Grodach, C. (2009). Art spaces, public space, and the link to community development. *Community Development Journal*, *45*(4), 474–493. https://doi.org/10.1093/cdj/bsp018

Hughes, C. J. (2021, Oktober 17). In the Bronx, Mott Haven suddenly gets a skyline. *The New York Times*, 12. www.nytimes.com/2021/10/15/realestate/mott-haven-bronx-new-construction.html

Jacquot, S. (2022). Gender mainstreaming. In *PAS QuickNotes* (No. 84). https://doi.org/10.5771/9783845264608-241

Jonnes, J. (2022). *South Bronx rising. The rise, fall and resurrection of an American city*. Fordham University Press.

Kern, L. (2020). *Feminist city. Claiming space in a man-made world*. Verso.

Leaden, C. (2022). *There is now a massive JLo mural in the Bronx*. Secret NYC. https://secretnyc.co/jlo-mural-nyc/

Leavy, P. (2017). Social research and creative arts. An introduction. In *Method meets art: Arts-based research practice* (pp. 3–21). The Guilford Press.

Lefebvre, H. (1968). *Le Droit à la Ville [Right to the city]*. Anthropos.

Mokha, K. (2011). Mott Haven tries to rekindle momentum. *Wall Street Journal*, 1–5. https://online.wsj.com/article/SB10001424052748704099704576289213167219704.html

NYU Furman Center. (n.d.). *Neighborhood profiles: Mott Haven/Melrose BX01*. Retrieved October 23, 2021, from https://furmancenter.org/neighborhoods/view/mott-haven-melrose

Samson, K., & Juhlin, C. L. Z. (2017). *Performative urbanism*. http://citeseerx.ist.psu.edu/viewdoc/download?doi=10.1.1.964.8115&rep=rep1&type=pdf

Stavsky, L. (2016). *Her story, the first annual female graffiti series, launches uptown with lady K Fever, Mel1, Rocky 184, Charmin 65, Miss Boombox, Gem13 and Neks*. Street Art NYC. https://streetartnyc.org/blog/2016/05/16/her-story-the-first-annual-female-graffiti-series-launches-uptown-with-lady-k-fever-a-tribe-called-mel-rocky-184-charmin-65-leeza-boombox-gem13-and-neku/

Stavsky, L. (2023). *Lady K Fever on the NYC graffiti women's festival at Bronxlandia with: Lovenotes, Nasa one, Chare, Flô, Kstar, Alice Mizrachi, Mrs, Claw Money, Lexi Bella, Mikki Mu and More*. Street Art NYC. https://streetartnyc.org/blog/2023/10/26/lady-k-fever-on-the-nyc-graffiti-womens-festival-at-bronxlandia-with-lovenotes-nasa-one-chare-flo-kstar-alice-mizrachi-mrs-claw-money-lexi-bella-mikki-mu-and-more/

Stickells, L. (2011). The right to the city: Rethinking architecture's social significance. *Architectural Theory Review*, *16*(3), 213–227. https://doi.org/10.1080/13264826.2011.628633

Thwaites, K., & Simkins, I. (2006). *Experiential landscape: People place and space*. Routledge. https://doi.org/10.4324/9780203462096

Ulmer, J. B. (2017). Writing urban space: Street art, democracy, and photographic cartography. *Cultural Studies – Critical Methodologies*, *17*(6), 491–502. https://doi.org/10.1177/1532708616655818

UNWomen. (2017). *Safe cities and safe public spaces: Global results report* (pp. 1–24). www.unwomen.org/-/media/headquarters/attachments/sections/library/publications/2015/un women-safecities-brief_us-web (1).pdf?la=en&vs=953

Weaver, S. (2024). The top spots to see graffiti and street art in NYC. *Time Out*. www.timeout.com/newyork/art/street-art-top-ten-spots-to-see-street-art-and-graffiti-in-nyc

21 Gravitational Waves Architecture

Architecture as a Tool for the Transmission of Scientific Knowledge

Massimo Faiferri, Lino Cabras, Fabrizio Pusceddu, Benedetta Medas and Daniele Menichini

Introduction. Cosmic Background Radiation and Anomaly as Opportunity. The Italian Pavilion at La Biennale di Venezia 2021

Often, in the process of research, we come across anomalies that we tend to consider marginal or insignificant in relation to our main observations. Nevertheless, the history of science teaches us that even a single anomalous result, obtained with methodological rigor, can challenge the entire interpretive model.

A symbolic example is the anomaly detected by Arno Penzias and Robert Wilson in 1964, initially attributed to local interference or external factors, but which turned out to be the first recording of cosmic microwave background radiation, the fossil echo of the origin of the universe. This case, often described as a lucky coincidence, shows how nature far exceeds our imagination and how unexpected discoveries are possible because of the vastness and complexity of the natural world (Melis & Pievani, 2021).

Scientific research has a duty to investigate precisely those places where certainties are challenged. The inability to ignore anomalies and the perseverance to investigate them represent a hallmark of human creativity, fundamental for survival and expressed mainly through art and technology.

The Italian Pavilion at the Biennale Architettura 2021 embraced this perspective, encouraging the listening to background noise and anomalies with respect to the dominant architectural paradigm. The goal was not to give voice to marginalization out of an ethical principle but to affirm the priority of research as a tool for observing the phenomena around us (Melis et al., 2021)

The Italian Pavilion was configured as a research laboratory, whose path represented a virtual exploration of Italy as a place of transition and adaptation. The projects presented, characterized by a high scientific and technological content, included interdisciplinary experiments between architecture, physics, and sciences, such as biology, botany, agronomy, and medicine (Melis & Caroli, 2021)

This is the context for the installation *Gravitational Waves Architecture*, which aims to translate the complexity of a high-level scientific structure into an artistic

DOI: 10.4324/9781003465188-27

and sensory experience capable of making articulated scientific content accessible to a wide audience (Coccia et al., 2021).

From the Theory of Relativity to the International LIGO-VIRGO Experiment

Gravitational waves, a pivotal element of Albert Einstein's Theory of General Relativity, have been experimentally confirmed through the international LIGO-VIRGO collaboration and the three interferometers operating in America and Italy. This momentous discovery has revolutionized the observation and study of the Universe.

Italy and its scientific community play a leading role in this cutting-edge research field. Through the Virgo interferometer, a large infrastructure built by INFN and CNRS at the European Gravitational Observatory in Cascina (Pisa, IT), and the Gran Sasso laboratories, Italy attracts astroparticle physics scholars and researchers from around the world.

The current Advanced LIGO and Advanced Virgo interferometers, while representing the second generation of gravitational wave detectors, are the first to actually measure gravitational waves. However, the infrastructure that houses them, designed in the 1980s and built in the late 1990s, limits their future development, which has already reached its limit. Moreover, these detectors can only investigate the local Universe, while there is an increasingly urgent need to explore the entire Universe, an operation that is only possible with third-generation telescopes capable of detecting gamma rays.

The Einstein Telescope (ET) is an ambitious European project that aims to build a state-of-the-art gravitational wave observatory capable of picking up signals from astrophysical sources throughout the Universe. ET was the pioneering project that introduced the concept of third generation worldwide, thanks to a conceptual design study funded by the European Commission. This innovative approach was consolidated globally with the proposal of an observatory in the United States (Cosmic Explorer – CE) funded by the National Science Foundation. Italy maintains a leadership role in ET, both in conceiving the project and coordinating the design study, which includes defining candidate sites to host the large research infrastructure.

The Einstein Telescope. Listening to the Universe by Capturing Gravitational Waves

For the realization of the Einstein Telescope, the massive scientific infrastructure dedicated to the study of gravitational waves, two sites were found to be suitable: one in Limburg, Netherlands, and the other in Sardinia, at the Sos Enattos mining site. The Sardinian site's candidacy is strongly supported by the Sardinia Region and the MUR, with the establishment of a pilot laboratory (SAR-GRAV) and an agreement signed in 2018.

In terms of geophysical stability, the low seismic and anthropogenic noise and the distance from the sea make the Sardinian site ideal for gravitational wave research and as a hub for observing space-time ripples.

The design proposal for the Einstein Telescope conceives of its non-hypogean component as an opportunity for spatial redevelopment. It outlines an integrated network, both physical and conceptual, aimed at making the invisible perceptible through an articulated landscape system.

A first system aims to reconnect the mine to the surface, uniting the urban centers of Lula, Bitti, and Onanì. These places become spaces for scientific dissemination, offering direct contact with underground research activities (Bartocci et al., 2021; Faiferri et al., 2021, 2023).

A second system aims to connect the urban centers, highlighting the productive peculiarities of the surrounding areas. A new pedestrian path unites the villages, enhancing the local landscape.

The third system involves the installation of poles about 50 meters high, adorned with colorful fabrics, to mark sites of special scenic value.

According to Bertrand Russell (1995), to advance culturally in this context, research must aim at the discovery of non-obvious data, constituting the "external world." This externality is neither spatial nor apparent but structured on sensible objects, invisible and beyond appearances, just as the Einstein Telescope project seeks to do.

In this perspective, the distinction between private worlds and the understanding of differences are fundamental to defining an equitable and sustainable future, in a community composed of infinite possible worlds that do not necessarily coincide.

In the Sardinian territory, these mechanisms are intrinsic to the characteristics of the landscape, to the point that the city loses relevance with respect to the territory and its environmental elements. Social relations, in these contexts, are defined by contemporary dynamics such as inequality, lack of public resources, ecological impact, lack of human resources, political instability and constant change, (Faiferri et al., 2019, 2020).

This recognition implies that architecture must adapt to these dynamics by structuring design processes that are more responsive to economic, political, environmental and, above all, social changes. Revealing places conducive to welcoming, learning and dialogue, fostering encounters between different forms of sociability and knowledge (Faiferri et al., 2019a), results in a web of open and adaptive architectures, composed of modules, bands, tessellations, ramifications, and patterns of association, in which lines of force come together and make every part of the territory perceptible.

Gravitational Waves Architecture

Gravitational Waves Architecture, among the high-profile technological installations of *Resilient Communities*, Italian Pavilion at the Architecture Biennale 2021, aims to demonstrate how high-level scientific projects can combine with the redevelopment of abandoned territories subject to depopulation, reflecting on the ways in which such scientific initiatives can be welcomed and shared by local communities (Merzagora & Rodari, 2007).

The prospects for transformation and regeneration are crucial for territorial development. The creation of a gravity wave observatory in the Montalbo area of

Sardinia represents a unique opportunity to generate positive social, economic, and cultural impacts.

The widespread dissemination of knowledge, the contamination of local knowledge and the generation of development opportunities are key elements of this reflection, which also translates into a modification of physical space and stems from the awareness that precisely the design of physical space in low-density territories, particularly in areas where infrastructure emerges, offers a unique opportunity to rethink the territory (Faiferri et al., 2023).

Gravitational Waves Architecture thus aims to create a synaesthetic sensory experience, allowing visitors to perceive the underground dimension of the Einstein Telescope through a dynamic pathway punctuated by audiovisual content

The result of an interdisciplinary collaboration between the Gran Sasso Science Institute (GSSI), the National Institute of Nuclear Physics (INFN), the Ecourbanlab Research Laboratory of the University of Cagliari, and the Colombian architecture firm El Equipo Mazzanti, the GWA (from Venice to Sardinia) exhibit showcases three main aspects of the ET project:

1. The design of the massive underground research infrastructure, an equilateral triangle of about 11 km on a side, dug about 200 meters deep.
2. The outcomes of the international architectural workshop ILS – Innovative Learning Spaces, which interprets the ET project as an opportunity to enhance and revitalize the area through the design of knowledge space as a public space and learning community building (Faiferri et al., 2019b).
3. The Surface Project, which imagines the transformation of places resulting from the realization of the infrastructure on an urban, territorial and landscape scale.

The exhibition route is delineated by two parallel walls 7.80 meters long and 3.20 meters high, which accommodate a fluid sequence of hourglass-shaped wooden elements, called "diabolos," arranged at different heights and with varying diameters. These rotating solids, whose shape recalls ancient Chinese origins, serve as supports for transmedia content, integrating visual and sound elements that illustrate design experiences related to the activities of INFN and the ILS Scientific School.

The typological diversification of the "diabolos" makes it possible to activate specific modes of interaction with the visitor, depending on the content conveyed: some elements are empty, others integrate devices for video projections, and still others act as supports for text and images or for sound content.

The installation was designed to be reconfigurable in different exhibition modes, thanks to its modular structure composed of individual elements that can be assembled. This feature allowed its disassembly at the end of the Biennial and subsequent reassembly in other contexts, either as a temporary or permanent installation.

The idea behind the installation is to recreate for the visitor the sensation of spatial compression typical of the underground gallery, through a dynamic path in which the "diabolos" act as knowledge transmission devices in a private dimension. The multisensory activation of the visitor contributes to the construction of a personal and immersive cognitive map (Tagliagambe, 2008).

Conclusions

The installation *Gravitational Wave Architecture* aims to provide individual experiences in intersubjective and interbody contexts, promoting active learning and discovery based on bodily perception and experience (Hustvedt, 2016). This approach reflects the spirit of modern research facilities, where exploration can benefit from friction and contamination with neglected cultural aspects in order to generate more inclusive and shared research.

"Where architectural opportunities proliferate around us, we are offered a seemingly unlimited idea of freedom. The structure around us is fertile and rich with invitations to agility, transformation and discovery, presenting us with a wide-ranging field of action. These possibilities of our surroundings are particularly evident in pristine landscapes and large cities, but they are also revealed in buildings with extraordinarily porous masses and uninterrupted cavities. In these spongy, eventful forms, there is no end to the course of action that individuals can grasp and decide for themselves. These buildings are essentially "open works" and "open forms" because of their spatial continuum and wide range of perspectives, offering infinite "open futures" that one is able to choose and guide" (Plummer, 2016).

References

Bartocci, S., Faiferri, M., Pusceddu, F., Cabras, L., & Pujia, L. (2021). Spazi e luoghi della conoscenza. La dimensione dell'apprendimento nei territori a bassa densità. In G. R. J. Mangione, G. Cannella, & F. De Santis (Eds.), *Quaderni della Ricerca: Vol. 59. Piccole scuole, scuole di prossimità. Dimensioni, strumenti e percorsi emergenti.* (pp. 77–88). Loescher.

Coccia, E., Faiferri, M., Mazzanti, G., Punturo, M., Cabras, L., & Pusceddu, F. (2021). Gravitational waves architecture. In B. Medas, P. Boarin, B. Foerster, & P. Corrias (Eds.), *Comunità Resilienti: Best practice Italiane. Approfondimento al Catalogo del Padiglione Italia "Comunita' Resilienti" alla Biennale Architettura 2021* (Vol. 02a, pp. 55–59). D Editore.

Faiferri, M., Bartocci, S., Cabras, L., & Pusceddu, F. (2019a). Dal paesaggio produttivo al paesaggio della conoscenza. In A. Calderoni, B. Di Palma, B. Nitti, & G. Oliva (Eds.), *Il progetto di architettura come intersezione di saperi. Per una nozione rinnovata di patrimonio, Atti del VIII Forum ProArch* (pp. 910–915). Proarch.

Faiferri, M., Bartocci, S., Cabras, L., & Pusceddu, F. (2019b). Apprendimento totale al Bauhaus: la nuova comunità del futuro. *Bloom, 29*, 57–69.

Faiferri, M., Bartocci, S., Cabras, L., & Pusceddu, F. (2020). Communicating scientific knowledge. In O. Carpenzano, A. Capanna, A. I. Del Monaco, F. Menegatti, T. Monestiroli, & D. Nencini (Eds.), *Creativity and reality – the art of building future cities* (Vol. 1, pp. 124–129). Edizioni Nuova Cultura.

Faiferri, M., Bartocci, S., & Pusceddu, F. (2021). Oltre le istituzioni scolastiche. Territori dell'apprendimento e nuovi paesaggi della conoscenza. Luoghi dell'apprendimento. *Officina_ Trimestrale di Architettura, Tecnologia e Ambiente, 34*, 46–51.

Faiferri, M., Bartocci, S., & Pusceddu, F. (2023). Paesaggi della conoscenza nei territori a bassa densità. In G. Peghin, A. Picone, & F. Rispoli (Eds.), *Quaderni del centro studi Mediterraneo del Paesaggio: Vol. 7. Tanti paesi. Aree interne e insediamenti rurali* (pp. 224–231). Libria.

Hustvedt, S. (2016). *The delusions of certainty*. Simon Schuster.

Melis, A., Medas, B., & Caroli, P. (2021). Resilient communies: Concept. In A. Melis, B. Medas, & T. Pievani (Eds.), *Architectural exaptation. Catalogo del Padiglione Italia Comunità Resilienti alla Biennale Architettura 2021* (Vol. 1a). DEditore.

Melis, A., & Pievani, T. (2021). Creative serendipity and exaptaon: Towards a crisis archi-
tecture taxonomy. In A. Melis, B. Medas, & T. Pievani (Eds.), *Architectural exaptation.
Catalogo del Padiglione Italia Comunità Resilienti alla Biennale Architettura 2021*
(Vol. 1a). DEditore.
Merzagora, M., & Rodari, P. (2007). *La scienza in Mostra*. Mondadori.
Plummer, H. (2016). *L'esperienza dell'architettura*. Einaudi.
Russell, B. (1995). *La conoscenza del mondo esterno*. TEA.
Tagliagambe, S. (2008). *Lo spazio intermedio. Rete, individuo e comunità*. Università Boc-
coni Editore.

Part 4
Conclusion

22 Reflection and Conclusion on the Evolution and Innovation of Exhibition Spaces

Alessandro Melis, Rozina Vavetsi and Fabio Finotti

Beyond Boundaries

The Architecture of Exhibitions has been a journey through the realm of creativity, a journey that cannot be concluded with this book alone due to the complexity of the topic. However, the book has attempted to provide an overview through the study of the idea of the exhibition space, a convergence of research, particularly on the theme of creativity, its origins, and its possible alternate evolutionary significance. For instance, heuristic studies on biology, with the game-changing concept of exaptation at the center, have fueled a critique of the rigid use of categories and classifications. This critique addresses the distinctions between art, science, and technology, as well as the distinctions between fine art, performative art, and visual art when these categorizations become obstacles to change and adaptation to environmental pressures, especially in times of global crises. A further aspect that characterizes the book is the relevance attributed to practice-based research through the examination of multidisciplinary case studies and innovations in technology. These support impact beyond academia through qualities such as significance, methodological rigor, and originality.

The four parts of the book respond to these aspirations, each serving a complementary and distinct purpose in building a comprehensive understanding of art exhibitions within alternative or extended categorization frameworks and contemporary settings. The rationale behind this structure is to gradually guide the reader from foundational concepts regarding the need for art exhibition and sharing since the inception of creativity to cutting-edge practices, culminating in a synthesis of interdisciplinary perspectives and real-world applications.

The first part of the book, focusing on the origin of the exhibition space from an evolutionary perspective, lays the groundwork by exploring radical historical and theoretical underpinnings of art exhibitions, providing readers with a contextual framework. By establishing a solid foundation for potentially provocative considerations, this part ensures that readers grasp the fundamental principles of the evolutionary perspective on creativity – as the shared root with the term "creationist" might make evolutionary creativity sound like an oxymoron if we don't extend the taxonomy of creativity – before advancing to more complex ideas.

DOI: 10.4324/9781003465188-29

The second part, transitioning into a discussion on experiential design as the backbone of contemporary art exhibitions, has highlighted technological advancements and methodological innovations. We have presented the possibility to bridge the gap between theory and practice through emerging technologies, including generative AI and machine learning, along with new methodologies, which are transforming exhibition spaces and shaping how creativity interconnects with life and modern needs.

By doing so, the expectation was to prepare the reader for the more nuanced and interdisciplinary discussions on research practices in the third part.

The third part, intended as the culmination of the book's exploration, as a collection of practice-based research and international case studies, presented a wealth of experiences and insights from experts across various fields. The focus on guest contributions, case studies, and professional and academic experiences underscored the diverse and interdisciplinary nature of contemporary art exhibitions. The description of the transformative potential of art exhibitions when they transcend traditional boundaries and embrace interdisciplinary approaches has propelled the conclusive reflections, included in this fourth and final part of the book.

Consideration on the Origin of the Design of Exhibition Space

"The Origin of the Design of Exhibition Space," in the first part of the book, explores the nature of art and science, suggesting they are not merely related but fundamentally the same, shaped by associative thinking. This perspective traces back to early symbolic representations in caves, demonstrating the human tendency to create and categorize. The history of humanity is presented as a struggle between subjective perception and an elusive objective reality, with art existing at the intersection of order and chaos. The exploration of exhibition spaces highlights their evolution, reflecting societal changes and human creativity.

The section titled "Exhibition Spaces Beyond Ideological Constructs" investigates exhibition spaces encompassing diverse environments, evolving from simple displays to sophisticated venues like museums and digital platforms. This evolution mirrors broader cultural and technological shifts, driven by human creativity, suggesting that the need to exhibit art is rooted in evolutionary changes in the brain, with early humans using art to process complex data through associative thinking. This inherent drive for creativity and exhibition is seen as part of our genetic makeup, with the brain's plasticity allowing for adaptive innovations.

In "The Dawn of Exhibited Artistry," the emergence of creativity around 200,000 to 150,000 years ago is described, leading to the first art exhibitions, such as cave paintings. Sites like Chauvet-Pont-d'Arc, Lascaux, and Altamira demonstrate early humans' artistic abilities, transforming caves into immersive exhibition spaces. It is demonstrated that these early artistic expressions are driven by the brain's associative thinking, creating spaces for communal artistic experiences long before the deliberate creation of dedicated exhibition spaces intended as architectural typologies.

"Echoes of Eternity" examines early burial practices as performative spaces, which can also be considered a primary way of exhibiting art, reflecting early architectural ingenuity and ritualistic behavior. Recent literature in the field is introduced, showing how these practices highlight the complexity of human societies and their evolving perspectives on death and art. Particularly, the Dinaledi Chamber, through the hypothesis of ritual behavior predating Homo sapiens, is described as a case study potentially challenging traditional views of human evolution, emphasizing the diversity in artistic and architectural practices.

Similarly to the Dinaledi Chamber, the case of Göbekli Tepe, dating back to around 10,000 BCE, is presented as a paradigm shift in history, introducing designed exhibition spaces predating the birth of the agricultural revolution. Its elaborate carvings and stone pillars suggest a complex combination of artistic, spiritual, and communal functions.

In the following chapter, the discussion on how classical and avant-garde art both contributed to human creativity is presented. While avant-garde art introduced complexity, classical art focused on beauty and the imitation of nature. The idea of exaptation as an evolutionary mechanism is indicated, supporting the notion that diverse forms of creativity coexisted. Additionally, it is demonstrated that while categorizations might be useful for understanding the environment, they can also become rigid ideological constructs, as in the case of art intended solely as an imitation of nature. The concept of mimesis, evolving over time, connects art to representations of reality, with shifting meanings of functionality.

Plato and Aristotle, as protagonists of this section of the book, are introduced to demonstrate how, despite having opposite positions, both belong to the Classical milieu, showing that taxonomical extensions could overcome the confines of today's classifications. Plato, for instance, viewed art as a "dangerous" imitation of reality, distracting from true knowledge. The "Allegory of the Cave" is the focus of this section, exemplifying the deceptive nature of sensory perceptions in the pursuit of higher knowledge. Aristotle, instead, saw art as a fundamental aspect of humanity, offering pleasure and catharsis. In this sense, his view aligns with the origins of creativity, as described in the first chapter, where art served functional and cathartic purposes. This perspective can help explain why early humans devoted time to art, possibly recognizing its many potentials, including the educational one. At the same time, Aristotle's human-centric and intentional approach to art contrasted with more abstract forms that thrived on ambiguity and spontaneity.

The following chapter, more conventionally than the preceding ones, traces the tradition of collecting and displaying objects from ancient civilizations, illustrating how temples in Ancient Egypt and public spaces in Greece and Rome functioned as early exhibition venues. In ancient Greece, the evolution of art exhibition mirrored shifts in philosophical and governance structures. Initially centered around palatial complexes and tombs, art transitioned toward public and communal roles with the rise of the polis, culminating in art expressing democratic ideals. Public spaces like the Agora displayed statues and monuments celebrating civic achievements, while temples and sanctuaries like Delphi and Olympia reflected collective religious and civic identity.

The Roman Forum, akin to the Greek Agora, is introduced as a central venue for displaying art that reflected the power and values of the Roman state. Public baths, amphitheaters, and other infrastructures integrated artistic elements, embedding art into everyday life. Roman public art emphasized imperial achievements and cultural belonging, with a patronage system ensuring art's presence in public life.

With the fall of the Roman Empire, new city models and ways of exhibiting art emerged, often repurposing previous structures. Gothic cathedrals represented holistic art exhibitions where engineering, stone carving, and symbolism intertwined. This collective effort fostered a shared cultural and artistic heritage. The concept of the spandrel, as described by Gould and Lewontin, is presented to illustrate how structural elements in cathedrals were repurposed for artistic expression, propelled by a collective form of evolutionary creativity.

Similarly, this synthesis of architectural and decorative elements exemplifying a holistic approach to art exhibition is also reflected in Islamic architecture. Early mosques, like the Prophet's Mosque in Medina and the Great Mosque of Damascus, integrated Byzantine elements, adapting them to Islamic contexts.

The Renaissance is described as a period that returned to an interpretation of creativity grounded in order, introducing the concept of the architect as a demiurge. This era emphasized intentional design as the pinnacle of human creativity. Art and architecture during this time focused on classical paradigms such as the imitation of nature and the human form. The section ended with notes on following periods. While other periods are seen as revolutionary from a design perspective, they were less disruptive in extending categorization toward more spontaneous forms of creativity. Examples of these include the Enlightenment, which shifted the focus of exhibition contents toward scientific research, and Modernism, which, while questioning the imitation of nature in favor of abstraction, explored functionalism from a rational, reductionist perspective.

Environmental Graphic Design and Technology Innovation

In the second part of the book, the discussion transitioned to environmental graphic design (EGD) as a foundational approach to art exhibitions in the contemporary world. The initial section introduced technology and innovative methodologies, emphasizing how EGD transforms ordinary spaces into engaging narratives that enhance and complement exhibitions. This multidisciplinary field integrates graphic design, architecture, technology, and behavioral psychology to enhance spatial experiences, establish identity, and create a sense of place. By employing elements such as imagery, signage, typography, color, and multimedia, EGD facilitates navigation, defines identity, promotes brand recognition, evokes emotional responses, and influences opinions. It fosters meaningful connections between people and their environments, making spaces integral to personal and collective identities.

Signage was described as crucial in EGD for communication, atmosphere, and place identity. Wayfinding systems guide people through complex environments, while branding creates and reinforces brand identities within physical spaces.

Placemaking transforms public spaces into vibrant, meaningful environments. The integration of technology, such as digital displays and augmented reality, enhances design solutions. User-centered design ensures solutions are tailored to enhance user experience and accessibility.

This section also traced the development of EGD from early symbols and inscriptions to its contemporary form. Early manifestations included prehistoric symbols, Roman inscriptions, medieval town seals, and Renaissance banners. The modern era saw influences from Art Nouveau, Modernism, Bauhaus, and Post-modernism, which shaped EGD with functional design, minimalism, and eclectic styles. From the mid-20th century onwards, principles established by design firms and the advent of digital technology transformed EGD into an experiential, inter-active discipline. Sustainability, inclusivity, and technology-driven solutions are central to modern EGD.

Thus, EGD plays a crucial role in defining a place's purpose and establishing visitor engagement. It enhances character, simplifies navigation, and fosters a sense of belonging. EGD supports corporate branding, social messaging, and public engagement by leveraging digital innovation to create interactive, immersive expe-riences that address complex needs and reflect societal values. Through sensory stimuli and storytelling, EGD conveys narratives, elevates emotional engagement, and celebrates cultural significance. By connecting people to their environment, it fosters community and identity. The chapter emphasized EGD's power to address social issues, educate the public, and inspire collective action.

Examples illustrated EGD's impact on social transformation, such as Keith Har-ing's murals addressing political and societal issues, Banksy's street art highlight-ing injustice, and Eduardo Kobra's murals raising awareness about social issues and celebrating cultural diversity. Tatyana Fazlalizadeh's posters address gender inequality and street harassment, while Francisco Toledo's memorial commemo-rates disappeared students in Mexico. The Orlando Towers symbolize hope and transformation in post-apartheid South Africa. The AIDS Memorial Quilt raises awareness of the AIDS epidemic, and artists like Andy Golub and Substantia Jones promote body positivity through their body art. Amnesty International's campaigns highlight human rights abuses, and Greenpeace's environmental campaigns raise awareness about deforestation.

A further pivotal feature of EGD is the integration of cutting-edge technolo-gies like digital signage, interactive displays, augmented reality, and virtual reality to create adaptable, real-time, and immersive experiences. Firms like Pentagram and C&G Partners use these technologies to educate, simplify, and humanize the built environment, transforming spaces into engaging and meaningful experiences. Environmental graphic design has the power to inspire social transformation, shap-ing perceptions and influencing behaviors to drive positive change. By integrat-ing beauty, functionality, and social messaging, EGD enhances spaces, amplifies voices, and fosters a global community dedicated to making a better world.

The incipit of the following section, regarding technology innovation, is dedi-cated to the reinterpretation of mimesis, traditionally understood as imitation, as it evolved to encompass modern technological advancements. Contemporary

curating practices include, in fact, digital tools and perspectives like virtual reality, transforming art exhibitions into immersive experiences. The rise of multiversal platforms fosters collective creativity, breaking down traditional boundaries of authorship and promoting democratic artistic expressions. Generative AI, in particular, transcends traditional mass production by enabling the creation of many unique artworks.

In this section, AI's potential to enhance creativity has been described as a possibility to transcend traditional categorizations, promoting more interaction between humans and technology. By adopting the concept of exaptation, where traits evolve to serve new functions, AI is described as a collaborator in creative processes. This broader taxonomy, encouraging innovative solutions and a more inclusive understanding of creativity, is reflected in projects like *Two Acrobats* and *Padiglione della Scienza*, where AI's role in merging physical and digital realms enhances artistic narratives. Generative AI, in particular, has been explored as an opportunity to challenge traditional notions of creativity and architect authorship, promoting a collective and iterative approach. Recognizing creativity as a communal journey, complemented by AI, fosters a more inclusive and innovative exploration of our potential.

In the third part of the book, the collected practice-based research and international case studies explored art exhibition trends and goals. This section moved beyond the conventional "white-box" curatorial approach, promoting interdisciplinary and holistic art exhibition practices. Experts, professionals, researchers, and scholars contributed their perspectives, aiming to provide a manual of art exhibition possibilities.

Anthony Caradonna's "Meta-Exhibition Designs" examined the integration of AI and human consciousness in creative fields. It highlighted pivotal moments in art history and contemporary installations that blend technology with art, enhancing human awareness. Giovanni Santamaria's "The Architecture of Exhibitions and the Exhibition of Architectures" traced the evolution of exhibitions from aesthetic displays to immersive experiences, emphasizing the merging of art forms and the use of technology to create synesthetic environments. Andrew Barrie and Mike Davis discussed New Zealand's unique architectural challenges and opportunities in "The Tyranny of Distance?" by emphasizing local materials and low-tech solutions. Their *Learning From Trees* exhibit at the Venice Biennale showcased sustainable timber-building traditions.

Fadhil Fadhil's "Components, Representations, and Pixels" explored the role of pixels in architectural design and digital fabrication, highlighting research on transforming 2D images into 3D models using digital techniques. Dustin White's "Stereoma" described an immersive installation creating a sensorial exploration of space, showcasing projects that integrate material geometry and LED lighting to engage the public dynamically. Antonino Di Raimo's "Field Notes From My Little Aurora" examined human-robot coexistence in domestic environments through personal experiences, highlighting the need for architectural spaces to adapt for robotic companions. Giuseppe Fallacara and his team described the "Marmomac Meets Academies" event, which promoted collaboration between universities and

the stone industry, emphasizing the blend of traditional stone craftsmanship with modern digital production techniques. Saverio Massaro and Enrico Lain's "Toward Non-Humans' Embassies" investigated performative staging and the relationship between art and design, using theatrical performances to explore non-human representations and challenge modern dichotomies.

Elena Cologni's "Places of Memory. 416_SR1938" explored historical contexts within the Jewish community in Pisa, fostering dialogue and memory through city interventions and combining static and temporary elements to create participatory memorials. Lanfranco Aceti's "Holier Than Thou" analyzed creativity within imperial propaganda contexts, critiquing how empires use art as a propaganda tool, and presented an imaginary Russian Pavilion at the Venice Biennale as a critique of imperial hypocrisy. Jonathan Alger and Maya Koptyman's "Phygital: A Designer's Call to Action" discussed the integration of physical and digital realms in design, creating immersive experiences and highlighting the potential of affordable technologies to transform physical spaces. Jose Antonio Lara-Hernandez examined how performative arts enhance the sense of place, focusing on Venice, and used case studies of key events to illustrate the role of performative arts in fostering belonging and identity. Barbora Melis' "Visual Voices: Female-Themed Murals as Community Exhibitions in the South Bronx" highlighted the transformative power of female-themed murals in reclaiming urban spaces, emphasizing the role of experiential design in fostering community engagement and unity.

Conclusion

The Architecture of Exhibitions provides an unconventional exploration of the evolution and innovation within exhibition spaces, offering radical insights that span both academic research and practical applications. The book emphasizes the significance of interdisciplinary collaboration, encouraging synergies between artists, designers, technologists, and researchers. This approach fosters the creation of innovative and impactful exhibition spaces that engage diverse audiences and address contemporary societal issues. Additionally, the study underscores the value of practice-based research, demonstrating how real-world applications can significantly enhance academic understanding and vice versa.

The book argues that art exhibitions predate civilization, with categorization emerging later. Early art, such as hand stencils and prints, likely served multiple roles, from ritualistic to educational, challenging traditional gender assumptions in prehistoric art. Göbekli Tepe disrupts the traditional narrative of architectural evolution, indicating that early humans created monumental projects with profound aesthetic and rational dimensions long before settled agricultural societies. This holistic perspective challenges modern categorizations, emphasizing the interconnected nature of human creativity, art, and architecture throughout history.

Technological integration is a key consideration emerging from the study, particularly exploring the intersections of emerging technologies and exhibition spaces. The focus on virtual and augmented reality reveals new possibilities for creating immersive experiences, while investigating the impact of generative AI

on curatorial practices and visitor engagement uncovers novel methodologies for enhancing exhibition interactivity and collective creativity. Generative AI reinvigorates the concept of style, allowing for variations in form and material use, challenging traditional notions of human superiority in creativity, and necessitating a reevaluation of our understanding of creativity. Ethical considerations in AI development are crucial to avoid exacerbating human flaws and biases. By embracing the synergy between human and artificial intelligence, we can navigate future challenges responsibly and creatively.

The process of reification, treating abstract concepts as tangible objects, is crucial in understanding societal structures and interactions. Art exhibitions and AI development reflect this process by making abstract ideas concrete. Recognizing these limitations allows for more nuanced and responsible knowledge and innovation.

The contributions of the book illustrate the transformative potential of integrating social, political, and experiential dimensions into art exhibitions. They emphasize the importance of narrative, memory, and community engagement in creating meaningful and immersive experiences. These insights advocate for a reimagined urban landscape where art and community intersect to create spaces of shared meaning and collective memory.

The insights from this study are highly transferable across various domains, including educational institutions, museums and galleries, and urban planning. For educational institutions, curricula in architecture, design, interior design, and digital arts can incorporate these insights to train a new generation of professionals adept at integrating traditional and contemporary practices. Museums and galleries can utilize the discussed methodologies to create more engaging and inclusive exhibitions. In urban planning, principles of environmental graphic design can enhance public engagement and create meaningful community spaces.

To facilitate the practical application of these insights, a handbook based on the extended taxonomy of exhibition space design is proposed. This handbook would serve as a comprehensive guide for universities offering courses in relevant fields, covering foundational concepts, historical perspectives, contemporary practices, and future trends in exhibition design. By providing detailed case studies, practical methodologies, and theoretical frameworks, the handbook would equip students and professionals with the tools to create innovative and impactful exhibition spaces.

Despite its comprehensive nature, the book faces certain limitations. The inherent complexity of exhibition design means that not all aspects could be covered in detail. The book's scope, while diverse, may not fully represent the global spectrum of practices and cultural contexts. Furthermore, the rapid pace of technological advancements poses a challenge, as new tools and methodologies emerge continually, potentially rendering some discussed techniques outdated.

23 Handbook

Designing Exhibition Spaces

*Alessandro Melis, Rozina Vavetsi
and Fabio Finotti*

Introduction

This chapter is a handbook tailored to students, scholars, and professionals, providing a structured set of guidelines derived from case studies and theoretical insights presented in the initial sections. Its primary aim is to support designers in creating exhibition spaces that are visually meaningful, engaging, and accessible to a diverse audience. By blending practicality with creativity, this guide ensures that each art exhibition captivates, educates, and inspires, reflecting the connections between art, science, and human evolution. Thoughtful design and innovative approaches can transform exhibition spaces into integral parts of everyday environments, fostering understanding, connection, and transformation, especially in times of global crises. This guide is an initial attempt to define rules of thumb to help in the design process while also encouraging future generations of designers to challenge and refine these principles as an exercise to understand opportunities and drawbacks in the definition of categorizations, classifications, and taxonomies.

1. Understanding Context, Audience, and Narrative

Research and Contextualization

* Investigate the cultural, historical, and social backdrop of the exhibition. Tailor the design to reflect and respect these elements, ensuring relevance and resonance with the audience.

Audience-Centric Design

* Identify the target audience's interests, backgrounds, and accessibility needs. Design with inclusivity and engagement at the forefront, accommodating diverse visitors.

Storytelling

* Craft a compelling narrative or theme that guides visitors through the exhibition, offering diverse pathways for exploration. Utilize spatial arrangements,

DOI: 10.4324/9781003465188-30

lighting, and signage to reinforce this storyline, ensuring a logical flow throughout the space. At the same time, be open to moments where visitors might challenge the curator's narrative, viewing these instances as opportunities for deeper engagement and discussion. Consider guiding visitors in a deterministic manner as one approach while also exploring a non-deterministic approach as an extension to this narrative.

Design With an Understanding of the Evolutionary Roots of Creativity

- Recognize that the drive to create and exhibit art is deeply rooted in human evolution, reflecting our inherent need to share and connect through creative expressions. Seek opportunities to integrate the container with the contents, embracing the interconnectedness of art, science, and technology as integral parts of the creative process.

2. Interactivity, Engagement, and Reflection

Interactive Elements

- Design spaces that encourage visitor interaction through tactile, auditory, and visual stimuli. Foster multisensory experiences to captivate and involve the audience, enhancing engagement and memory retention. Move beyond the notion of the visitor as a passive user following the curator's directives. Strive to make curators and visitors part of the same collaborative agency, avoiding the designer's demiurgic position.

Spaces for Reflection

- Create areas for visitors to sit, reflect, and discuss their experiences. Interactive stations, comment walls, and social media integration can facilitate community dialogue and personal reflection.

Historical Continuity and Modern Innovation

- Blend historical narratives and traditional practices with contemporary innovations, creating a layered and dynamic sense of place that resonates with visitors on multiple levels.

Every Space Is an Exhibition Space

- The design of art exhibition spaces should not be a specialized task. All designers should strive to respond to humanity's profound need for creativity, recognizing that every surface and space can be a venue for exhibiting and sharing art. Embrace the idea that every environment has the potential to become a platform for artistic expression and connection.

Public Art and Urban Design

- Extend the concept of art exhibitions beyond dedicated buildings, incorporating public art into urban design. Embrace the temporary appropriation of public spaces, making art a living part of the urban fabric and engaging the community in unexpected ways.

3. Flexibility, Adaptability, and Accessibility

Flexibility

- Incorporate modular and adaptable elements that can accommodate various exhibits and evolve over time. This flexibility allows for dynamic presentations and efficient use of space, ensuring relevance and adaptability. Simultaneously, recognize that the most sustainable design approach is to repurpose existing structures. Aim to design art exhibitions in spaces that serve multiple functions, and be prepared to creatively utilize surfaces and layers that were originally intended for different purposes or had no specific purpose.

Universal Accessibility

- Ensure the space is accessible to all visitors, including those with disabilities. This includes physical accommodations (ramps, elevators) and sensory accommodations (audio guides, tactile exhibits), promoting inclusivity and engagement.

Participation Methodologies and Tactical Urbanism

- Employ participation methodologies and tactical urbanism to engage the community actively in the design process. This fosters a sense of ownership and ensures that the exhibition space reflects local needs and values, making it more inclusive and dynamic.

4. Integration of Technology

Thoughtful Use of Technology

- Employ technology to enhance the visitor experience without overshadowing it. Interactive screens, augmented reality, and immersive installations should provide added value and insight without overwhelming the audience. Strive to understand how technology can function both as a tool and as an integral part of the exhibition itself.

Blending Physical and Digital

- Seamlessly combine digital and physical elements. For instance, use augmented reality to visualize historical contexts or interactive media to engage visitors more deeply, creating cohesive and immersive experiences.

Building Narrative Environments Through Technology

- Integrate cutting-edge technologies like interactive displays, dynamic signage, augmented reality (AR), and virtual reality (VR) to enhance user experiences, provide real-time information, and create immersive environments that connect people to the space.

5. Spatial Dynamics and Flow

Natural Movement

- Design the space to facilitate natural, spontaneous movement, creating a rhythm of open and intimate areas. Utilize architectural elements and clear signage to ensure smooth navigation, enhancing the overall visitor experience.

Environmental Context

- Integrate geographical and topographical dimensions into the design, promoting a sustainable interaction with the surrounding environment, and emphasizing the connection between the exhibition space and its setting.

6. Materiality and Form

Innovative Use of Materials

- Experiment with materials that emphasize temporality and singularity, such as organic and perishable materials. This can create dynamic and evolving exhibits that resonate with visitors on a deeper level.

Digital Fabrication

- Embrace digital tools like 3D printing to translate designs into physical forms, enhancing spatial and tactile qualities, and pushing the boundaries of traditional exhibition design.

7. Creative Lighting Techniques

Highlight and Mood Creation

- Use lighting creatively to highlight key pieces and set the mood. Experiment with different lighting types (natural, artificial, spotlights) to enhance the visual impact and guide visitors through the space.

Dynamic Lighting

- Employ programmable LED lighting and other advanced technologies to create responsive environments that change based on visitor interaction, enhancing the immersive experience.

8. Sustainable Practices

Ecologic Design

- Prioritize sustainable practices in material usage and exhibit maintenance. Incorporate recycled materials and upcycling techniques to minimize environmental impact and promote sustainability. Embrace the concept of exaptation, viewing sustainability as an opportunity to innovate and repurpose materials creatively.

Promoting Environmental Awareness

- Design exhibits that include critical topics like climate change and social justice, engaging visitors in meaningful dialogue and reflection and encouraging awareness and action.

9. Community and Collaboration

Fostering Local Engagement

- Involve the local community in the design and creation process. This fosters a sense of ownership and ensures the exhibit resonates with local values, promoting community engagement and pride.

Industry-Academic Partnerships

- Encourage collaborations between academic institutions and industry. Joint projects can lead to innovative solutions and new design paradigms, bridging the gap between theoretical knowledge and practical application.

Public Participation in Urban Design

- Implement participatory design processes that involve local communities in the transformation of public spaces. This approach ensures that the design resonates with the needs and aspirations of the community, fostering a sense of ownership and pride in the resulting spaces.

10. Environmental Graphic Design (EGD)

Definition and Scope

- Utilize environmental graphic design to transform physical spaces into narratives, enhancing and complementing exhibition themes. Use imagery, signage, typography, color, and multimedia to influence perceptions and interactions, establish identity, promote wayfinding, and convey messages.

Key Components

- **Signage:** Communicates information and defines atmosphere.
- **Wayfinding:** Guides people through environments using integrated systems.

- **Branding:** Creates and reinforces identities within spaces.
- **Placemaking:** Transforms public spaces into meaningful environments.
- **Technology:** Integrates digital elements for real-time information and interactivity.
- **Sustainability:** Prioritizes eco-friendly materials and practices.
- **User-Centered Design:** Tailors solutions to enhance user experience and accessibility.

Significance in Contemporary Design

- EGD simplifies navigation, enhances branding, and fosters community engagement. It shapes experiences and encapsulates a place's essence, making spaces integral to a person's identity.

Crafting Spatial Narratives

- EGD connects people to places through visual storytelling, fostering a sense of belonging and community. It transforms spaces into immersive experiences that engage and educate visitors.

11. Gender-Sensitive Design

Promoting Gender Inclusivity

- Ensure that the design of exhibition spaces is sensitive to gender inclusivity. This involves considering gender-neutral restrooms, nursing rooms, and spaces that are safe and welcoming for all genders.

Addressing Gender Representation

- Pay attention to the representation of different genders within the exhibits. Ensure diverse voices and stories are told, reflecting a broad spectrum of human experiences.

12. Diversity, Inclusivity, and Equity

Celebrating Diversity

- Design exhibits that celebrate cultural, racial, and gender diversity. Ensure the content and presentation methods honor and respect the experiences and contributions of all groups.

Inclusive Practices

- Implement practices that ensure all voices are heard and represented in the exhibition process, from planning and design to execution and feedback. This includes active engagement with underrepresented communities to ensure their perspectives and experiences are included.

Equitable Access

- Strive to provide equitable access to exhibits for all visitors, ensuring that financial, physical, and social barriers are minimized. This involves considering sliding scale ticket prices, providing multilingual materials, and ensuring physical spaces are navigable for all.

Representation and Equity in Exhibits

- Focus on curating exhibits that represent a wide range of cultures, histories, and identities. Ensure that the narratives presented are balanced and do not perpetuate stereotypes or marginalize any group.

Training and Awareness

- Provide training for staff on issues of diversity, inclusivity, and equity. This helps create an environment where all visitors feel welcome and respected, and staff are equipped to address any issues that may arise.

Collaborative Design

- Foster collaborations with diverse artists, designers, and cultural practitioners. This not only enriches the exhibition content but also promotes a more inclusive and representative design process.

13. Integration of Generative AI, Computation, and Robotics

Innovative Technologies

- Leverage generative AI, computational design, and robotics to create dynamic and adaptive exhibition spaces. These technologies can help personalize visitor experiences, optimize layouts, and introduce interactive elements that respond to visitor behavior.

Enhancing Creativity

- Use AI and robotics to push the boundaries of traditional design, allowing for the creation of complex forms and interactions that would be difficult to achieve manually. These technologies can also enable real-time data analysis and feedback, enhancing the visitor experience.

Future-Proofing Exhibitions

- Integrate AI and robotics in ways that future-proof exhibitions, enabling them to evolve and adapt to new technologies and visitor expectations over time. This can include the use of machine learning algorithms to tailor content to individual visitors or robotic systems to adjust exhibits dynamically.

Personalized Visitor Experiences

- Employ AI to analyze visitor data and preferences, creating personalized experiences that engage visitors more deeply. For example, AI can recommend specific exhibits or content based on a visitor's interests, creating a more tailored and engaging experience.

Interactive and Responsive Design

- Utilize robotics and AI to create interactive and responsive environments. These technologies can adjust lighting, sound, and other environmental factors in real-time based on visitor interactions, creating a more immersive and dynamic experience.

Ethical Considerations

- Address ethical considerations in the use of AI and robotics, ensuring transparency and privacy for visitors. This involves being clear about how data is collected and used and ensuring that AI systems are designed to be fair and unbiased.

Final Remarks on the Handbook

By integrating these principles and practices, designers can create exhibition spaces that are not only visually appealing and engaging but also inclusive, accessible, and forward-thinking. This holistic approach ensures that exhibitions can serve as powerful platforms for education, inspiration, and connection in an ever-evolving world.

As we conclude this handbook on designing exhibition spaces, it is essential to recognize the dual nature of this guide: while it provides structured guidelines and insights, it also serves as a playful exercise in itself. The very structure of this handbook reflects the categorizations and classifications it critiques, inviting readers to consider it not only as a resource but also as a provocation.

This handbook is intended to support designers, students, and scholars in creating exhibition spaces that are visually meaningful, engaging, and accessible. However, it also challenges the reader to question and refine the principles presented here. The act of designing exhibition spaces is not just about following set rules but about understanding and navigating the opportunities and drawbacks inherent in any system of categorization.

The process of designing exhibition spaces often involves imposing a structure, a narrative, or a classification upon a collection of objects, artworks, or ideas. This act of categorization is both necessary and limiting. It helps create a coherent experience for visitors but also risks oversimplifying or constraining the richness of the subject matter. As such, this handbook encourages designers to approach these categorizations critically and playfully, recognizing their provisional nature.

One of the key themes of this handbook is flexibility and adaptability. Just as exhibition spaces must evolve to accommodate new exhibits and changing audiences, so, too, must our understanding and approach to design evolve. This handbook is not a final word but a starting point, inviting designers to experiment, innovate, and challenge established norms. The principles outlined here are meant to be flexible, adaptable, and open to reinterpretation.

Designing exhibition spaces should be seen as a playful exercise, an opportunity to explore the boundaries of creativity and functionality. This playfulness is not about trivializing the design process but about embracing the joy and innovation that come with exploring new ideas and approaches. By viewing this handbook as a provocation, designers are encouraged to push the limits of what is possible, to question the status quo, and to imagine new ways of engaging and inspiring their audiences.

As you move forward in your journey as a designer, take this handbook as both a guide and a challenge. Use it to inform your work, but also to question and refine it. Embrace the playful nature of design, and be open to the unexpected and the unconventional. In doing so, you will not only create compelling exhibition spaces but also contribute to the ongoing dialogue about the role of design in our world.

In conclusion, let this handbook be a celebration to the dynamic and evolving nature of exhibition design. By balancing practicality with creativity, structure with flexibility, and guidance with provocation, we can create spaces that not only captivate and educate but also inspire and transform.

Index

Page numbers in *italics* indicate figures on the corresponding pages.

9781032736297